Game Design Deep Dive

Game Design Critic Joshua Bycer is back with another entry in the *Game Design Deep Dive* series to discuss the Role-Playing Game genre. Arguably one of the most recognizable in the industry today, what is and what isn't an RPG has changed over the years. From the origins in the tabletop market, to now having its design featured all over, it is one of the most popular genres to draw inspiration from and build games around. This is a genre that looks easy from the outside to make, but requires understanding a variety of topics to do right.

- A breakdown of RPG mechanics and systems, perfect for anyone wanting to study or make one themselves
- The history of the genre – from tabletop beginnings to its worldwide appeal
- The reach of the genre – a look at just some of the many different takes on RPGs that have grown over the past 40 years
- An examination of how RPG systems can be combined with other designs to create brand new takes

Joshua Bycer is a Game Design Critic with more than 7 years of experience critically analyzing game design and the industry itself. In that time through GameWisdom.com, he has interviewed hundreds of game developers and members of the industry about what it means to design video games.

Game Design Deep Dive
Role Playing Games

Joshua Bycer

CRC Press
Taylor & Francis Group
Boca Raton London New York

CRC Press is an imprint of the
Taylor & Francis Group, an **informa** business

Cover Design by Peggy Shu

First edition published 2024
by CRC Press
2385 Executive Center Drive, Suite 320, Boca Raton FL 33431

and by CRC Press
4 Park Square, Milton Park, Abingdon, Oxon, OX14 4RN

CRC Press is an imprint of Taylor & Francis Group, LLC

© 2024 Joshua Bycer

Library of Congress Cataloging-in-Publication Data
Names: Bycer, Joshua, author.
Title: Game design deep dive : role playing games / Joshua Bycer.
Other titles: Role playing games
Description: First edition. | Boca Raton, FL : CRC Press, 2024. |
Series: Game design deep dive | Includes bibliographical references and index.
Identifiers: LCCN 2023017941 (print) | LCCN 2023017942 (ebook) |
ISBN 9781032363660 (pbk) | ISBN 9781032363714 (hbk) | ISBN 9781003331599 (ebk)
Subjects: LCSH: Fantasy games. | Board games.
Classification: LCC GV1469.6. B93 2024 (print) | LCC GV1469.6 (ebook) |
DDC 793.93—dc23/eng/20230808
LC record available at https://lccn.loc.gov/2023017941
LC ebook record available at https://lccn.loc.gov/2023017942

ISBN: 9781032363714 (hbk)
ISBN: 9781032363660 (pbk)
ISBN: 9781003331599 (ebk)

DOI: 10.1201/9781003331599

Typeset in Minion
by codeMantra

Dedications

Sadly, while writing this book, several friends and family passed away that I wanted to dedicate this book to.

My grandmother Judith Pousman, she always listened to my video game ideas even though she never played them. She was a person who spoke her mind, and I hope she finds peace with my grandfather.

My friend Robert Leach passed away far too soon. He has been a supporter and friend of mine through some of the hardest periods of my life and growing Game-Wisdom. When I needed his help with something he was always there, and I miss him greatly.

Contents

Foreword

I always save writing the foreword for the last part of these books, and I'm really glad I did it with this one. This is now the longest book I've written to date, and I can't see any of the future entries reaching this size. The RPG genre most represents mechanics and systems that define a game – from tabletop and pen and paper to the most complicated RPGs. This is a genre that is not easily defined, and one that, thanks to the abstraction at its heart, can go almost anywhere with its design.

What's funny to think about is how for the early 2010s, platformers were considered the go-to genre for new designers and why the first Deep Dive was based on it. But the reach and diversity of RPG mechanics now make it even more popular and even harder to break down in terms of what's good and bad about it. Much like a classic RPG from the 90s, get ready for a very epic, and lengthy, RPG adventure.

Acknowledgments

For each *Game Design Deep Dive*, I run a donation incentive for people to donate to earn an acknowledgment in each one of my upcoming books. I would like to thank the following people for supporting my work while I was writing this book.

- Michael Berthaud
- Ben Bishop
- D.S
- Jason Ellis
- Jake Everitt
- Thorn Falconeye
- Puppy Games
- Luke Hughes
- Adriaan Jansen
- Jonathan Ku
- Robert Leach
- Aron Linde
- Josh Mull
- NWDD
- Rey Obomsawin
- Janet Oblinger
- Onslaught
- David Pittman
- Pixel Play

Social Media

Social Media Contacts

- Email: gamewisdombusiness@gmail.com
- My YouTube channel where I post daily design videos and developer interview: youtube.com/c/game-wisdom
- Main site: Game-Wisdom.com
- Twitter: Twitter.com/GWBycer

Additional Books

If you enjoyed this entry and want to learn more about design, you can read my other works:

20 Essential Games to Study – A high level look at 20 unique games that are worth studying their design to be inspired by or for a historical look at the game industry.

Game Design Deep Dive: Platformers – The first entry in the *Game Design Deep Dive* series focusing on the 2D and 3D platformer design. A top-to-bottom discussion of the history, mechanics, and design of the game industry's most recognizable and long-lasting genre.

Game Design Deep Dive: Roguelikes – The second entry in the *Game Design Deep Dive* series focusing on the rise and design of roguelike games. A look back at how the genre started, what makes the design unique, and an across-the-board discussion on how it has become the basis for new designs by modern developers.

Game Design Deep Dive: Horror – The third entry in the *Game Design Deep Dive* series examining the philosophy and psychology behind horror. Looking at the history of the genre, I explored what it means to create a scary game or use horror elements in any genre.

Game Design Deep Dive: F2P – The fourth entry in the *Game Design Deep Dive* series focusing on the mobile and live service genre. Besides looking at the history and design of these games, I also talked about the ethical ramifications of their monetization systems.

Game Design Deep Dive: Trading and Collectible Card Games – The fifth entry in the *Game Design Deep Dive* series looks at the deck-building genre along with CCGs and TCG design, as well as covering the balancing that goes into designing cards and sets.

All my books are available from major retailers and from Taylor & Francis directly.

Introduction

1.1 The Goal of *Game Design Deep Dive:* RPG

It's taken six books, but it's finally time to talk about the second major genre in the industry: Role Playing Games. In my first book in this series looking at platformers, I talked about how it was one of the most designed genres in the industry due to how many examples there are and how long it has been a part of the industry (Figure 1.1).

With RPGs, we now turn to a genre that is even bigger, arguably has had a larger impact, and thanks to game engines that I'll talk about later, it is even easier to try and start building a game with. However, with so many examples out there, just like platformers, there is a huge difference between good and bad takes – requiring even more work to stand out.

For this Deep Dive, we're going to examine the history of RPG design – from tabletops to consoles and PCs, to now being on literally every platform out there. Both RPG and action are genres that have fundamental elements to them that make up the basics of their **core gameplay loop**, and I'm going to discuss what abstracted design means to RPGs. Abstracted design is one of the two overall design philosophies that a game can be built on, and it's essential for you to understand what it is and how people respond to it being included in a video game.

DOI: 10.1201/9781003331599-1

1

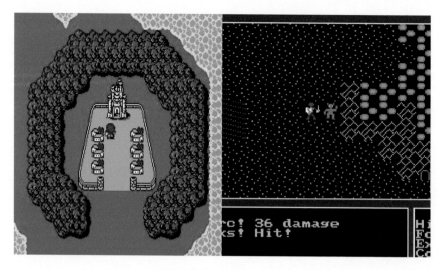

Figure 1.1

Welcome to the start of a very long book, and what better way to begin than by showing screenshots of RPGs that started it all with *Final Fantasy 1* and *Ultima 1*.

One of the most interesting aspects of this genre is that it has since evolved beyond just being a type of game, and is now being featured in multiple genres, even action games. Balancing RPG and action-based design is one of the hardest things to do from a design perspective, and I'm going to discuss both why it is and why designers continue to chase this combination.

One detail that will not be discussed in this book related to RPG design is story development and writing. This book is focused on the design and methodology that goes into making an RPG. Creating a plot, meaningful dialogue, and interesting characters is not something I am versed in and there are other books out there about story writing.

By the end of this book, you should have a good understanding of RPG-based **systems**, what are popular ways of building an RPG, and the balancing that goes into them. Like platformers, you don't need a lot to make a basic example, but standing out in the market today requires you to go above and beyond.

1.2 The Breadth of RPG Design

Before I get into the first major topic, I want to talk about the difficulty of talking about RPG design for this book. To try and chronicle every single RPG released in the past 40 years is an impossible task, even every single original RPG. Thanks to indie development and public game engines, there are countless games that have been developed that have never reached the mainstream audience; I haven't even heard of them (Figure 1.2).

Figure 1.2

RPG design today can mean almost everything – from a traditional game like *Dragon Quest 11* (released in 2020 by Square Enix), to something very untraditional like *Betrayal At Club Low* (released in 2022 by Cosmo D Studios).

If you're hoping for a complete list of games, or a complete list of every kind of RPG system that you can fit into your game, that's not going to happen here. With the history of the game industry, RPG design sits next to platformers and adventure games as one of the oldest, but the fundamentals and elements of RPGs have had the biggest reach out of any game genre to date.

One of the things you're going to learn as you read this book is that what is an RPG has changed dramatically from the 70s/80s to the 90s, then from the 2000s all the way through the 2010s. Focusing specifically on traditional RPGs, there is a simpler timeline and design that could make for its own separate book. However, the goal of the *Game Design Deep Dive* series is to look at the evolution of the game design and systems and what they mean for the market today. Part of said evolution is how RPG mechanics can and have been applied to multiple genres, and that making an RPG like the ones that were released during the golden age of the genre is not going to be anywhere as successful today. And studying only the famous games of the past is not going to help you improve. Even defining what is an RPG today is a difficult topic – with every subgenre focusing on different aspects of RPG design – there really isn't any one system that is "required" to be in an RPG or RPG-styled game anymore.

While the RPG genre is not a thematic one such as horror, the appeal of its design is universal, and why so many games now implement some form of it even if they are not classified as RPGs (Figure 1.3). If you want to succeed at making an RPG today, you need to understand where the genre has been, innovations

Figure 1.3

Something tells me you weren't expecting to see this in a book on RPG design, and yet, these two characters belong to games with RPG systems in them.

and evolutions that have been developed, and arguably why the most successful examples that defined RPGs in the past…would be absolutely crushed in the market today.

Within the genre, there are multiple subgenres each with their own histories, design qualifiers, unique rules, and more. On the one hand, not mentioning them at all would make this book far more compact and easier to write. However, their designs still belong in the RPG genre, and trying to classify what does and doesn't belong in an RPG book is not something I want to do. However, dedicating equal time and space to every subgenre would mean that I'm not writing one book on RPG design, but at least five at once. To wit, I will be focusing the design chapters specifically on elements that are either considered the most popular to be included in an RPG or the ones that can be applied to as many of the subgenres as possible. If there is something unique on a topic related to a subgenre, I will point that out to be as thorough as possible. In the future, the different subgenres of RPGs could easily be their own, and probably smaller, editions of the *Game Design Deep Dive* series.

2

The Tabletop Beginnings

2.1 Discussing *Dungeons & Dragons*

Role Playing Games owe their existence and original design to the tabletop market and to *Dungeons & Dragons*. To discuss the entirety and reach of *D&D* and tabletop design are outside the scope of this book, and there are several books available that chronicle both.

Dungeons & Dragons was first published in 1974 by Gary Gygax and David Arneson by Gygax's company Tactical Studies Rule. Designed as a fantasy game, *D&D* would establish many standards that would form the basis for tabletop RPGs and the **CRPG** genre (Figure 2.1). Playing a game of *D&D* required several elements starting with someone who runs the game known as a "Dungeon Master" or DM. The DM's job is to tell the story of what is happening, provides players with challenges and interactions, and controls the flow of a play from beginning to end. Dungeon Masters can either use prebuilt campaigns and stories that came with the game, buy new officially licensed stories, or create their own.

Players create their characters from different archetypes and classes which has changed over the years. While playing, characters can level up (a **mechanic** that I will be talking at length about later in this book), acquire new gear, spells,

DOI: 10.1201/9781003331599-2

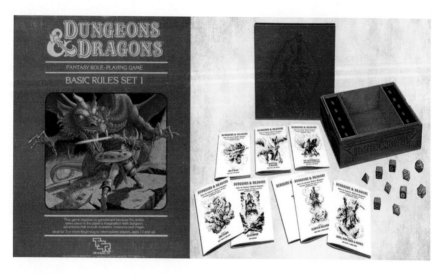

Figure 2.1

Dungeons & Dragons is the property that we would credit as the originator of RPG design, with its influence even impacting what would become Japanese Role Playing Games.

and more. Characters can be personalized or customized in a variety of ways, and these systems have become some of the most popular aspects of RPG design.

Over the years, the game has changed and altered its rules on multiple occasions. New editions have been released, and there was a point when the game itself was split between basic and advanced rules. As of writing this book, the game is up to its fifth main edition, with a sixth one in the works. The rules for *D&D* define everything there is about the game, and why it is a big deal when a new ruleset is released.

Because this book is not focused exclusively on *D&D*, I am providing a short summary of it here, but make no mistake, the impact the game has had on all aspects of the game industry is astronomical. Due to the different editions and the variety of properties associated with *D&D*, it is hard to find accurate numbers for how much it is worth; some estimate that it brings in at least 100 million in revenue a year.[1]

As a property, *D&D* is credited with many firsts when it comes to the game industry and RPG design. It is the first **TTRPG** of all time and would set many standards that the genre still uses to this day. Within the different editions, the rules for how everything works – from character progression, to combat, spells, etc., would become the foundation for countless RPGs; many of which will be talked about in this book.

An unintentional benefit that *D&D* provided was creating a game that can be much more about the interactions between players than the actual content of the game itself. The benefits of role-playing – acting and behaving as the character

2. The Tabletop Beginnings

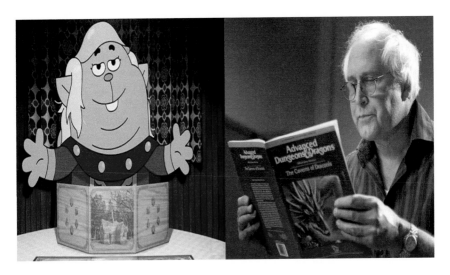

Figure 2.2

Dungeons & Dragons has become a pop culture fixture in recent years – being used or heavily referenced in TV shows and cartoons.

someone plays – have shown to help people when it comes to building confidence, creativity, and more. For people who have poor social skills or trouble communicating, they found a healthy outlet with *D&D* and games like it (Figure 2.2). There are people who play *D&D* and tabletop games not for the challenge or completing stories and campaigns, but simply to hang out with people like them who also want to spend some time escaping into a fantasy world. Returning to the creativity aspect, there are many people who grew up inspired by *D&D* or created their own stories and campaigns using the setting as a template.

When it comes to game design, many of the early RPGs would base their systems and rules off *D&D*. When I talk about CRPG design in Chapter 3, one of the groundbreaking aspects of early CRPGs was translating the rules and play of *D&D* without needing a Dungeon Master, as the game itself would handle that task. And regarding *D&D*'s influence on games, so many of the most popular RPGs to be released in the history of the game industry stem from either being inspired by *D&D* or took place within the property itself. Over the past 50 years of *D&D*, the property has been licensed countless times, and I'll talk about those games throughout this book. Besides games, there have been TV shows, several movies, and the hit online show *Critical Role* that simply started thanks to professional voice actors airing their *D&D* sessions online. The world surrounding the game has also grown over the years and has influenced fantasy writers and storytelling from that time.

There was some controversy at the start of 2023 while writing this book from the current developer of it with Wizards of the Coast, and the current publisher Hasbro. The customization and personalization aspects of *D&D* have been a part

of an open-source license or OSL allowing creators of custom campaigns to have the freedom to make, play, and publish them, without needing to pay any residuals to WOTC and Hasbro. It was leaked that WOTC and Hasbro were going to change this license to require people to pay residuals on any money earned with custom content, and it led to an open revolt by the community. They have since rescinded these changes, but it has hurt a lot of the goodwill of the property.

Even now, after so much time has passed, *D&D*, and its ruleset, still provide the DNA and inspirations for many RPGs and TTRPGs, and because of that, its influence and impact will never completely leave the industry. Over the years, there have been other popular TTRPGs spawning their own fandoms, and sometimes, their own digital games. For example, *Vampire: The Masquerade* (designed by Mark Rein-Hagen) which was first released in 1991 as part of the *World of Darkness* franchise has spawned several digital games. And there are many more out there that don't have videogame properties yet but are still popular among TTRPG circles.

Tabletop design is an important aspect of game development to understand, as it has influenced game design in many ways.

2.2 Examining Tabletop Design

As I talked about in the last section, many RPGs and games make use of tabletop design as the foundation for their gameplay, and the genre itself could be a future Deep Dive. The basics of all tabletop games have universal aspects to them that can, and have, been translated to videogames.

Tabletop games are built entirely on abstracted-based design, a concept I will explore more in Chapter 5. The player themselves is not directly controlling the outcome of events – how fast you move your figurine has no bearings on winning or losing. Instead, the player will roll dice, with the outcomes of those dice being further modified by rules, character skills, and gear, to determine what happens in the game, and for games that don't feature dice, they have their own unique rules for determining the outcome of events. One of the reasons for having the rules and different editions of *D&D* was to provide the formulas and how to calculate what happens for any kind of event in the game. In videogames, these calculations are often hidden from the player to reduce the complexity of the game – instead of providing a complicated formula for a to-hit chance, the game may simply just state what the player's chance of success is with no further information (Figure 2.3).

All tabletop games use, for lack of a better term, "low number design philosophy" as the core of their gameplay. Low number refers to keeping any kind of numerical value used in the game as small as possible. Where videogames can have players growing to the point where they have thousands of health and do millions of points of damage, low number will keep things as small as possible. This accomplishes two things – it reduces the need for advanced math; making the game easier to play and understand. From a balancing standpoint, it keeps

Figure 2.3

Tabletop design philosophy can be used in a variety of games as a means of streamlining rules and systems, such as when Firaxis released their own takes on *X-Com* with *XCOM Enemy Unknown* and *XCOM 2*.

power levels from getting too far out of control. In my book *Game Design Deep Dive: Deck Builders*, I discussed how **TCGs** and **CCGs** build their games around low number design to give them more flexibility when it comes to creating special rules and card abilities.

The distinction between a tabletop game and a tabletop RPG comes with the greater control that the players have over their experience. In the last section, I mentioned the use of a "Dungeon Master" or one player who guides the experience and storytelling for the group. For just tabletop games, there isn't one person who oversees the entire play, but there might be someone who knows how the game works who will explain it to the other players.

The complexity of a TTRPG is the main reason for their unique place in the tabletop industry, and what would eventually lead to the rise of CRPG design. In this section, I said that tabletop games use low numbers to reduce complexity, but TTRPGs do feature complexity built into their rules. Every action that a player can do, or something that can happen to them, must be calculated by the dungeon master based on the character's attributes and equipment. Therefore, a big part of the ruleset that comes with a TTRPG goes into detail about calculating results and the formulas to use. With that said, the official rules are not set in stone and required to be used by the dungeon master; it all depends on the kind of game the group wants to play. As I mentioned in the last section, there are plenty of people who play TTRPGs just for character interactions and role playing, and they may not care about combat or following specific formulas.

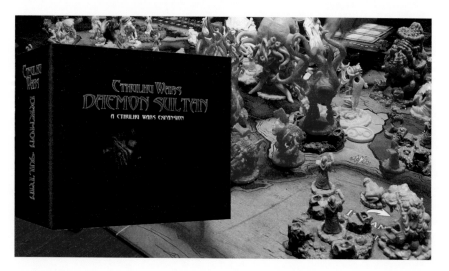

Figure 2.4

Many successful tabletop games continue to grow with expansions aimed at adding in more pieces, ways of playing, and growing the game even further, such as Cthulhu Wars.

Due to the physicality of tabletop games, it isn't possible to "patch" them or release updates in the same way as digital games. Many TTRPGs are expanded over time with new expansion boxes that can add in everything from new storylines, figurines, game systems, maps and boards, and much more (Figure 2.4). Part of the Kickstarter boom that happened in the 2010s was tabletop designers going to the platform to fund the initial production and future production of their games; with tabletop Kickstarter successes bringing in some of the highest donations out of all the campaigns on the platform.

There is a lot more to the depth, genres, and playstyles of tabletop games that is off topic for this book, but the influences and reach will be seen as I talk more about the growth of the RPG genre. As a brief aside, if you're curious about the production and logistics of physical goods and games, be sure to read *Game Design Deep Dive: Trading and Collectible Card Games* for the challenges and considerations that go into producing and shipping physical game products.

Note

[1] https://www.forbes.com/sites/brettknight/2022/10/11/could-dungeons--dragons-be-the-next-harry-potter-stranger-things-have-happened/?sh=63d984d42e6f

3

The Foundation of CRPG Design

3.1 The Legacy of Ultima

Following the success of TTRPGs and the introduction of video games and computer games to the market in the seventies, we would soon see the rise of many CRPGs. A CRPG can stand for "Computer Role Playing Game," but others have also referenced this as a "Classic Role Playing Game." For this book, I am going to use the original terminology to keep things easy to remember.

Like the other genres I've covered in previous books, trying to pin down what is considered "the first" is a hard task, with many computer games released in the 70s and 80s that never reached mainstream popularity. There are several franchises that started at this time that would become ground zero for the start of RPGs and subgenres within it (Figure 3.1).

Whenever anyone talks about the origins of CRPG design, there is one name that comes up: Richard Garriott, who is the creator of the *Ultima* franchise. Richard was inspired by TTRPGs and released a small game called *Akalabeth: World of Doom* in 1979 for the Apple II computer. The popularity of the game led to him working on something grander that would become the first *Ultima* released in 1980. *Ultima 1: The First Age of Darkness* has the player creating their

DOI: 10.1201/9781003331599-3

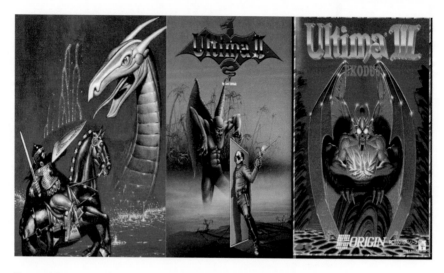

Figure 3.1

Ultima is the game that would begin the CRPG genre for PC, with its first three games being some of the most celebrated for the time.

own character who is summoned to the world of Sosaria to defeat the evil wizard Mondain. This is also where players would meet "Lord British" the character who would become Richard Garriott's avatar and major presence in the series.

Players would explore the world from a top-down perspective and dungeons from a first-person perspective that is also known as one-point. Defeating enemies and completing quests would earn them experience that would allow the player's character to level up and grow stronger. This loop would become standard to almost any RPG released to this day, and I will discuss it more in Chapter 5.

The main series would expand into a nine-game story, with every three games being a part of its own trilogy. Over the course of the games, the story and complexity grew, with introductions of party-based combat in *Ultima 3: Exodus* released in 1983, and virtues and the Avatar in *Ultima 4: Quest of the Avatar* released in 1985. The story of the series would also expand beyond just about a fantasy world and would explore deeper themes in later games thanks to the virtues. Beyond that, there were multiple spin-off games, console ports, and one of the most important games to **MMORPGs** with *Ultima Online* released in 1997. *Ultima Online* was one of the early MMORPGS to become popular thanks to so many players who grew up playing the earlier games. One of the most shocking moments at that time was when someone killed Lord British who was controlled by Garriott.

Due to how long the series has been around for; even starting before the industry crash in the 80s, finding accurate profit statements for it has not panned out. But the legacy of *Ultima*, much like *Dungeons & Dragons*, has stood the test of time. Like *D&D* before it being the first TTRPG, *Ultima* would become the

first CRPG for many people growing up, and its design practices and innovations would inspire other games. *Ultima Online* is still active today; having switched developers several times over the years. Richard Garriott currently is still working on game projects and is supposedly developing a blockchain game as of writing this book at the end of 2022.

3.2 Delving into Dungeon Crawlers

The 80s into the 90s would see the start and development of many popular CRPG franchises built on different styles, much like the golden age of the adventure game genre. As with other books in this series, for every franchise I mention here, there are countless others that could easily fill this book detailing them all.

The first-person perspective for exploring dungeons that *Ultima* used would serve as the style for a variety of first-person RPGs. *Wizardry: Proving Grounds of the Mad Overlord* was released in 1980 by Sir-Tech. The game was built at what would become known as a "dungeon crawler RPG." This style of CRPG is about the player building a party of characters to explore a dungeon for treasure and glory (Figure 3.2). At the start, the player creates a team from a collection of character classes and races – the classes determine what equipment and skills they can use, and the races offer bonus attributes that align with different classes. The exploration was done in first-person until the player runs into a random enemy, and then it switches into combat, predominately turn-based, with the player's team fighting against the enemy.

Figure 3.2

Dungeon Crawlers have branched out to either focus on turn-based battles, or real-time movement, but both designs are about exploring a fixed series of environments.

Dungeon crawlers have a reputation for being on the harder side compared to other RPGs. If the player's party dies in the dungeon, the only way to recover the items and gear lost is to create another party to reach where the original one fell. It was very easy in these games to get into a situation where the player does not have the resources to create and outfit a second party and are unable to continue.

The appeal of dungeon crawlers is the focus on party **customization** at the forefront of the experience. Unlike other styles of CRPGs and RPGs in general, dungeon crawlers often feature very simple stories as just the framing for doing the challenging dungeons. Advanced examples would have unique classes where players could spend hours figuring out the best party composition to use (Figure 3.3).

Wizardry's popularity would lead to it growing to eight games in the main series. As an interesting touch, the games themselves would form into different sets of stories, with players able to transfer a party from a previous game to the start of the next one in the set. While the series itself ended in 2001 by the original developers and Sir-Tech, that has not stopped dungeon crawlers from continuing in popularity outside of the US.

The influence of *Wizardry* can be felt the most from Japanese developers, who not only developed spin-off games – with many remaining exclusive to Japan, but developers creating their own takes on dungeon crawlers. One of the most popular outside of *Wizardry* was the *Etrian Odyssey* series developed by Atlus and first released in 2007 for the Nintendo DS. The game was marketed and pitched as a spiritual successor to *Wizardry* and would lead to multiple games, its own

Figure 3.3

Later examples of dungeon crawlers would differentiate themselves with classes that did not follow the traditional designs, such as *Etrian Odyssey 3*, and this will come up again in Chapter 9 when designing classes and skills.

spinoffs and reviving dungeon crawlers in the US. Today, there are many indie developers carrying the torch for dungeon crawlers that I will come back to discussing the indie market in Chapter 7. One of the breakout dungeon crawler hits for the PC was *Legend of Grimrock* released in 2012 by Almost Human Games.

For me personally, dungeon crawlers are some of my favorite examples of CRPGs that I've played, and the depth of their systems represents important aspects of learning RPG design that I will talk about throughout this book.

3.3 Origins of Open World RPGs

Where dungeon crawler RPGs would focus on one area, open world RPGs would become some of the largest spanning CRPGs to be released. *Might and Magic* was first released in 1986 and was developed by New World Computing. Open world RPGs can differ based on their design to either feature the player controlling one character or a party. In *Might and Magic*, players constructed a party to explore the world of Varn. While the series first focused on traditional fantasy, there were many sci-fi elements and themes that would be revealed over the course of the main entries.

The series would grow to ten main games, but only the first nine were worked on by the original studio (Figure 3.4). *Might and Magic* would also lead to the spin-off series *Heroes of Might and Magic* with the first game being released in 1995. Unlike the main franchise, the spin-off series were turn-based strategy games, where players would move armies around on the map and combat turned

Figure 3.4

It's easy to look at these screenshots of different *Might and Magic* games now and think they don't look impressive, but open-world RPGs like these were some of the most advanced and largest games released for their time.

into a RPG fight between the two sides. This style of strategy game would later grow with other franchises, and I will return to it in Chapter 6.

Open world RPG design is far grander compared to dungeon crawlers. In the last section, I mentioned that dungeon crawlers typically focus on gameplay over story, but open world RPGs tend to do both. The huge game space to explore provides players with far more options and ways of interacting beyond combat. Early entries in this genre were also designed on the harder side, with the player having to be careful when keeping their characters alive long enough to get leveled up and afford better gear. While these games will always have a main quest or objective to achieve, there is often a multitude of side quests and areas to explore where the player can get more experience and learn more about the world and setting. The ability to completely explore a world was one of the major draws of these kinds, and it wouldn't be until many years later as game engines became more powerful and easier to use that smaller studios could develop games with a similar scope.

When comparing the two in terms of success, open world RPGS never fell out of popularity, and the reason why has to do with two mega franchises.

3.4 The Success of the Elder Scrolls

The 90s was a huge era for RPG design both on the PC and consoles. Some of the biggest franchises for RPGs originated during this decade, and two of them would take open world CRPG design in very different directions.

In 1994, the first game in the *Elder Scrolls* series: *Arena* was released by Bethesda Softworks. The series takes place on the continent of Tamriel with each game focusing on different regions of it. Each game would involve the player creating a character who often starts out as a lower-class citizen or a prisoner, before being called on to complete an epic quest.

What separated the *Elder Scrolls* games from other open world CRPGs was that each game was entirely played in real-time (Figure 3.5). Instead of switching to a turn-based mode for fighting, or exploring was done step-by-step, the player could move and interact with everything seamlessly. Combat involved casting spells and using the mouse to imitate swinging weapons at close range. The player was completely free to not only explore the game space but also build their character however they saw fit.

The series would introduce different guilds that the player could join that would focus on different styles of play and had their own quests and characters to meet. Due to how the games were designed, it was possible to build a character overtime who could do a little bit of everything, and expert players would figure out the best stats to improve to create overpowered characters.

The game space itself also stood out, with the settings for each game being some of the largest areas to explore. The developers would use a mix of hand-crafted areas with **procedural generation**. They would generate the environment and layout of the game and then design areas like dungeons, caves, towns, and points of interest that would define the experience.

3. The Foundation of CRPG Design

Figure 3.5

The Elder Scrolls consist of some of the most celebrated CRPGs of all time, including *Morrowind* and *Oblivion* featured here, thanks to the variety of ways to play, and the scope of their game spaces.

Since the release of *Arena* there has been five main games, spin off games, multiple expansions for *Morrowind* (released in 2002), *Oblivion* (released in 2006), and *Skyrim* (released in 2011), and an online game released in 2014 as their biggest sellers. The series has easily earned over a billion dollars, making it one of the most profitable franchises that is not a live service or mobile game. Today, Bethesda's developer branch is known as Bethesda Games Studio, with Softworks now acting as the publishing side.

Despite now being over a decade old, *Skyrim* is still one of the most played RPGs, with ports on every major platform in the industry (Figure 3.6). Part of the longevity has been thanks to fans creating **mods** for the game. Some could be as simple as creating new clothing, to going as far as adding unique stories, environments, and characters. The wealth of mods for the game can be found on the site Nexus Mods, with many players who no longer play the base game, but instead install their favorite mods when they return to it.

Bethesda has grown to become one of the most popular and recognized game studios in the world. As of writing this in early 2023, fans are waiting for more information about the next *Elder Scrolls* game and the game *Starfield*, which will be Bethesda's first science fiction-based game.

3.5 The Retro Future of Fallout

The Fantasy genre has, and continues to be, the go-to setting for many RPGs. When an RPG does come along that eschews it, audiences tend to take notice.

Figure 3.6

Skyrim by itself was already a great game for CRPG fans, but the support by modders has transformed it into a game that may never run out of content and ways of changing how it looks and plays.

Fallout was released in 1997 by Interplay Productions and stood out thanks to its retro-futuristic setting. Taking place in an alternate world where people fled underground into massive shelters known as vaults during the nuclear scare which did end up leading to nuclear war. The player creates a character who is charged with leaving their vault to find a water chip needed to keep it running.

Fallout featured its own take on character customization and combat starting with the S.P.E.C.I.A.L. system. Each letter stands for a different attribute that the player could add points to which would dictate what styles of play they would be best suited for. During creation, they could also assign various perks that would provide further positives and/or negatives to their character before beginning their adventure (Figure 3.7).

Exploration was done in real-time but would go turn-based when the player had to fight. Besides just attacking an enemy, they could also try to target specific body parts to either disable the enemy or try to strike a weak point. This kind of style would be translated when the games went into real-time combat in later entries using the "V.A.T.S" or vault-assisted targeting system. It allowed players to pause the game and use it to manually target specific parts of an enemy – negating the need to have good reflexes to be able to play and win fights.

Fallout's setting and story helped to distinguish it from other RPGs. The world itself was open, with the player required to complete specific tasks to finish the game. There was an in-game timer that the player would need to find the water chip and bring it back to the vault by or they would lose the game. Finding towns and completing quests would provide more about the backstory and clues for the

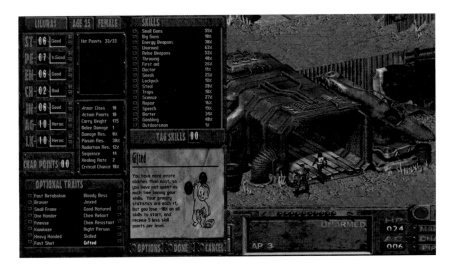

Figure 3.7

For the first time in this book, I'm showing what it looks like to build a character using *Fallout* 1's system on the left. This is a critical aspect of CRPG design that allows someone to create any character they want, or ruin any character they want if they don't know what they're doing.

player to follow. Even though they would only create one character, it was possible to find and recruit **NPCs** that would follow them and help in combat. Being able to play the game your way was a major selling point, and *Fallout* is famously known as one of the few RPGs where you can finish it and defeat the final fight without needing to resort to combat.

Fallout would go on to be considered one of the defining CRPGs and would have a sequel, a tactical strategy spin-off, and was planned to have a MMORPG released in the 2000s. Unfortunately, Interplay ran into huge financial problems in the 2000s and the company went bankrupt in the mid-2000s. In a twist of fate, Bethesda would buy the rights to the **IP** and would continue releasing games in the franchise but using their own designs and similar gameplay systems from *The Elder Scrolls* series (Figure 3.8). Today, the last single player RPG set in the universe would be *Fallout 4* released in 2015, and there is Bethesda's take on making an online version with *Fallout 76* released in 2018. *Fallout 76* plays more like an MMORPG, but after a negative launch, it has grown and fans have reported that it is a far better experience now. At this time, there are rumors of a *Fallout 5* being developed, but nothing set at the time of writing this book.

3.6 Bioware's Redefining of CRPGs

There is one other game studio that would go on to find massive success in the CRPG market and become one of the most influential developers in that

Figure 3.8

Integrating the V.A.T.S not only made the later *Fallouts* more approachable, but also helped when it came to porting it to the consoles and was easier to use compared to aiming with the thumbsticks.

space. Bioware was founded in 1995 by five original members: Ray Muzyka, Greg Zeschuk, Trent Oster, Brent Oster, Marcel Zeschuk, and Augustine Yip, with Ray and Greg staying on as the leads and working on their first major title. With an interest in pen-and-paper games, they wanted to develop an RPG which would become *Baldur's Gate* when publisher at the time Interplay had the license for *D&D. Baldur's Gate* would be released in 1998. As with the other games mentioned in this chapter, the player would create their own character who the story would revolve around (Figure 3.9). The player must explore the region known as the Sword Coast to figure out a grand conspiracy and why someone is out to get them.

When it comes to CRPG design and its ties to TTRPGs, Bioware with *Baldur's Gate* was the closest in terms of providing the feel of a TTRPG but on the computer. The game made use of the rules featured in *Advanced Dungeons & Dragons* 2nd edition for character creation, progression, and everything about how the game would play out. The player and their party would explore in real-time but would go into turn-based when they had to engage with enemies.

Returning to Chapter 2, this was the game that would set one of the most popular aspects of playing CRPGs – being able to have a game with the depth of a TTRPG without needing someone to handle the Dungeon Master role. This style of directly using TTRPG rulesets for CRPGs would become the standard and what many fans have come to expect out of traditional CRPGs to this day.

Baldur's Gate's success would have a profound impact not just for CRPGs and Bioware, but providing a larger audience for *D&D*. Following its success,

3. The Foundation of CRPG Design

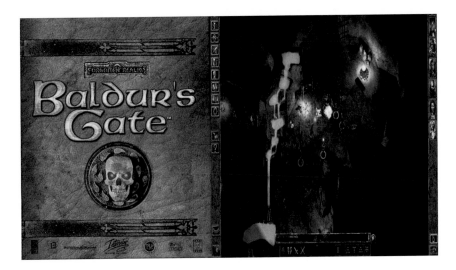

Figure 3.9

Baldur's Gate would be the first time that a CRPG would mirror the rules of *Dungeon & Dragons*, but certainly not the last (the screenshot shown is from the enhanced remaster released in 2013).

we would see other games based on various properties and settings in the *D&D* universe with several published by Interplay before they went bankrupt. From Bioware directly, they would release *Baldur's Gate 2* in 2000 and *Neverwinter Nights* in 2002; both using *D&D* rulesets.

In 2003, Bioware would redefine the CRPG market with *Star Wars: Knights of the Old Republic*. Making use of a modified TTRPG ruleset, *KOTOR* was an original story told in the "Star Wars" universe. Players would still create their own custom character with different backgrounds that would eventually lead to them becoming a Jedi. *KOTOR* would present itself differently compared to previous CRPGs that used an isometric perspective. The player and their party would run around in real-time in a third-person perspective (Figure 3.10). When combat started, the player could issue commands, but viewing the battle happened without directly pausing after each action. The game was still turn-based but presented itself almost like a real-time combat system. This style would become colloquially known as "Pausable Real-time" or "Real-time with pause" – where the player can just let combat play out and watch but could pause at any time to directly issue orders or change tactics.

The impact *KOTOR* had on the market and RPG design was huge. With its success, *KOTOR's* style and third-person presentation for CRPGs would become the new standard and Bioware would cement themselves as one of the premier studios for RPGs. Their follow-ups would go on to great success, and they were acquired by EA in 2007.

Figure 3.10

An understated aspect of Bioware's contribution to CRPG design was providing the "spectacle" of watching characters fight and use their abilities much like in an action game, but still built from RPG rulesets and design and not requiring an action game background to enjoy them.

Mass Effect, released in 2007, is one of the most successful series from Bioware and considered one of the greatest RPGs of all time. The game was a massive science fiction story that would be told across three games, featuring original real-time systems and design from Bioware. This would be the first time in the studio's history that they built a game around third-person shooting, with the ability to issue orders to the various teammates. A major aspect of *Mass Effect*, which originally was popularized with *KOTOR*, was allowing the player to influence the overall story through their decisions, and I will discuss this more in the next section. In 2009, they released *Dragon Age* which returned to fantasy with their own original setting and RPG design. The game played at a faster paced compared to *KOTOR*, but not as action-driven like *Mass Effect*. Later entries would mix up the game systems, but the series overall has been another success.

The 2010s was a rough period for the studio, with *Mass Effect Andromeda* releasing to poor reviews, and the failure of *Anthem* when it was released in 2019 as the studio's attempt at making an action-RPG-focused game. As of the end of 2022, fans are awaiting more news about what's next from Bioware with speculations of a new *Mass Effect* and *Dragon Age* game.

Even though the original founders are no longer a part of Bioware, the studio has been instrumental in defining CRPG design for modern audiences, and their best games are still celebrated to this day.

3. The Foundation of CRPG Design

3.7 Morality Trends

In the next chapter, I'm going to breakdown some of the major differences between CRPG and JRPG design, but following the successes of Bioware, there was a brief trend in the 2000s that originated with CRPG design.

Many CRPGs feature a system that tracks the player's choices throughout the game; one of the most popular examples is the "faction system." When the player completes quests or aids a faction in the game, their standing in that faction will go up, and the standing with the opposing faction will go down. At certain thresholds, the player can unlock unique quests or items, or faction members in the world will either aid or attack them based on their standing. This system provides some impact by the player's actions on the game space and increases the replay value of the game by letting them try other faction options on subsequent plays.

With *KOTOR*, one of the unique aspects at the time was the morality system (Figure 3.11). Dialogue options and different actions on quests would influence the morality of the player's character – either tilting them toward the light side and be a Jedi, or to the dark side and become a Sith. From a story perspective, different characters in your party would either support or condemn your actions and may even turn on you at the end of the game. What the game did was your overall morality was in flux until you made it to the final section of the game,

Figure 3.11

Letting the player influence the morality of their character and the story was a huge trend in the 2000s, and while it started with RPGS like Knights of the Old Republic, it would soon be featured in multiple genres and games like *Black & White* from Lionhead Studios released in 2001.

which at that point, whatever side you were leaning more toward will be locked in and the story will proceed from that viewpoint.

From a gameplay perspective, as the player either went more toward the light or dark side, unique abilities and modifiers for their skills would become available. If you ever wanted to use Force Lightning to zap enemies with, then you would have to go all in on the dark side path.

After *KOTOR*, morality sliders became one of the most used systems not just in RPGs. There were many games released in the 2000s that had this kind of design to it; and presented the player with different endings based on what route they took.

Unfortunately, we began to see the limitations of a generic morality system in videogames and designers started to criticize it. The first problem was that the moral choices felt too binary and simple – are you someone who gives money to the poor or kicks puppies in the street? The rubber banding going between good and evil also meant that choices didn't really impact things if the player could just offset good and bad actions with something else. The game *Fable* by Lionhead Studios released in 2004 was one of the most extreme examples of using a morality slider due to that rubber banding.

Tying gameplay to basic morality also led to the problem of games promoting one side by giving the "cool powers" or best advantages to one of the choices. In *Bioshock* (developed by Irrational Games and released in 2007), the game made a huge deal out of you either saving or killing characters known as "Little Sisters." However, it was proven that going the good route and saving them was always better from a gameplay point of view, because it would provide more advantages over the long term. Developers did not want to promote "being evil" as the best way to play and would do whatever they could narrative-wise to keep the player on the straight and narrow with few exceptions (Figure 3.12).

Some games tried to have it both ways with having an "anti-hero" who could get away with doing bad things if it meant that they would ultimately end up saving the day somehow. In the *Overlord* series developed by Triumph Studios and first released in 2007, the player controlled "the Overlord" who was trying to take over the world. However, it would always show them essentially fighting another bad guy or force to make it seem like they were still the better of the options.

Another issue that came with trying to build franchises was deciding what ending was considered canon and be what the next game in the series would build on. This led to a huge controversy and fan backlash with *Mass Effect 3* released in 2013, and how the game tracked the player's choices from the first game to the last, and people were expecting the ending of the trilogy to consider those choices. From a development standpoint, there is just no way to realistically make a game that will create an ending that considers three different game's worth of choices. The disappointment and backlash was so strong, that Bioware had to completely redo the endings for the game. For other developers, they will either write sequels that take place so far in the future that the original game

Figure 3.12

Games like *Bioshock*, in my opinion, showed just how poor morality choices were from a gameplay perspective. There was no greater decision-making or gameplay impact to it other than – do you want more and better stuff later, or fewer stuff now?

doesn't have a say in the story, or they will flat out decide which ending was the real one that the series is built around.

As games started to tell more serious and grounded stories, the use of morality sliders has declined (Figure 3.13). In the 2010s, there have been many indie games that have done far more interesting things with player choice by moving away from just having it represent 100% good or 100% evil, which I will talk about in Chapter 7.

3.8 A Quick Collection of CRPGs

The CRPG genre is one of the oldest, alongside JRPGs, in the industry, and there were a lot of them released from the 90s to today, some of which will come up later in this book. Specifically, from the 90s through the 2000s saw a variety of CRPGs that while they weren't as recognizable as the previous examples, still were respectable franchises.

The Bard's Tale, which eventually became a trilogy, was first released in 1985 and created by Michael Cranford and developed at Interplay. The first three games were classic CRPG-designed by the original creator. There was a real-time RPG spin off released in 2004 and then the fourth official game returning to the CRPG design in 2019.

Another famous part of Interplay was the Black Isle Studio division that specifically worked on the CRPGs that the studio was developing. Part of the

Figure 3.13

Two modernish examples of using morality or player choice correctly would be *Vampyr* (released in 2018 by DONTNOD Entertainment) and *Dishonored*. In both, choosing to cause more trouble would make the game more combat-heavy, but let you play around with more of your abilities. Going the other way was harder and required more planning and skill on the player's part.

original group of Black Isle, which was helmed by Feargus Urquhart, did work on both original *Fallouts*. Another famous game from this division was *Planescape Torment* released in 1999. *Planescape* stood out by letting players control "The Nameless One" an immortal being trying to figure out why he is immortal and what happened in his previous life (Figure 3.14). This is one of the few RPGs outside of the roguelike genre to build the concept of immortality directly into the game experience and story. The game was ahead of its time with a greater focus on conversations and avoiding or getting around direct combat if need be. It is another RPG that is considered one of the best examples of CRPGs to this day. Black Isle Studio was closed in 2003, with former members starting their own studio Obsidian Entertainment later that year. Obsidian would go on to make a variety of RPG and RPG-inspired games in the 2000s, including a hidden gem I liked called *Alpha Protocol* in 2010 that was a third-person RPG built around being a spy and building your character around different playstyles. Obsidian would diversify their releases in the 2010s including working on the expansion to *Fallout 4* titled *New Vegas* in 2010. Following a successful Kickstarter, they would release their own original CRPG IP with *Pillars of Eternity* in 2015 and they were acquired by Microsoft in 2018.

Another group of former Black Isle Studios developers would go on to form Troika Games in 1998. Even though the studio closed in 2005, they did put out several games that would go on to become cult classics of RPG design. *Arcanum:*

Figure 3.14

Planescape Torment is another highly celebrated CRPG and was one of the few games outside of the roguelike genre that would have a main character who could not be killed tied to the story.

Of Steamworks and Magick Obscura was released in 2001 and allowed players to explore a world that was a mix of steampunk and fantasy, allowing them to learn magic or fight with guns and gadgets. In 2004, they released *Vampire the Masquerade: Bloodlines* based off the pen and paper game but was played as a third-person real-time RPG. While these games did go on to be cult classics, the studio had an issue when it came to technical issues. Both *Bloodlines* and *The Temple of Elemental Evil* (released in 2003) were released with many bugs and problems in them. With *Bloodlines*, it would be several years later for fans to release an unofficial patch that corrected many of the issues and helped the balancing of skills.

The evolution of CRPG design and the changes studios made during the 2000s could easily be traced once again to the success of Bioware, and there were other CRPGS both large and small from other studios in the 2000s, but we would see a major shift in terms of what kind of RPGs would be released when I talk about the indie market and the 2010s in Chapter 7.

4

JRPG's Takeover of the Console Market

4.1 Dragons and Fantasy

We now turn to the other half of the equation when it came to the rising popularity of RPG design in the industry. During the 80s and into the early 2000s, CRPG design remained mostly on the PC platform. Games that did end up getting ported, or having an original entry exclusive to consoles, often didn't work well due to the limitations back then. It wouldn't be until the 2010s that both console and PC developers saw the value in making sure that their games were ported properly for the intended market and trying to reach as wide of an audience as they could.

What that means was for console and handheld gamers who were looking for RPGs to play, they would predominately be playing JRPGs, or Japanese role-playing games. I'll discuss the major differences between CPRGs and JRPGs at the end of this chapter. With how CRPG fans will reference *Ultima* as the first big CRPG, JRPG fans have two franchises that started the worldwide appeal of JRPGs.

In 1986, Japanese publisher Enix would release *Dragon Warrior 1* (known in the US as Dragon Quest) developed by Chunsoft (now known as Spike Chunsoft). The game was designed by Yuji Horii, who would have a major role in every *Dragon*

DOI: 10.1201/9781003331599-4

Warrior game in the entire series. Inspired by classic CRPGs, Yuji wanted to make an RPG that was more streamlined and something that could be played on consoles (Figure 4.1). Teaming up with famed artist and creator of the hit manga and series *Dragon Ball* Akira Toriyama who did the art and character designs. The game was composed by Koichi Sugiyama, who would have an impact on the music until his death in 2021. Despite how memorable his music was, Sugiyama did spark controversy due to his opinions on politics and Japanese Nationalism that did leave fans polarized for supporting the series until his passing.

The game had the player controlling the hero who has been summoned to defeat the evil Dragonlord. To do so, the player must explore the world, collecting magical orbs and finding better equipment to eventually reach the Dragonlord and defeat them. Outside of towns, the player would not see any enemies on the map. Instead, after a random amount of time has passed, the player will get into what has now been popularized as a "random encounter" to fight enemies – something that has been used in many RPGs to this very day. While the game is influential as the defining title and foundation of JRPGs, it was still far behind in terms of complexity and depth to CRPGs. Players could only control one character, and the world itself did not offer much in terms of exploration and storytelling.

This left the door open for the next game to become the undisputed standard of JRPG design for decades – *Final Fantasy*. The series was created by Hironobu Sakaguchi and was going to be his final game for the studio Square (known as Squaresoft in the US) if it didn't become a big hit.

Figure 4.1

Dragon Quest, despite being released on multiple platforms over the decades has always retained its same gameplay and turn-based combat structure.

The first game was about the player creating a party of four, otherwise known as the "Warriors of Light" who would need to travel around the world to gain the power to defeat Chaos. Like *Dragon Warrior*, players would have to fight random encounters while wandering around the world but having four party members meant that battles could be between larger groups and offer more options for the player. The four-person party would become another standard of JRPGs. Each party member could be assigned to a different class, and this is the game that would begin the series' designation of magic and mages as white for healing and holy spells, black for elemental and destruction, and red as the mix between the two. At one point in the game, the different characters would be promoted to a higher class – allowing them access to the best weapons, or spells for mages, in the game. Besides the gameplay and story, the series also features some of the most memorable music in the game industry thanks to composer at the time Nobuo Uematsu. The main theme and battle victory theme from *Final Fantasy 1* are still two of the most iconic themes in the entire industry to this day.

Despite the "final" in the title, *Final Fantasy* has been one of the longest-running series in the entire game industry (Figure 4.2). Even though the first game ended in a way that didn't set up a sequel, the series turned into an anthology – with each game taking place in its own universe with unique characters, and the connection being some of the spells and equipment, and the overall theme of the series. What has made the series stand out, even among CRPGs, has been the developer's willingness to alter and change core systems from game-to-game.

Figure 4.2

Final Fantasy, despite being the foundation of what would become JRPG design, has changed so much between iterations and platforms to the point that the latest games would not be recognizable as part of the same genre as the originals.

Some notable examples would be *Final Fantasy 3*'s (released in 1990) introduction of the "job system," one of the best examples of customization that I will discuss in depth in Chapter 9. The job system allowed the player to switch what class or "job" of each party member. Changing jobs altered their stats and available skills, but it was possible for characters to use skills from other jobs to create characters who specialized in many ways of fighting. *Final Fantasy 6* (released in 1994) is famous for not only having one of the best and most original stories at the time, but also impressive music and one of the largest rosters of characters to be seen in a JRPG. *Final Fantasy 7* was a watershed moment for the series, being the first fully 3D entry and switching platforms and hardware to the PlayStation and CD format in 1997. As MMORPGs and RPGs became more real-time, the series has evolved further with the now hit MMO *Final Fantasy 14* (re-released 2013) and the radical departure of *Final Fantasy 15* (released in 2016) being more action oriented and this trend would continue with *Final Fantasy 16* released in 2023. The series has had multiple spin-off games, including the very popular *Final Fantasy Tactics* released in 1997. In 2022, Square Enix released the first half of their remake of *Final Fantasy 7* – featuring a completely different combat system and retelling of the story.

Final Fantasy has had a monumental impact on JRPG and RPG design. The standards it set have been a part of JRPG design for decades. For many first-time developers who want to create an RPG, the *Final Fantasy* formula is often the go-to. Despite its success, the series is one of the most expensive games to develop, with each entry taking years to be released. In 2003, after several years of losing money, and the failed *Final Fantasy* movie, Square merged with Enix to form Square Enix. As of this time, *Final Fantasy 14* is still going strong, and fans are waiting for more news about the second half of the *Final Fantasy 7* remake. The studio/publisher is also one of the few major names still publishing JRPGs on console and PC.

4.2 The Golden Age of JRPGs

To try and chronicle every major JRPG and innovation, much like CRPGs, in a single section in this book is impossible. While the CRPG side was dominated by a few key franchises, the 90s into the early 2000s was considered the golden age of JRPGs with different developers experimenting with variations of the *Final Fantasy* style and creating new designs as well (Figure 4.3).

Before the golden age, there was one interesting JRPG design thread that didn't catch on among other developers, but in a way, would predate the design of action RPG genre that I will talk about in Chapter 6. *River City Ransom* released in 1989 by Technos Japan was a beat-em-up which involved running around River City beating up gangs. While predominantly an action game, it along with *Double Dragon* (released in 1987 by the same developer) had the RPG system of gaining experience and leveling up. With River City, beating up enemies would give the player experience that could be used to level up and improve your character's

Figure 4.3

The 90s through to the 2000s would give birth to a variety of fan favorites and cult classic JRPGs, which would move further and further away from the traditional style as the years went on.

abilities, as well as eating food to gain permanent stat boosts. Even though the game is now considered a classic and is being continued by studio Wayforward, there hasn't been as many games that have used this system since.

This was the period where we would begin to see games that were built on real-time combat but used RPG stats and abstraction. This is not the same as action RPGs that I will be discussing in Chapter 6. Enix published a trilogy of games from Quintet that were built on this concept of real-time combat with RPG leveling up and equipment with *Soulblazer* (1992), *Illusion of Gaia* (1993), and *Terranigma* (1995). The studio also put out the classic game *Actraiser* in 1990 that combined action gameplay with city building. Another popular trend that we would see from the JRPG genre was combining different game systems and styles with JRPG design.

Another trend that was not as good was that many JRPGs released to success in Japan were never translated and ported to the global and US markets. In my previous book *Game Design Deep Dive: Horror*, I talked about the game *Sweet Home* (released in 1989 by Capcom) which was not only one of the earliest examples of a horror RPG but also a game that would go on to inspire the design of *Resident Evil* (1996). As of today, the only way to play it outside of owning a Famicom (the Japanese version of the NES) is to play it via emulation with a fan translated patch. Speaking of the NES and Nintendo, one of the most famous cult classic JRPGs was the *Mother* series (known in the US as *Earthbound*). The US only saw *Earthbound*, which was the second game in the trilogy, released in 1994. The series took place in modern settings, which modern or futuristic RPGs

are far rarer than fantasy-based ones. The game became a classic thanks to its variety of enemies, mix of happy and dark storylines, and the infamous final boss known as Giygas, whose portrait remains one of the most disturbing ever seen in an RPG. Despite fans begging Nintendo to release *Mother 3* (released in Japan in 2006) globally, it has not happened as of this time.

Another series that would also face challenges of getting its games ported and translated was *Shin Megami Tensei* or "SMT." The first SMT game was released in 1992 on the Super Famicom (the Japanese version of the SNES) by Atlus. The SMT games stood out for having far darker stories compared to other RPGs at the time. Each game would have the player discovering demons are in our world, and using a device, they are able to communicate, team up, and fight with them. A major component of the depth of an SMT game came from its "Press Turn" combat system. Anytime the player hits an enemy with an attack of the element they are weak against, they get an extra action during the turn. If the player accidentally uses something that gets ignored, they lose a turn. This meant the player had to switch out their party to make sure they capitalize on hitting the enemy's weakness, while not having any characters who give the opponent more actions. Each game would have strong religious themes, with the player often having to battle different interpretations of God and the Devil, with many of the demons they could recruit being inspired by mythologies from around the world. It was for those darker and religious themes that arguably kept the earlier games to being only released in Japan. The series would expand with multiple spin-offs and side stories; the most popular being the *Persona* series first released in 1996. Instead of recruiting demons, the player would control a team of students who could gain the power of demons to help them try to save the day. Infamously, *Persona* 2 was split into two parts with the second part not being released in the US due to the player having to battle Hitler as one of the bosses. The SMT games would remain niche successes in the US until *Shin Megami Tensei: Nocturne* in 2003, and the global sensation of *Persona 5* was released in 2016.

In 1995, Square would release *Chrono Trigger* which would go on to become another defining game from the company and JRPG design. The game featured a huge cast of characters that came from different time periods, multiple endings, and is considered one of the most popular JRPGs. The game starred Chrono, who after a mishap causes him to time travel, he learns that the world gets destroyed by a creature called "Lavos" in the future and decides to change the history of the world by fighting it. *Chrono Trigger* may have been the first, but certainly not the last, JRPG to tackle the topics of time travel and other complicated topics.

In 1996, Square teamed up with Nintendo to develop *Super Mario RPG: Legend of the Seven Stars*. It was conceived to be a game that had traditional JRPG designs but would be more accessible to people who weren't already fans of the genre (Figure 4.4). This game would be the progenitor of several original mechanics and systems that would go on to inspire other designers. Unlike other RPGs where movement was very slow and limiting, *Super Mario RPG* was faster and built as a two-and-a-half D platformer with a focus on jumping

Figure 4.4

Super Mario RPG married real-time controls and exploration with a different kind of turn-based combat, and this style would prove to be successful in other RPG franchises and when Nintendo created the *Paper Mario* brand.

around. There were no random encounters in the game – every enemy outside of boss fights would be wandering around the different areas. It was possible to avoid combat if the player was fast enough. Future games that did this would also let the player attack on the field to start combat with an advantage or get hit while moving around to have a disadvantage. Another innovation was with the introduction of "action commands" as a way of bridging the JRPG and platforming design further. By pressing corresponding buttons at the right time during combat, the player could inflict additional damage, resist enemy attacks, get free items, and more. The action command system would be another aspect that indie developers would make heavy use of in the 2010s. While this would be the only game in the series worked on by Square, Nintendo would continue the series with other developers and on other platforms throughout the years. Action command-focused games would be further popularized thanks to *Legend of Dragoon* (released in 1997 by Japan Studio) and the *Shadow Hearts* series (first released in 2001 by Sacnoth) among others.

When fans typically talk about the golden age of JRPGs, they refer to the PlayStation 1/PlayStation 2 era which would be from 1994 to around 2006. Square would publish and develop a lot of these games during this period. The use of 3D would lead to a variety of original RPGs and new designs. In 1997, *Grandia* was released by studio Game Arts and was the first to my knowledge of a game that had "timeline-based combat." Turn-based games in the past would give the player some indication as to who the next character would have their action, but

Grandia and games like it would provide a visual representation of turn-order. This became a part of the strategy, as if the player could hit an enemy preparing for an attack, they could cancel it out. Future games would expand on this design with the ability to further manipulate the timeline – moving characters forward or back on the timeline to influence combat.

As a brief aside, now famous studio From Software who blew up in the 2010s with "soulslikes" and the *Dark Souls* series would get their start during the PS1 era with *King's Field* released in Japan in 1994 (it was not released globally). The impact of the soulslike market on RPG design will be discussed further in Chapter 7.

Another series that got its start in the 90s was *Suikoden* which was developed by Konami and released in 1995. The series became famous thanks to its story and the unique aspect that each game had 108 characters, or "The Stars of Destiny" that players had to collect. Each character served some kind of purpose in the game's different systems and combat.

Besides the as-for-mentioned *Final Fantasy 7*, Square would also develop and release *Parasite Eve* in 1998. Trading fantasy for the modern era, the game drew an audience for its use of pausable real-time combat and an emphasis on guns and ranged combat. This would not be the last time that a developer would move away from traditional fantasy settings. There were series like *Wild Arms* released in 1996 by Media. Vision that was a wild west-themed game, *Xenosaga* (first released in 2002 by Monolith Soft) that took place in the far future, and many, many, more. Another cult classic was *Valkyrie Profile*, first released in 1999 by Tri-Ace and published by Squaresoft. The game was about controlling characters who would form a squad which each character's actions mapped to a different button on the controller. The story would change based on which characters the player would release and which ones they would hold on to for their party.

The *Legend of Heroes* series is one of the few JRPG entries that would follow in suit with classic CRPGs with having stories tied to multiple entries. Developed by Nihon Falcom (the first entry released in 2004 with the subtitle Trails in the Sky), the series would expand with different entries tied together as part of their own spinoff/side story. For each story arc, players could transfer characters and completed storylines from one game to the next.

During the late 90s into the 2000s, Squaresoft was one of the most popular companies in the world, and they would leverage this to develop the copyright nightmare that was *Kingdom Hearts* with the first game released in 2002 (Figure 4.5). The game featured original characters and stories by Squaresoft, along with *Final Fantasy* characters, but also the collaboration and integration of Disney characters and properties who all lived in a multiverse of various universes. With the different sequels, side-stories, and remakes, I could not begin to tell you what the overall plot of the game has become. Looking back, this would also begin the company's experiment into real-time RPG combat. Players would always control a main character who was backed up by AI partners. The AI would fight, support, and heal during combat, and their behaviors could be tweaked from the game's menu.

When the PlayStation 3 was released in 2006, the rising cost of developing games on modern consoles, and the growing trend of action and open world games, saw JRPGs take a hit. However, in the 2000s, handheld technology had advanced to the point where it was possible to have the power of older consoles in handheld form. With the releases of the Gameboy Advance (2001), the Nintendo DS (2004) and Sony's PSP (2005) provided JRPG designers with new platforms for the genre. The lower cost of development would turn the handhelds into the perfect format for JRPGs, and we could argue that this trend would extend to the 2010s with the rise of mobile games. The handheld market during this period would lead to the development and continuing of many franchises that were considered "too risky" for consoles. In the last chapter I mentioned *Etrian Odyssey*, and when the design team was interviewed, it was revealed that the reason the series started on the Nintendo DS was a way of cutting the cost of development and risk on the project.

Nintendo would be responsible for two different cult classic series that got their start on the *Game Boy Advance*. Nintendo published *Golden Sun* by Camelot Software in 2001. The series combined traditional JRPG design with a focus on puzzle solving and was considered one of the best JRPGs at the time. Even though it started on the Famicom, US audiences would get their first *Fire Emblem* game in 2003 (developed by Intelligent Systems). The series mixes strategy and RPG design (that I will discuss more in Chapter 6), with the big selling point was that characters could be permanently killed if you weren't

Figure 4.5

The amount of clout Squaresoft earned put them into the enviable position to be able to use the Disney license for their games, and I can't begin to imagine how much negotiating was done to make *Kingdom Hearts* happen.

careful with how you used them. After some niche successes, the series blew up and became one of Nintendo's major franchises with *Fire Emblem: Awakening* in 2012.

Despite the cost of development, there were still popular JRPGs that came out for the PlayStation 3 and other consoles at the time. The PlayStation 2/PlayStation 3 period would lead to the development of games that did not play like traditional JRPGs that will come up in the next chapter.

The golden age period is one of the most influential when it comes to RPGs; both the CRPG side that I talked about in the last chapter, and JRPGs here. Many of the subgenres and future games I'm going to talk about in later chapters could trace their inspirations from this timespan. And for every game and series I've talked about so far, there are many others that were released as either one-off ideas or smaller series that did not survive to this day.

4.3 Pokémon's Pop Culture Dominance

In my book *Game Design Deep Dive: Trading and Collectible Card Games* I talked about how *Pokémon* ended up becoming one of the top three TCGs in the world, but the franchise's true start would be as one of the most popular RPGs to this day (Figure 4.6). Even though SMT was the first major series to have the game design of what would be known as a "creature collector" RPG, *Pokémon* achieved worldwide success first. The very first iteration of the series came out in 1996 by

Figure 4.6

Pokémon's creature collector gameplay has remained consistent since the very first game, with the latest games of *Scarlet* and *Violet* being the first time the series has gone into a fully open world.

Game Freak on the Game Boy. You played as a Pokémon trainer who must go around the region collecting and training Pokémon to become the top trainer. As the trainer, you didn't do any direct fighting, but instead sent out your Pokémon one at a time to fight wild Pokémon and enemy trainers.

The depth of the series comes from the number of Pokémon that players can collect. In the original release, there was 150 different Pokémon to collect. Pokémon were categorized by their element and what special attacks and abilities they had access to in combat. A major part of the design was the rock-paper-scissors balance – each Pokémon was strong against one element type and weak to another. If a Pokémon was hit by their weakness, they would often take double or more damage from the attack. To capture wild Pokémon, players would have to weaken the Pokémon without defeating them, and then throw out a pokéball to finally get them.

The first game would also have one of the most brilliant marketing points to kids and a nightmare for parents. When Pokémon came out, the release was split into two different games: *Pokémon Red* and *Pokémon Blue*. Both games were entirely playable from start to finish; however, each game would have different Pokémon exclusive to it. If you wanted to "catch them all," you either needed to buy both games or find a friend with the other copy and trade Pokémon with them. For every major release of a Pokémon game on a Nintendo handheld, they would continue this release trend.

Pokémon's popularity can be attributed to the variety of Pokémon available and how much depth there was under the surface. For casual players, the Pokémon games are not that hard to play and learn, but building a great team proved to be very complicated. Later entries would introduce ways of special evolving Pokémon to more powerful types, more element types, the ability to breed Pokémon to pass on skills, and being able to play against other players with your team. The success of the brand led to multiple movies, TV shows, spin-off games, licensing the IP, the popular TCG, merchandising, and Pokémon games have now been appearing on Nintendo's main platform since they have ended support of their handheld line. Today, "Pokémon" is owned and controlled by The Pokémon Company, which is made up of Nintendo, Game Freak, and Creatures. It is estimated at this point that the brand itself has earned over 100 billion dollars in its lifetime to date. When JRPGs started to see a loss in popularity and sales, that did not impact *Pokémon* whatsoever, and it has remained one of Nintendo's, and the industry, most profitable brands to this day.

I will be discussing more about the design and attraction of creature collectors in Section 6.6. Even though both *Pokémon* and *Shin Megami Tensei* are still around, that hasn't stopped indie developers from making smaller takes on it, and the design cues being the inspiration for mobile games that have become one of the most lucrative takes in the market.

Figure 4.7

The split between CRPG and JRPG design constantly changed over the years, and the differences between the two today are blurred further. Thanks to more gameplay focused CRPGs like *Divinity 2* (pictured left), and the style and storytelling of *Persona 5*. And this is just scratching the surface of the many kinds of RPGs that have been released.

4.4 CRPG vs. JRPG

This book is not done with the history lesson just yet, as I'll be talking about modern RPG design starting in Chapter 7. But it is now time to discuss one of the most hotly contested topics among fans – what is the difference between a CRPG and a JRPG (Figure 4.7)? The line between the two has blurred over the 2010s, but there are some foundational elements that we can use to differentiate the two.

A CRPG focuses more on the player controlling "themself" in the game. Even if they are playing as a named character, the game is more about the player having an active role in how the story develops and greater fidelity of customizing themselves and their party (if the game is built that way). While there may be a main story or goal to achieve, the player is often free to decide how much or how little they engage with it at any one time. Many fans love the freedom that CRPGs provide to literally be able to go anywhere in the world and find quests and stories to follow. The moment-to-moment gameplay is built to be very easy to engage in, with the depth focusing on the actual building of the character and charting a path through the world.

A major component of traditional CRPG design is a robust character creator at the start of a game. Before someone can even see the game space, they are building their character and deciding everything from their background,

profession, race, a starting set of skills, and perhaps most important of all – what their attributes will start at. For games that lean more toward the *D&D* or table-top rules style, changing your core attributes after character creation is hard to do. Whatever the player starts at attribute-wise will dictate what builds they are best suited for, what are the best options to solve quests, and will govern the overall play experience. Even though characters will level up and grow stronger over the course of the game, the character creator will impact the trajectory that character will take. Because of all the choices the player must make, CRPGs are often highly replayable based on doing story events differently and trying a different build out.

For JRPGs, their plots are mostly linear, except for a game having different endings based on final choices. The player controls a named character who has agency within the story. Even if the player controls the main character's response during cutscenes, the story will not be impacted or manipulated to produce different results. Where CRPGs focus heavily on the character creator and the opening, JRPGs often start the player with a character that literally has no skills or very few. Growth occurs over the course of playing the game. By leveling up and finding better equipment, the player will be able to do more in combat. Many JRPGs will feature unique systems for progression and unlocking new abilities (Figure 4.8). While CRPGs will start with far more decision making, JRPGs offer more depth over the overall length of the game. One of the biggest attributions to

Figure 4.8

The one area where JRPGs have succeeded over CRPGs has been a willingness to explore different gameplay systems, and why the term "JRPG" is so nebulous when describing a style of gameplay. Despite this action shot, this comes from the game *Resonance of Fate* (released in 2010 by Tri-Ace) that was a turn-based game with bullet-time shooting and dodging each turn.

the system depth of JRPGs is that even though many have been inspired by the likes of *Final Fantasy*, developers were more willing to introduce new systems, mechanics, and even changing the underlining rules for how everything works. Unlike CRPGs, JRPGs are not known for having replayability. If the highlight of a CRPG is creating a character and inhabiting the world, JRPGs are about mastering the game systems present and going a long for the ride of wherever the story will go.

There is no point in trying to debate which style is better; both have their strengths and weaknesses and a built-in audience. Personally, I prefer JRPGs because I'm more systems focused as opposed to story. With that said, there are games from both subgenres that don't fit with the traditions and structure of them. This list would steadily grow over the 2010s as new RPGs were introduced that began to blur the lines between CRPG, JRPG, and even action design.

With how much the genre has changed as a whole, and the evolutions of CRPG and JRPG design, even these qualifiers discussed here have been argued by fans and designers that they don't quite work anymore. For the final chapter of the book, I will talk more about this topic after I have covered the rest of the evolution of the genres.

5

Basics of RPG Design

5.1 Abstracted vs. Action-Based Progression

In the Game Industry, the RPG genre is still one of the major and most popular genres to understand when it comes to game development. Broadly speaking, there are two methodologies when it comes to progressing while playing a game or creating gameplay around that are pivotal to understand if you want to be a game designer (Figure 5.1).

Because this book is focused on RPG design, I'm going to briefly talk about, for lack of a better term, "reflex-driven" or action-based gameplay first. Reflex-driven gameplay covers games where the player's own reaction time and input determine the outcome of playing. This encompasses all action-based genres – shooters, fighting, action, or any game that has a focus on real-time combat. If the player can't react fast enough, or is not good at performing multiple inputs quickly, they are not going to be able to win. Progression in this respect is that the player is improving their reflexes, timing, and muscle memory, to be able to better react to what is happening on-screen. Reflex-driven games often have a higher barrier of entry and **skill floor** compared to other genres. The 2000s was defined by many popular action games and reflex-driven gameplay. When I cover

DOI: 10.1201/9781003331599-5

Figure 5.1

Reflex-driven and abstracted gameplay have their own unique considerations and fanbase, and understanding them is one of the first things in order for you to be able to effectively build games around either one.

the action genre in a future Deep Dive, I'll discuss things more about what reflex-driven gameplay is all about. Another way of describing this concept would be the progression occurs internally within the player. However, with that said, that would also include the player learning the rules and mechanics of a game that would be separate from the reflex-driven design.

Abstracted design refers to any game where the in-game attributes and player choices are the primary factors in succeeding. Another term to describe this would be "**avatar** progression" referring to the player's in-game character. In these games, the player is not personally swinging a sword or performing complex commands to use magic. Instead, the game will perform those maneuvers and provide the player with the outcome. The "abstraction" comes from the greater complexity of the rules and systems of the game that determine whether the player succeeds after issuing commands. In an action game, when the player swings a sword at an enemy, if that sword's model shows it connecting with the enemy, then the player knows that they scored a hit. In an abstracted game when the character swing a sword, attributes like sword mastery, dexterity, and the enemy's own ability to dodge could be factored in. Even if the player sees the sword connecting, the underlining rules and formulas may rule that the character "missed." Another way of describing this kind of progression would be external progression, as the player themselves is not changing how they play the game or what they're doing, but the characters and equipment in-game affecting things.

	Base Stats		Attack Power			
Level	106	HP	1823 / 1823	R Armament 1	393	
		FP	100 / 100	R Armament 2	27	
Runes Held	36875	Stamina	125	R Armament 3	27	
Runes Needed	69939			L Armament 1	155	
		Equip Load	57.8 / 76.7	L Armament 2	27	
			Heavy Load	L Armament 3	27	
		Poise	67			
Attribute Points		Discovery	110.0	Defense/Dmg Negation		
Vigor	52	Memory Slots	6	Physical	137 /	34.004
Mind	20			VS Strike	137 /	28.636
Endurance	25			VS Slash	137 /	34.508
Strength	38			VS Pierce	137 /	32.886
Dexterity	20			Magic	143 /	25.844
Intelligence	10			Fire	175 /	25.554
Faith	10			Lightning	123 /	24.152
Arcane	10			Holy	143 /	27.731
				Resistance		
				Immunity	369 /	133
				Robustness	384 /	184
				Focus	295 /	95
				Vitality	256 /	106

Figure 5.2

The focus on attributes and stats to dictate everything from how much damage someone does, to what abilities they can even use, forms the basis of abstracted-design philosophy. In *Elden Ring*, despite the game being controlled like an action game, the attributes and RPG leveling are what determines a character's ability to fight and survive.

In Section 5.3, I will talk more about what RPG progression is. For now, a defining aspect of abstracted systems is the process of upgrading, or "leveling up," your characters (Figure 5.2). In a reflex-driven game, there are very few ways of making your character stronger – if the player does not keep improving, there won't be anything within the game to give them an edge. This philosophy would change greatly when I discuss modern RPG design and how things changed in the 2010s.

Between the two, reflex-driven games reward the player who can make quick decisions and react accordingly. Abstracted games reward the planner – someone who considers all their options and tries to make the best one with the information given. Due to the focus on character progression and choices, abstracted games often are longer to play compared to reflex-driven titles. The popularity of abstracted systems was a huge aspect of the rise of mobile games and mobile design that I discussed at length in *Game Design Deep Dive: F2P*.

The key takeaway I want everyone to understand from this section is that combining abstraction and reflex-driven design at their extremes is like water and oil for the fans. A fan of reflex-driven gameplay such as fighting games may not enjoy playing a game that is all about watching the game do things with very little input from them. Likewise, someone who likes to plan and make a variety of game-effecting choices may not want to play a game that requires quick reflexes and a high **APM**. Part of the modernizing of RPG design that occurred in the 2010s was trying to bridge the gap between the two philosophies. This can go in several

5. Basics of RPG Design

directions. Two of the most popular are adding attribute and gear progression to reflex-driven games, and implementing reflex-based challenges to turn-based titles. Even though it has led to new franchises and designs, there has not been a game yet that has been able to perfectly combine reflex-driven and abstracted gameplay 50:50. One of the two is always going to be the dominating aspect of the core gameplay loop, and if you try to fight that, or don't understand who your intended audience is, your game is going to have a harder time finding a fanbase.

5.2 Class-Based Design

Due to the origins of the RPG genre coming from tabletop design, many RPGs have used "classes" as a way of categorizing and balancing different characters and playstyles. The class represents the profession of a character – which impacts what equipment they can use, how their stats grow, what skills or abilities they will be able to use; essentially the class defines the playstyle of the character. Part of the decision making that the player must do is figure out how they want to build their character(s), and by extension, how they will grow over the course of playing the game (Figure 5.3).

A concept as old as the genre itself is what fans consider the "holy trinity" of party dynamics. That for a traditional RPG, the player should always have a

Figure 5.3

Classes and archetypes are there to provide the player with a rough template for building a character, but many RPGs today allow someone to specialize in certain aspects related to, or different from that archetype. In these two games *Wolcen: Lords of Mayhem* (first released in 2020 by Wolcen Studio) and *Grim Dawn* (released in 2016 by Crate Entertainment), the player decides what abilities and passive bonuses to invest in.

"warrior": someone who can take hits for the party and protect weaker characters, a "healer": someone who can heal the other party members and keep them in the fight, and a "mage" or "rogue" attacker: someone who deals the most damage but can't survive direct combat for long. Games that have characters with high attacking capabilities and low defenses are commonly referred to as a "glass cannon." Over the years, there have been RPGs that lean heavily on the trinity mindset, and those that rebuke it with nontraditional classes – like an offensive healer, someone who can summon minions, characters who can provide **buffs** or **debuffs**, and many more. Even within the roles of the classes themselves, many games will provide multiple skills within the class that can alter their role to fit the party. For example, giving the warrior more offensive skills to let them be a damage dealer instead of just taking hits.

From a stat or attribute perspective, the class dictates what stats are important for the respective class and how that character should be developed throughout the game. For instance, if we have a "mage" who casts a variety of spells, they may need higher "intelligence" to learn and use stronger spells, but for a warrior, "health" and "defense" to let them survive attacks would be more important. To further emphasize this, many RPGs will have a class's skills scale based on a primary attribute – providing the player with an obvious clue as to what their characters should focus on.

The positive of class-based design is that it provides the player with a variety of ways of playing a game, which means more replayability. Going through a game as an archer vs. a giant berserker provides a different experience. For games that let the player build an entire party, part of the fun is figuring out what classes would fit the best and the playstyle that they want to focus on. This kind of party-based focus became a trend of mobile and **gacha**-styled games over the 2010s. How far you can go with a class-based system depends on the designer. There are games that let the player have full control to create hybrid characters who can use any skill, and there is a famous series I'll be talking about in the next chapter that take it to the extreme.

However, class-based design is often very rigid and does have some downsides to consider. Giving the player freedom to build a character(s) also means giving them the freedom to potentially ruin their experience with a suboptimal party. Many CRPGs have front-loaded all the decision making for character design at the very beginning as I discussed. For experienced players of the genre, they can quickly figure out what they want their character to be about and get the game started. For novices and new players, they can easily pick the wrong skills, focus on the wrong attributes, and make the game infinitely harder or even impossible to win. Some ways to combat this include having premade characters, tutorials, and tooltips for character creation, or just not having this kind of system in the first place. There are designers out there who argue that this frontloading is bad game design and is not player friendly.

From a balance standpoint, many games in the past did not do any balancing when it came to having customizable parties and fixed fights. A trope for JRPGs has been giving the player a variety of skills that can do all sorts of things, but

Figure 5.4

Job systems make it harder for someone to unintentionally ruin a character, as they are never locked into one for the long term, while providing long-term progression as opposed to having to build everything for a character right at the start.

every boss is immune to them. A classic example of having a false choice in a RPG is having a skill or class so good that you must always take it, or something that has literally no functionality in the game. Balancing RPG design is going to be discussed further throughout this book.

In Chapter 4, I talked briefly about a job system that was first featured in *Final Fantasy 3*. The difference between a job and a class is that classes are usually fixed at character creation – once you decide a character is a mage, then they're going to stay a mage for the entire game. Jobs offer the player the ability to have their characters swap jobs, usually at save points. For games that go this route, each job has its own individual leveling, and as a character levels up the job, more skills and passive abilities become available for it (Figure 5.4). Please note, that the terms "job" and "class" are just different names and many games have used their own terminology and the distinction I used here is just for example purposes.

In terms of stats or attributes, this depends on the game itself. Some games will have the character's actual level affect their stats. Other games will have whatever job that's chosen affect the character's attributes at that time. For example, if John is a level 35 archer and decides to switch jobs to a mage, his stats will revert to that of a level 1 mage. To incentivize learning multiple jobs, some games will have permanent stat bonuses that stick with a character for getting to specific levels of a job.

Job and class systems are where we can see the depth that an RPG can go to with its characters and character design. Like many of the topics in this book, how far you want to invest in these systems is entirely up to you. As I'll discuss in Chapter 6, series that would go on to use procedural and random generation

heavily benefitted from letting the player create, finetune, and customize their characters in a variety of ways. And I will discuss how balancing works with different classes and their respective skills in Chapter 9.

5.3 RPG Progression Design

Another major aspect of RPG design is how progression is handled. In the first section of this chapter, I talked about how abstracted design provides more ways to progress compared to reflex-driven design. A mainstay of RPG design is the concept of levels and leveling. The level of a character, skill, enemy, etc. is the abstracted representation of how experienced or powerful it is. This has been the foundation of every RPG ever designed and gives the player an easy-to-understand metric for power – a level one character is weaker than a level 50 character for instance.

To level up, the player must perform some kind of task in the game. The basic example is to fight enemies: when the player wins a fight, they gain experience; once they meet a certain threshold, they will level up (Figure 5.5). For games that have random encounters, it is possible for a player to keep fighting enemies and gaining experience to eventually reach a point stat-wise where they can overpower a tough enemy or boss. This kind of gameplay is referred to as "grinding"

Figure 5.5

How leveling increases power takes many different forms based on the RPG design. In *Fire Emblem: Three Houses* (released in 2019 by Intelligent Systems) on the left, character stats are automatically adjusted. For *Diablo 2* on the right (the remastered version released in 2021), the player manually adds points after every level. There are other methods as well, but it will be up to you to decide how much control the player has.

5. Basics of RPG Design

and is another foundation of many RPGs. For games that don't have random encounters, each fight become that much more important, because the player will only have a limited number of battles to gain experience.

For games that aren't as combat focused, they may still adopt the leveling system for character progression, but only completing quests and/or moving the story along will give them experience. This prevents the player from using leveling to simply get around any challenge and makes the act of leveling far more important. Even for games that don't focus on combat, the use of leveling as a progression system works to let the player focus on specific attributes or ways of playing, and use leveling to make those options better or give them a greater chance to succeed with them.

Balancing experience and leveling is part of the process of designing an RPG. You don't want the player to just instantly go from level 1 to 1,000 in a minute. The amount of experience required to level up will get progressively higher as the player rises in level – for instance: the player needs 20 experience to reach level 2, 60 experience to reach level 3, 200 experience to reach level 4, and so on. The experience earned from enemies is often balanced in one of two ways. First, every enemy has a fixed amount of experience given; no more, no less. This prevents the player from just fighting weaker enemies forever and provides a reward in the form of faster leveling if the player can punch up and fight stronger enemies. The other option is that the enemy has a base amount of experience they will give, but that amount is affected by the difference between the player's character and the enemy. In this example, if a level 5 character kills a level 7 enemy, they gain 140 points of experience; but if a level 1 character kills the same enemy, they could earn 657 points, and if a level 15 character fights that same enemy, they may only earn 1 point. Like the first example, this punishes players for fighting weaker enemies and rewards them for pushing as high as they can go.

The use of RPG progression and leveling grew massively over the 2010s, and how many games would start using RPG systems in them, as I'll discuss further in Chapter 8. One of the reasons why games have used RPG progression is that it provides another route to get past a tough challenge. If someone is playing a traditional first-person shooter and their reflexes aren't good enough to defeat an enemy, then their progress in the game is over. But if the player could go and upgrade their health, or make their weapons do more damage, that could allow them to eventually get past that challenge. Having RPG progression be used in this fashion has also been adopted by roguelike games to make them into "roguelites" that I talked about in *Game Design Deep Dive: Roguelikes* (Figure 5.6).

The problem with RPG progression is that at the end of the day what the player is doing is not changing, the only change is the numbers behind the scenes. If I'm swinging a sword, launching a fireball, or firing a gun, those individual actions are not changing whether I'm level 10 or level 10,000,000. There will always come a point in games built on RPG progression where if the player is not finding new things to do or challenges, they're going to get tired of just watching numbers go up and leave. For live service games, they must have frequent content updates

Figure 5.6

Roguelite design is about having a two-tiered progression system – the character gaining power during the run itself, and then the persistent unlocks that permanently improve characters going forward. *Rogue Legacy 2* (released in 2022 by Cellar Door Games, visualizes the persistent unlocks via growing the player's castle.

and new challenges to retain consumers. For single player games, this is where the story will pick up the slack to motivate someone to keep playing to see how everything ends.

Another trend that affected RPGs from the 80s/90s to today is that consumers are not as interested in very long games anymore. Some of the best CRPGs and JRPGs in the 90s could easily have 80+ hours of gameplay to go through. However, a lot of that was made up of just fighting random encounters and trying to figure out where to go. Today, consumers prefer a quality experience that is on the shorter side, rather than one that is padded out with hours of meaningless content. For mobile games that use RPG systems, it's not about hooking someone for hours of gameplay, but providing bite-sized enjoyable sessions that they can keep coming back to. Understanding modern **UI/UX** conventions for each genre is a topic that comes up in every Deep Dive, and I will go over some of the major ones for RPGs in Chapter 9. Speaking about mobile games, especially hero/character collectors, having to take every single one of them into combat to level them up would be far too annoying for consumers. This has led to these games providing a secondary resource that gives experience to characters without needing to use them first, becoming the standard for mobile games.

There are also other ways of implementing leveling, such as requiring specific resources to be consumed, leveling up groups of characters instead of one, or having no leveling whatsoever. If you choose to not have a traditional leveling system and progression, then it must be replaced with some other form of progression.

The use of leveling as progression is by far the simplest aspect of abstracted design. For it to be effective, there must be something for the player to overcome with those newfound levels. As I'll talk about in Chapter 9, the challenges that the player will have to deal with should grow concurrently with their power, and they should be adequately rewarded too.

5.4 Asymmetrical Balance

Using abstracted elements allows designers to create situations that have their own unique rules or abilities, and that brings up the concept of asymmetrical balance. When we examine traditional sports or contests, both sides are supposed to be as even as possible – the same number of players per team, the same gear, adhering to the same rules, etc. This is symmetrical balance: both sides are operating the same way and the winner is the one with the best skill.

Asymmetrical balance is when both sides are operating with different advantages or options, and winning not only comes down to skill, but how one side makes use of its unique advantages (Figure 5.7). The basic example of this would be fighting games where both players are using different characters. In a series like *Street Fighter* (first released in 1987 by Capcom), if player A is using Ryu, and player B is using Vega, both characters have ways of fighting and engaging that the other player does not. Ryu can attack at range with hadoukens, while Vega's special moves move him across the arena to set up more combos. A far more advanced example would be games like real-time strategy or multiplayer online battle arenas,

Figure 5.7

Fighting games are one of the purest examples of asymmetrical balance, when you can't just compare different characters like apples to oranges, as every advantage/disadvantage someone has, becomes a part of the strategy of using them.

or **MOBAs.** In a MOBA, every player controls a unique champion on the field with access to abilities that no one else has. Even though champions can be categorized by specific playstyles: support, assassin, etc., they each handle differently.

For RPGs, there is always a huge difference between what the player can do and have access to vs. bosses and higher-class enemies. Returning to 5.2 with the trope of bosses that are immune to specific abilities, that was not done by accident. The goal was to present an enemy that the player cannot easily win against and being able to use skills that could instantly kill it would break that balance. For years now, RPG designers have given bosses unique spells, special rules for fighting them; anything to make that fight different from the standard enemies. Another famous mechanic designers have used is that for turn-based games where every character gets one action per turn, bosses could be set up to do two or more during their part of the turn.

However, part of the challenge of having asymmetrical balance is to avoid designing elements that are either useless due to the design of the game, or so overpowered that they don't have a reasonable counter. Regarding having skills that the bosses were immune to, later JRPGs would find ways to keep these skills without making them too powerful. Returning to *Shin Megami Tensei*, every boss would always be immune to the game's instant death abilities, but given how challenging regular combat was, it was still beneficial to have them for the enemies who were weak against them. Being able to buff the player's team and debuff the bosses was an important strategy. The rules were that every buff/debuff could be enhanced several times by casting it repeatedly on an enemy. Both would run out after several turns, requiring you to cast them again, and bosses could use skills to cure them of debuffs sooner.

One of the more interesting solutions some games have done was to provide bosses and elite enemies with "resistance." How this worked was that an enemy regardless of being a normal, elite, or boss could be affected by any condition or debuff. After the enemy recovers, they earn resistance to that debuff – either completely canceling it out or reducing the chance for it to happen on subsequent attempts. This allows the skills to keep their utility but prevents the player from constantly using them to lock down the enemy every turn. Some games will remove the resistance after X number of turns. In the *Etrian Odyssey* series, the game would introduce a special skill in later entries that could be used to remove all resistances built up over the battle to let elites and bosses be susceptible to aliments again. There still isn't an agreed upon rule for how skills like this should be applied, and every game has done something differently.

As RPGs grew from the early days to the modern era, designers have become more aware of the balancing that needs to be done when dealing with asymmetry (Figure 5.8) Thanks to the internet and forums, developers can clearly see from consumers whether something is working as intended. Today, both CRPGs and JRPGs have fewer skills, but instead focus on making what's there more interesting, and more effective, to be used.

Figure 5.8

Single player games provide greater opportunities to create unique and interesting encounters when you don't have to worry about the fairness of competition. In *Darkest Dungeon*, the hag boss can capture one of your party members and requires the player to juggle attacking her and attacking her cauldron to free them.

5.5 Examining Equipment and Items

The use of equipment and items is an essential aspect of the abstraction-based progression that occurs in RPG design. Besides leveling up, acquiring new gear is the other major way that a character can grow in power. As part of the universal scaling of RPG design, live service games can just keep adding new equipment to a game. Part of the reason why many action-based games have adopted RPG systems is with this way of adding in-game power to the player's own skill (Figure 5.9).

Equipment represents any piece of gear that can be added to a character. There are no fixed rules for how much or how little gear a character can have on them. A lot of the discussion about what equipment does in a game will factor into designing the systems and balancing of your game that I will be focusing on in Chapter 9.

As a primer, the role of equipment is to provide added stats to a character's attributes. Equipment can either be generalized or class/character specific depending on the design. Each role/class in your game should have corresponding gear that they can equip that best suit that playstyle. This can either be implicit by having specific bonuses for using certain gear types built into a character/class, or just explicitly saying that a piece of equipment can only be equipped by a specific class.

Figure 5.9

For stat-heavy games, like *Labyrinth of Galleria: The Moon Society* (re-released in 2023 by Nippon Ichi Software), equipment is just there to provide a boost to a character's stats. In other RPGs, the equipment has stats unique to it that a character won't be able to grow on their own.

Using the concept of the class trinity I mentioned in Section 5.2, here are some basic examples of gear:
Warrior:
 Longsword:

 • Size: One-handed
 • Damage Type: Slashing
 • Damage: 15–23

 Chainmail:

 • Type: Heavy Armor
 • Defense 35

Mage:
 Wizard Staff:

 • Size: Two-handed
 • Damage Type: Blunt
 • Damage: 2–3
 • Special Effect: Allows the casting of magic spells.

Wizard Robes

- Type: Light Armor
- Defense 10
- Special Effect: Boosts mana by 30 points

Cleric
Rosary of Light

- Size: One-handed
- Damage Type: Holy
- Damage: 1-1
- Special Effect: Allows casting of holy spells, does increased damage to undead enemies.

Blessing of Faith

- Type: Cleric Armor
- Defense 30
- Special Effect: Restores 10% of health each turn. Boosts healing spells by 15%

The restrictions and attributes of every piece of gear must be determined while you are building your systems. Any change to how equipment behaves will then need to be adjusted to every other type of equipment in your game.

In games that feature fixed equipment – equipment created by the designer and not procedurally generated – the gear will be categorized by specific types and then expanded with higher versions of them to give a sense of progression. As an example, using the longsword item I just mentioned:

Longsword Class

1. Metal Longsword
2. Steel Longsword
3. Silver Longsword
4. Gold Longsword
5. Elemental Longsword
6. Divine Longsword

The properties and functionality of the weapon are not changing going from 1 to 6, what is changing are the stats associated with the weapon. This methodology can be applied to every equipment type in your game. To add more diversity to the gear choices, many RPGs will have gear that act as "sidegrades" that either are designed for a specific playstyle or are meant to counter a unique threat or

situation. The basic rule of gear is that as the enemy threats grow, the strength of the gear that the player can find should also grow to compensate.

One last point before I discuss item design, and that has to do with procedural generation. Procedurally generating equipment is a popular aspect of ARPG design that will be discussed more in Section 6.2. By setting up the properties and gear types for the game to pull from, it is possible to infinitely generate gear that can appear in a game (Figure 5.10). For linear and story driven games, it is often better to focus on specific gear that fits what is going on and the progression of the game. For games that are meant to be replayed and areas procedurally generated, having the game generate gear becomes a major strategy of how that will relate to the player's skills and playstyle.

Having rarity for gear is something that is dependent on the game and the design itself. In games with procedurally generated gear, rarity is used for progression and as a reward to chase. For games with handmade gear, rarity may still be put in as a way of distinguishing the quality of gear and provide an easy reference point for players to gauge the general strength of their items. In these examples, higher rarity gear may be a reward for a tough quest, after a boss fight, or just hidden for the player to discover while exploring. Regardless, higher rarity in any game will confer higher base stats and/or unique benefits for using that gear.

The item category consists of anything that the player can use either in or outside of combat as a consumable to aid them. The role of items is to act as a limited version of the utility that is offered by skills. The most famous example would be

Figure 5.10

Procedurally generated equipment means setting up a base template for what an item must have, and what it can have, and doing it right is a lot harder than it sounds. With *Wolcen* (released in 2020 by Wolcen Studio), the gear system is a little flat in terms of providing diverse options, at least in the early game.

the simple health potion: by consuming it, a character regains a certain amount of health. This is a category that can be as small or as large as your design demands.

Another utility of items is to provide a service that the player does not have access to otherwise without the item. Recovery items that can prevent or cure ailments can be used as an alternative when the party doesn't have someone who can cure them otherwise. Powerful items can do multiple things like heal the entire party, revive defeated characters, make someone invulnerable, and so on. The catch is that these items are always consumed upon use, and it can lead to players hoarding items and not using them in life-or-death situations. As a designer, you want to make the bread-and-butter items: the ones that the player should always have readily available, as cheap as possible so that they aren't conditioned to hold onto them. A design decision that you will need to weigh is whether there is a low limit to the number of items that can be held at one time. Some games set the limit high, like 99 copies, which is often more than enough that someone would use in a situation. Another concept is having a weight limit that the player cannot go over without suffering movement penalties. This is often done in CRPG design or games where the player only controls one character at once. This isn't done as much these days, as it can prove to be frustrating for modern gamers. Having a limit on consumable items can also be a point of balance in your game if the items are important for progression and challenge and being able to upgrade consumable space or usage limits as the game goes on.

When thinking about the design of what items you want to include in your game, look at the common situations that a player can run into and use them as the basis for the items (Figure 5.11). Can someone become poisoned by an enemy attack? How about starving if they don't eat food? Advanced versions of items can be used to make an aspect of your game easier for a certain period of time – such as an item that removes all enemy encounters temporarily. What you don't want to do is design items that are so powerful that someone will never use them or feel horrible about wasting them. This has been one of the primary causes of "item hoarding" – where a player will hold onto an item and not use it, even if it means saving their play, because they want to use it for some unknown future situation. This is why when I talk about balancing aspects of your gameplay in Chapter 9, you want to weigh the cost of an item with its intended utility.

For both the equipment and item side of your RPG, you must also build a UI that makes going through the items as easy as possible. Discussing UI/UX will be saved for Section 9.8, and there will be more discussion about the utility of gear throughout Chapter 9.

As the last point for this section, I want to talk about some common aspects of the inventory itself. Depending on the game's design, and the level of detail you want, you may or may not want to have limitations in your inventory. Some games give the player essentially an endless bag to store all the weapons, potions, and miscellaneous items that will drop while exploring. For games with a greater focus on equipment management, or having the right equipment for a specific situation, they may have a limit on how much a character can have on them at one time.

Figure 5.11

Good item design fulfils a need of the player, and the more items you have, the easier it should be to quickly access them. In the *Monster Hunter series (Monster Hunter Rise* released in 2022 by Capcom) shown here), a lot of work has been done over the years to make it easy and accessible to use the variety of items needed during a fight, including a customizable quick menu.

This can be either handled by inventory slots – where every item, no matter how big or small takes up one slot, or by having a weight limit that the character's inventory can't exceed. While inventory management was an aspect of many RPGs in the 90s through to the 2000s, it is another aspect of classic RPG design that doesn't hold up as well in the modern market. There are plenty of games designed around traditional JRPG and CRPG designs that use inventory limits in some capacity, but it can be viewed as another potential pain point for a game today. The reason why is that inventory management takes away from the actual act of playing the core gameplay loop, unless there is some kind of gameplay system to how someone manages their inventory. In the game *Backpack Hero* (developed by Jaspel and released in 2022), where items are placed in the inventory in relation to one another affects how the character behaves in combat. Today, you want the player to spend as little time as needed going through and sorting their inventory. Likewise, examining items and equipment should be as straightforward as possible. This is where a lot of the discussions in RPGs surrounding the UI/UX of your game will come in, with those discussions, again, saved for Chapter 9.

To wrap up this section, gear and items are another part of the RPG experience where the extent and their potency are entirely up to you. Just remember, the more parts to your game will mean more balancing that you will need to do. Equipment is not something that adding more of, if at all, will inherently make your game better. You want the type and variety of equipment to match

the progression and scope of your game. Some games may just have a fixed set of equipment that is given to the player over the course of a game, if it's a game with a set story and pacing. It all depends once again on what kind of focus your game's progression is going to be about.

5.6 Is Grinding Good?

Earlier in this chapter I brought up the concept of grinding, but I wanted to spend a little more time on the phenomenon and what it means when designing a game. The act of grinding, again, is performing a task repeatedly for some kind of long or short-term goal that cannot be obtained any other way.

Two of the most popular examples of this are grinding enemy encounters for experience and repeating content for specific rewards (Figure 5.12). In the game *Earthbound*, one of the strongest weapons in the entire game was the gutsy bat, and it could only be earned through a random drop in one area with a 1/128 chance as just one example. Many MMORPGs have built entire questlines out of having to gather specific items that only drop once the player has the quest.

What's important to understand about grinding is that the individual action is not what the player is focusing on; only the end goal matters, and the amount of time to grind is variable. Grinding can be viewed as either a necessity or an optional way to get past a challenge. Being able to level up characters to give them

Figure 5.12

In some games, grinding is an act the player feels like they need to do if they're stuck in a section. In other games, grinding can be required when the game introduces harder challenges. In this scene from *Labyrinth of Galleria*, it took a long time of playing and planning to fight these late-game bosses.

extra power before a tough fight can act as a workaround if someone is stuck. However, there is a difference between the game intentionally forcing grinding, and the player choosing to grind on their own accord. For many RPGs and MMORPGs, the games were built to force the player to grind with no other way to get around it. If a quest requires the player to collect 50 buttons off the ground, there isn't a way to speed that up or get around it – the player is going to have to collect those buttons. Just the act of setting an item requirement to a number far higher than what someone would casually get while playing in an area is explicitly forcing grinding in that game. Another example of forced grinding is when the player must have certain resources available before they are able to attempt something, and if they fail, then they need to repeat the grinding to restock those resources. This is often seen in games where there is a lot of consumable items to use and can become punishing for players who aren't good at the game. To that point, you do not want to make the game purposely harder for people who are already struggling at it. If there are items they need to stand a chance, make those as easy to acquire and refill as possible.

When people talk about good grinding, or effective grinding, it is when they are the ones who are dictating when and where they want to grind, and the actual grinding is as streamlined as possible. For many mobile RPGs today, there is often grinding that needs to be done to collect specific materials that drop from stages to be used for upgrading characters. In games where this is a major part of the gameplay loop, designers will put in the option to "auto-play" those stages after the player wins one time – letting them just get the resources from the encounter without having to watch or directly play the stage again. In games that have multiple systems of character progression, being able to pick which ones to focus on to power up characters is another positive example of grinding. The difference is that the player is the one who is deciding to do this, and not the game explicitly or implicitly forcing them to.

But with that said, it takes me to the question for this section: is the act of grinding considered a positive in RPGs today? I would argue that it is not (Figure 5.13). Later in this book I'll be talking about UI/UX in Chapter 9, and part of improving the experience of the player is going for a more qualitative experience over a quantitative one. A major reason why a lot of RPGs over the past 30+ years were longer compared to other games was due to the amount of padding that made up the act of playing them, and grinding was a big factor there. Again, there is a difference between the player feeling like they should grind something to give them an advantage or achieve a bonus goal, and the game flat out forcing them to grind to complete a quest or make it past a difficult section. In today's market, where time is a far more precious resource, anything that prevents the player from enjoying the gameplay is a negative on the experience.

For games that either give the player the option to grind, or have grindable sections, it is better to look at ways of allowing the player to "work smarter, not harder" in this respect. Some examples would be having items or ways of improving the drop rate of required items – either making it more likely, or even

Figure 5.13

Mobile games heavily focus on some kind of grinding for resources as the means of improving characters. In *Arknights* pictured here, characters can be promoted two times – increasing their base stats and unlocking new abilities and skills, and this can be taken further as new progression systems were added.

guaranteeing, they will drop while fighting enemies. If the player must craft items as part of the quest, allow them to just set up auto crafting once the resources are in their inventory. If you decide that you want to have grindable sections or systems in your game, look at ways to make those experiences as pain-free and as streamlined as possible.

Grinding, no matter if it's good or bad, is about adding more time that the player must spend in a game. It is becoming rarer today for a game to make continual or repeated grinding a positive experience for the player. But with that said, if someone makes the decision to spend the next hour fighting robots to get the parts needed to craft that amazing laser gun because they want to do it, then it's fine to let them. However, if it turns out that laser gun is the only way to beat an upcoming boss, and without it the fight is impossible, then that's a different story.

6

Subgenres of RPGs

6.1 The Experimentation of RPG Design

In the next chapter, I'm going to move into the modern era of RPG design and how it became adopted by a lot of genres. Following the successes of traditional CRPG and JRPG designs in the 80s and 90s, developers began to experiment with combining other genres and game systems with RPG design. The difference between this and what I'm going to talk about in the next chapter is that these subgenres are still classified as RPGs; the next chapter will focus on games that use RPG design but aren't considered part of the genre.

In Chapter 4, I brought up the confusion and debates surrounding calling a game a JRPG or CRPG, and the examples that are going to come up could further muddy those waters. For gamers, these genres are typically just described as their subgenre and aren't considered either a JRPG or CRPG (Figure 6.1).

What's interesting to note for this chapter is that it's going to be far larger in terms of examples compared to the CRPG and JRPG chapters. What fans consider to be "traditional" examples of both remained consistent for the most part from the 80s to the 2010s. The fan base for both knew exactly what kind of game they wanted to play, and those studios focused entirely on them. If you were a

DOI: 10.1201/9781003331599-6

© 2021 SQUARE ENIX CO., LTD. All Rights Reserved.
CHARACTER DESIGN TETSUYA NOMURA © GEN KOBAYASHI & KENJI IWASAKI

Figure 6.1

For this book, it's now time to talk about the RPGs that moved very far away from traditional JRPG/CRPG design while still being part of the genre, such as *Neo: The World Ends with You* (released in 2022 by Square-Enix).

fan of one CRPG or one JRPG during this time, then you would easily be a fan of the rest of them. Attempts that tried to do something different did not do as well compared to the popular examples. While there have been other open world RPGs released, none of them have ever come close to the success of *The Elder Scrolls* or CRPGs that outdid Bioware at their peak.

As for JRPGs, many would add in additional minigames or side content that were outside the norm; *Final Fantasy*'s gambit of minigames became famous, including their TCG featured in *Final Fantasy 8* (1999) known as *Triple Triad* and the never-before-seen sports game "Blitzball" from *Final Fantasy 10* (2001). However, the basic gameplay did not change, and it wouldn't be until *Final Fantasy 12* (2006) that the franchise went in a different direction with a look similar to that of the real-time CRPGs that Bioware was making at that time. In fact, the outcry from fans who didn't like FF12 was the very reason why I decided to check it out, and it was one of my favorite games of that year.

The steadfast nature of the RPG genre did not happen to the other genres that I've covered in previous Deep Dives. Instead of refining and iterating with new design examples of the genre, developers just created new subgenres by combining RPG systems with other gameplay loops. This practice would go on to define the modern era trend of the 2010s to today across all the platforms. Every subgenre in this chapter could very well have its own Deep Dive entry associated to it with how far they developed and the evolution of their designs.

6.2 Devilish Action RPGs

The action RPG genre is the one that first began to merge reflex-driven and abstracted design. The core concept was to take an RPG with all the familiar progression systems and combine it with the pacing and speed of an action game (Figure 6.2). For fans of RPGs reading this book, there is a specific franchise that's going to come up here that many consider to be the first action RPG.

However, returning to the start of JRPGs in Chapter 4, there are games that were released in the 80s and early 90s that could classify as action RPGs depending on how loose we want to define the genre. If the qualification is an action-based game that has RPG systems in it, there are a lot of known, and lesser known, games released for early PC and consoles that would qualify. I already mentioned *River City Ransom* in Chapter 4, but both the franchises of *Castlevania* and *The Legend of Zelda* (by Konami and Nintendo respectively) had action RPG sequels. Both released in 1987, *Castlevania 2: Simon's Quest* and *Zelda 2: The Adventure of Link*, each had their protagonist who could acquire new gear and grow in power over the course of their adventures. Link in *Zelda 2* would level up, and the player could decide which of his stats to upgrade first. On the PC side, a game that is credited to be the first action RPG was *Dragon Slayer* by Nihon Falcom in 1984. Even the arcades would have games that would classify as action RPGs, such as *Gauntlet* released in 1985 by Atari and *Magic Sword* released in 1990 by Capcom.

Figure 6.2

The concept of action RPGs has evolved to the point of designing a predominately reflex-driven experience but has RPG abstraction and progression tied to it, such as with *Remnant: From the Ashes* (released in 2019 by Gunfire Games).

6. Subgenres of RPGs

When discussing what would set the trends of the action RPG genre, *Ultima Underworld: The Stygian Abyss* is that game. Developed by Blue Sky Productions and released in 1992, this was the game that pioneered what we consider to be the qualifiers of an action RPG: a game with real-time exploration and combat, with the ability to level up a character and find and equip new gear to progress. Another aspect of this game's importance is that it is technically the first real-time game to be playable in 3D, even before what would be considered the first first-person shooter on the market with *Wolfenstein 3D* released 3 months later by Id Software. The level of interaction the player had in *Ultima Underworld* would also classify it as part of the immersive sim genre that I will be discussing in Section 6.5.

What all that said, when you ask consumers what the first action RPG is, there is one franchise that made action RPGs a game industry staple – *Diablo* by Blizzard Entertainment. The original *Diablo* was developed by a division of Blizzard at the time known as Blizzard North with David Brevik as both the original creator and cofounder of the studio. In interviews and talks, David said that he was inspired by the roguelike genre, but at the same time, he wanted to make something that would be quick to play and to get into. The story involves the player creating a hero out of three different classes to visit the doomed town Tristram. Under the church, Diablo, the Lord of Terror is gathering its power and it is up to the player to descend and defeat them.

Many of the design staples and innovations in *Diablo* would become foundations for action RPGs for years to come. Like a roguelike, *Diablo* did not feature any fixed maps outside of the starting hub area (Figure 6.3). When someone

Figure 6.3

The *Diablo* franchise, despite some ups and downs with *Diablo 3* and *Diablo: Immortal*, is still the quintessential ARPG experience, with fans enjoying Diablo 4 in 2023.

starts the game, all the floors that the player will visit are procedurally generated. Fixed encounters in the form of several boss fights were set to show up on specific floors, with Diablo waiting on the final floor. One of the most influential aspects of *Diablo* came in the form of loot generation. The three classes the player could pick would each find and acquire unique skills and could be further modified by raising their stats after each level up.

Until *Diablo*, most RPGs would feature fixed loot and gear that would show up over the course of playing. Even if enemies had a random chance of dropping something, every piece of gear was handmade and balanced by the designers. Taking a page from roguelikes where items could drop with randomized effects on them, *Diablo* would popularize procedurally generated gear drops. How this works is that the designers create an **algorithm** built on top of what would be known as a "loot table." The loot table is essentially a spreadsheet of every aspect of a gear that could be tweaked and generated during runtime.

As a quick example, a basic loot table could have the following columns:

- Type of gear
- Level scale
- Rarity of gear
- Damage scale
- Bonus modifiers

To generate gear, the game needs to know all possible types of gear that are in the game. The level scale refers to what level the player is or the enemies they're fighting to pull gear that fits that range. *Diablo,* and many games after it, would have each type of gear made up of different qualities to represent finding better gear – going from a short sword to a longsword, to a broadsword and so on.

The concept of rarity tiers is another trend that *Diablo* would kick off for action RPGs. Every piece of gear could be generated at different rarity tiers – the higher the rarity, the better the stats of the gear, and it would also be assigned additional modifiers that could affect the gear, the hero, or both. The game was programmed with a percentage chance of generating the different rarities, with the higher ones having a far lower chance to appear, unless the player was fighting elite or boss-class enemies. The lowest tier would often be just fixed items in terms of stats and modifiers, but everything above it would be generated differently.

Every time the player killed an enemy, the game would perform a check to see if it should generate gear. If the check succeeds, the game would go through the loot table one step at a time to create the gear that would drop, with all this happening in the span of milliseconds.

Diablo's success officially started the action RPG genre in force on the PC, with many franchises being built off the UI, and gameplay loops that *Diablo* popularized. In 2023, the latest and fourth official game in the series was released to critical and commercial success.

For the rest of the genre, there have been many franchises and one-off games. Besides *Diablo*, the other major franchise that has popularized action RPGs would be *Path of Exile* by Grinding Gear Games. Released in 2013, the game came out at the perfect time to capitalize on the design issues and problems fans had with *Diablo 3*. The game was also one of the first successful free-to-play games that was not released on mobile. For more about the design and monetization of it, you can find it in *Game Design Deep Dive: F2P*.

One of the best takes on ARPG design that came from the indie space was *Grim Dawn* by Crate Entertainment first released in 2016. The game was made by many members of the studio Iron Lore Entertainment who worked on the ARPG *Titan Quest* (released in 2006). Both games used their own form of progression in the form of masteries. Instead of choosing a class at the start of the game, the player could pick different masteries that had their own unique abilities, passives, and play styles (Figure 6.4). They could then add a second mastery of their choosing to create a unique character. With its own take on ARPG design, *Grim Dawn* became a success, getting several expansions released, and the studio is now working on *Farthest Frontier* which is a city builder.

In the 2010s, gamers would see ARPGs that moved away from traditional class archetypes in favor of a more free-form system. Starting with *Diablo 3*, players could mix and match a class's skills at any time outside of combat. Some games would turn the weapons themselves into a pseudo class that players could experiment with. An underrated example of this was *Victor Vran* by Haemimont Games released in 2015. While the game used the same isometric perspective

Figure 6.4

While *Diablo* and ARPGs like it focused on very rigid class designs and skills, *Titan Quest*-inspired ARPGs like *Grim Dawn* created their "classes" as a collection of abilities that could be mixed and match however the player saw fit.

and aesthetic of an ARPG, it was controlled more like an action game – giving the player the ability to move and actively dodge attacks. Each one of the weapon types was in itself a class that the player could use: with its own attacks, rules, and special effects. Providing the player with more action-based abilities would slowly become a trend in ARPGs, with Blizzard integrating the real-time dodge into the console release of *Diablo 3*.

There is a lot more I could discuss with the history and design of *Diablo* and other action RPGs that I will save for possibly a future Deep Dive. For this book, action RPGs as a genre would prove that RPG systems built on top of action games could work and would arguably form the basis for the rise of action-based RPGs that I will talk about in the next chapter. The pulls of growing a character, finding and equipping better gear, and fighting through waves of enemies all at the same time would form the core gameplay loop of action RPGs – fight monsters, get loot, grow in power, and repeat.

Even though these games were built heavily on the RPG systems and progression of abstracted design, they were reflex-driven games first and foremost. To succeed, players had to juggle avoiding damage, casting spells or using skills, and making sure to keep an eye on their health, all in real-time. They were also major examples of customization and how it could be applied to action games that I will return to in Section 9.3.

Action RPGs also represent the push and pull between the reflex-driven and abstracted systems. The player not only needs to have good enough reflexes, but also needs to find the gear they need to keep up with the power levels of the enemies. Messing up that balance can lead to players having wildly different

Figure 6.5

A newer trend seen in ARPGs is removing classes all-together, and instead focus on each weapon type being a class to itself, such as with *Victor Vran*.

6. Subgenres of RPGs

experiences – with some easily getting through the game thanks to luck, and those struggling with trying to find the equipment they need. This is a genre that the basics are very easy to do, but it is difficult to make an ARPG today that can stand out (Figure 6.5). Some recent trends have been focusing on live service in a similar way that *Path of Exile* did, but the risks is that any chance to either the action or abstracted side of the gameplay will require a balancing of the other due to how interconnected they are. Even though ARPGs aren't as action-focused compared to some of the later examples in this book, the feel of movement and the different attacks are important to get right, and that would be something to be discussed in a book specifically around action or ARPG design.

6.3 Strategy RPGs

Another genre that saw the benefits of implementing RPG systems was the strategy genre. Strategy, made up of both real-time and turn-based, was popular on the PC. Trading hand-to-hand combat and guns for managing armies and nations, this is an incredibly broad genre in terms of the types of systems and gameplay that can fit in it.

Regardless of playing a real-time or turn-based game, strategy games were known to have fixed units – the 10th tank you build is going to be the same as your 500th. Strategy games typically focus on large-scale conflicts – with players controlling dozens, or even hundreds, of units over the course of a match.

Figure 6.6

Strategy/tactical RPGs greatly emphasize small-scale battles where each individual action is a huge deal. Such as with the *XCOM* games that have further reduced the number of controllable characters down to six maximum.

Strategy RPGs (abbreviated to SRPG), or also known as tactical RPGs, focus on small-scale conflicts. Instead of controlling a lot of generic units, the player is controlling a handful of unique characters, either named characters from the story, or characters created by the player (Figure 6.6). Instead of your characters disappearing after the stage is over, they would persist from mission to mission continuing to grow in power. Depending on the game, if a character is killed, they could be permanently removed from the rest of the game.

This is another genre that is very hard to distinguish what is the first game, as there were many experiments with different genre combinations and designs from the 80s through to the 90s. To make things even more complicated, there is a third name for it with "simulation RPG" that was popularized in Japan. The simulation RPG also includes designs about simulating a job, conflict, or real-world task with the aid of RPG systems. One of the most recognizable franchises considered in this style was the *Romance of the Three Kingdoms* series developed by Koei and first released in 1985. Based loosely on the famous novel "Romance of the Three Kingdoms," the player had to try and unify China during the 14th century. The player would interact with many named characters who could grow over the course of the campaign or be killed.

Due to the many potentially "first" games that could be considered, I am going to try to focus on the games that deal with small armies at the tactical layer with RPG systems. Going with that qualifier, one of the first would be *Fire Emblem* that I briefly mentioned in Chapter 4. While the series wasn't brought over to the US until 2003, it was first released in Japan in 1990. Here, your army was once again made up of individualized characters. While they would belong to specific classes that dictated their attack types and specialties, each person was unique with their own personal story. Like *Pokémon*, the *Fire Emblem* series was built on a rock-paper-scissors system for attack types. Given the general fragility of units, having a unit caught out of position and hit with their weakness could easily kill them in one shot. Once a character was killed, they were removed from the rest of the game and any storylines that they were a part of. Each character was leveled up individually based on them scoring the last hit on an enemy. This created the controversial system that many tactical RPGs used where it was possible to ruin your playthrough if one character would get all the experience, leaving your weaker characters unable to progress. Future examples of the genre would allow any character who did damage to gain experience, and other ways to earn experience to compensate for this. The developers would also eventually add in the option to turn off character death, which while polarizing from fans, did open up the game up to a larger audience.

Besides characters progressing from stage to stage, the player also had to worry about the durability of their weapons. Every weapon had a durability stat that would decrease every time it was used. Once that weapon ran out of durability, it would be destroyed and removed from the rest of the game. Players could buy more weapons from shops or find them as rewards from chests or off special

Figure 6.7

The *Fire Emblem* series has come a long way, and much of its reinvention to where it stands now has been making the games more approachable to a larger audience as opposed to increasing the difficulty and making battles more punishing.

enemies. As I mentioned earlier, the series found renewed interest following *Fire Emblem: Awakening*, and later entries would add more to the character interactions and their growth outside of combat (Figure 6.7).

Not to be outdone, Sega had its own SRPG with *Shining Force* first released in 1992 by Climax Entertainment. Unlike *Fire Emblem*, characters would not be permanently killed if they died during combat. There was also a greater focus on exploration compared to *Fire Emblem* that just had the battles from stage to stage. The game would feature similar elements when it came to combat and how characters would gain experience by performing actions.

One of the most influential games not just for Strategy RPGs, but the industry, was *X-Com UFO Defense* released in 1994 by Microprose and designed by Julian Gollop. The game itself combined tactical strategy with RPG systems, and the use of a dynamic campaign to create a game that has become its own genre of design. The player was the commander of an organization called X-Com whose job was to defend the Earth from alien attacks. The gameplay was split between managing and growing your bases around the world, researching alien technology to upgrade your units, shooting down alien UFOs, and then going into tactical battles with your troops, affectionately known as "squaddies." Every person you recruit has randomized values in different attributes, which can grow as they perform actions in the field.

The game is famous for its high difficulty curve at the start with your untrained rookies using basic firepower going up against powerful aliens. Eventually, you'll unlock better equipment in the form of power armor, energy weapons, and more,

to even the odds. Combat was entirely turn-based, with each squaddie having a resource called "Time Units," or TU, that dictated all the things they could do in a turn. They could take shots that used up less TU but at the cost of accuracy, and squaddies that were promoted would get more TU to use. Keeping your squaddies alive was incredibly difficult, with it being very easy for one alien shot at the start to kill someone until you researched and developed body armor.

Unlike other games, failing a mission did not mean the end of the game, and there were plenty of times where you had no choice but to try and retreat. Resources collected during missions could be used back at your home base to either be sold for more money, or research to unlock new weapons and gear for future missions. The overall goal was to disrupt the aliens enough to grow in power and discover where their home base was and take it out in one final mission. The gameplay loop to this day remains unique with its approach to multiple game systems representing base management, monitoring the Earth, and fighting at the street level. The series would remain a hit for strategy fans but having mixed receptions to later games. In 2012, the series was rebooted by Firaxis Entertainment with *XCOM: Enemy Unknown* and the follow up: *XCOM 2* in 2016 that were both heavily praised for their new takes on the design. Both *XCOMs* focused more on low number design and less on RPG systems that were used in the originals that formed the foundation of combat and progression.

In 2019, *Phoenix Point* was released by Snapshot Games and was designed by Julian Gollop. The game featured more complicated systems and rules for controlling characters and combat. Most noticeably, the game allowed players to manually aim their squaddie's weapons when targeting enemies to try and disable limbs or hit weak points. There is also the series *Xenonauts* developed by Goldhawk Interactive that is pitched as a modernized version of the original *X-Com* with a sequel currently in the works at the time of writing this.

Strategy RPG design would also diverge into different paths thanks to both PC and console designers having their own takes. On the PC side, a trend that we would see was the merging of tactical RPG combat with the greater scope of a turn-based strategy game. Series like *Heroes of Might and Magic* and *Age of Wonders* (first released in 1999 by Triumph Studios) are some of the most well-known examples. In both games, the player controls units and manages their kingdom and armies like a turn-based strategy game. Whenever armies meet on the field to fight, the games switches to a tactical layer where the player must individually control units and use their abilities to win. This kind of approach to having different systems of strategy and RPG design in one game would grow over the 2000s to today, with the *Total War* franchise (created by Creative Assembly) as one of the most popular (Figure 6.8). The game is played as a turn-based strategy where you'll manage cities, advisors, and regions while moving armies around. Combat occurs as a real-time battle with the spectacle of watching hundreds of units fighting at the same time.

Many Japanese developers would have their own takes on SRPGs and tactical RPG design. Both Square and Enix separately had two of the best tactical RPGs with the *Final Fantasy Tactics* and *Ogre Battle* series (first released 1997 and 1993

Figure 6.8

The *Total War* series has always existed as a dichotomy of real-time and turn-based design. What the player does in one affects the other, and the series has spun off from focusing purely on historical takes to covering Romance of the Three Kingdoms in *Total War: Three Kingdoms* (released in 2019), and the *Warhammer* universe with their respective spin-offs.

respectively). Square directly developed *Final Fantasy Tactics* and is still considered one of the best thanks to its deep storyline and the variety of units to use. The game combined the job system of earlier JRPGs with the customization and individual unit focus of a strategy RPG. Characters could start in one job and move to other ones to change their options or unlock new abilities that they could use whenever they wanted.

With *Ogre Battle*, the series was designed by Quest Corporation. In the first game, players constructed armies out of different units and formations. Each army was represented on the map as an individual unit, and when two opposing forces collided, they would fight with the player not having direct control. Later entries in the series would move to the individual unit style, and *Tactics Ogre: Let us Cling Together* (released originally in 1997) also stands with *Final Fantasy Tactics* as one of the best of the genre thanks to its involving plot and gameplay. Both series would have their sequels spread across multiple platforms into the 2000s.

Speaking of the 2000s, this is where two last major examples for this massive section first appeared that would offer their own spins on SRPG design. In 2003, developer Nippon Ichi would have their first major hit with *Disgaea: Hour of Darkness*. *Disgaea* played a lot like other SRPGs, but instead of offering escalating challenges and difficulty, the game focused on multiple systems and progression and powering characters up. Instead of trying to keep the player and the enemies

on even terms, the developers fully intended the player to use these systems to break the game and the difficulty curve. It was possible with enough time to level characters up to level 9999 and do millions of damage in a single hit. The game also featured procedurally generated stages inside the items and equipment that could boost gear up the further the player went inside that item.

Another variation on strategy RPG design that has its own share of fans started with *Valkyria Chronicles* by Sega and first released in 2008. The unique aspect of this game was its battle system. Known as BLITZ which stands for: "Battle of Live Tactical Zones," the game combined third person shooting with turn-based strategy. Every turn, the player is given command points that they can use to directly take control over a unit. Once in control, they have complete freedom to run around the map while enemies would take shots at them. After a set time limit or the character is used to attack, the player goes back to the map to then take control over another character if they have points to spare. This idea of having "turns" but giving the player full control over a character for a period of time has been experimented with by other designers over the 2010s.

Keep in mind, with all the games that combined strategy, tactics, and RPG design, the list presented in this chapter is just a drop in the bucket compared to all the games that were released, and the ones that remained exclusive to Japan or other territories.

As one final example, and one of the biggest in the market complexity-wise, are the grand strategy games. Grand strategy titles are those that focus on the running of a nation, species, etc., with a huge emphasis on managing multiple territories with individual characters who can impact things and grow and change over the course of a game. The reigning champ in this space would be Paradox Interactive with long-term series like *Crusader Kings* and *Europa Universalis first* released in 2004 and 2001 respectively.

Strategy RPGs are some of the most system-heavy examples of RPGs, thanks to the focus on character development, character movement, and interactions between the characters and the environment. In terms of the market, it's very important as the developer to figure out what kind of audience you are aiming for – is your game meant to be played by casual fans with simple systems? Or do you intend to make something like an *X-Com* or *Disgaea* with depth to combat or progression respectively. There are so many aspects unique to the design and gameplay exclusively for strategy RPGs that would be going off topic for this book.

6.4 When RPGs Got Massive

This is the second Deep Dive to mention the Massively Multiplayer Online Role-Playing Game genre, or **MMORPG**. For more about the monetization design and overall history of MMORPGs, you can find that in *Game Design Deep Dive: F2P*, and perhaps someday in its own separate Deep Dive.

To recap briefly here, MMORPGs formed as an evolution of Multiuser Dungeons or "**MUDs**" from the late 70s through to the 90s. People could connect to their MUD of choice and play and interact with each other. The ability

for people to communicate and interact with each other like this would lead to the development of MMORPGs that were at a far larger scale than anything a MUD could achieve. From the 90s into the 2010s, there were a lot of MMORPGs released, with quite a few of them no longer available to play.

In terms of the ones that would set the stage for the MMO gold rush in the 2000s, there are three to briefly touch on. *Ultima Online* as I mentioned back in Section 3.1 took the setting of the original *Ultima* and opened it up to everyone interacting with one another. As mentioned, the game allowed players to fight and kill each other in what would be known as player vs. player, or **PvP**, content; leading to Lord British being accidentally killed.

Everquest is considered by many to be the #2 recognizable MMORPG, released in 1999 originally by Verant Interactive. As more 3D MMORPGs were coming out, *Everquest* is the game that provided the basic blueprint that would be followed and refined for years to come that I will come back to further down. Like *Ultima*, the draw was the sheer scope and ways in which players could interact with the world and each other. Up until this point, there wasn't another 3D MMORPG with this level of detail, and both *Ultima* and *Everquest* are still being supported to this day.

While *Everquest* is considered the second most recognizable MMORPG, *World of Warcraft* by Blizzard Entertainment is number one (Figure 6.9). First released in 2004, the game is credited as the MMORPG that would kick off the gold rush period of the genre throughout the 2000s and into the early

Figure 6.9

In a surprise move, Blizzard re-released the original version of *WoW* as *WoW Classic* in 2019; made up of the original expansions and balancing, it now sits alongside the retail version that has changed since the first release in terms of progression and gameplay.

2010s. Taking and refining *Everquest*'s design, *World of Warcraft* was the most approachable MMORPG for its time and expanded *Warcraft*'s story beyond the real-time strategy games. The game has arguably earned the most money in its lifetime than any other MMORPG. At its peak, it had the most subscribers of any MMORPG coming in at over 10 million a month subscribed to the game.

The gold rush period would emphasize the major draws of MMORPG design as games where players could inhabit a world and interact with one another. Many MMORPGs were pitched around successful IPs, such as Marvel and DC, *Dungeons & Dragons*, The Matrix, Star Wars, and countless others. Unfortunately, developers learned the hard way that even though there were millions of people playing *World of Warcraft*, the MMORPG genre was not actually that big. A lot of the MMORPGs would crash and fail due to low numbers and lead to studios being closed. The ones that survived did this by either being completely different from *World of Warcraft* like *Guild Wars* (first released in 2005 by ArenaNet), or by forgoing the monthly subscription and becoming a free-to-play game.

In today's market, MMORPGs are not as big as they were, with mobile games now being the most played genre and platform. Even though *World of Warcraft, Ultima Online,* and *Everquest* are still supported with new content being developed, their subscriber base has gone down. The top MMORPG in the world currently is *Final Fantasy 14* which was re-released in 2013 after a failed first launch and has since redeemed itself to be #1.

The MMORPG gameplay loop is something that has been developed, refined, and perfected over the years. A lot of what would form the basis for mobile game design in the 2010s is built off this gameplay loop. From an RPG perspective, MMORPGs are always about controlling one character, with the concept that the player is controlling themselves in the world. The story of these games typically involves the player as someone existing in the world who is called on to perform a quest. The RPG leveling progression I discussed in Section 5.3 is the framework that the entire game space and gameplay are built off. Starting at level 1 with a created character, the player can go on quests and fight enemies to gain experience and level up. The character's level acts as a progression gate through the world up to the level cap. The world itself is designed so that every character, regardless of if there are different starting locations will begin in a **biome** or region with the weakest enemies. Each region has self-contained missions that players can complete either alone or with other players. From a design perspective, the game should reward a player with enough experience through the main quests to be able to progress through the story. Side quests often reward the player with bonus equipment but aren't required to play. A great example of keeping all its content relevant was *Guild Wars 2* which was released in 2012 (Figure 6.10). If the player went to a region where the quests were lower than their level, the player's stats would revert to that of the region when performing the quests. Completing them would earn them experience and gear relative to their actual level.

As a character levels up, more progression systems will often become available, including additional ways of interacting with the world. Being able to craft items

Figure 6.10

While the *Guild Wars* series has never reached the same heights as *Everquest* or *WoW*, it continues to thrive and survived the MMORPG crash by marketing and positioning itself as a different kind of MMO experience. To this day, there are no subscription requirements, and the main purchases are expansions and story-content.

allows someone to either make equipment that can help them or sell it to other players. A polarizing aspect of MMORPGs has been the buying and selling of virtual goods for real money. Many developers have tried to stop this from happening, but it has only created a black market of people selling in-game money as "gold farmers" or the actual buying and selling of items. Some developers have embraced this, like *EVE Online* developed by CCP Games (released in 2003) that has a fully realized economy of goods.

The goal of every MMORPG is to reach whatever is the current level cap (MMORPGs may raise this through expansions over time) and get to the endgame content. Endgame content in MMORPGs will fall into two groups: PVP against other players or guilds, or going on "raids," which are very difficult dungeons that require coordination between a huge group of players. Raid content is always expanded on new expansions and is the source of the best equipment in the game. Often, when new story content is added via expansions, the level cap is raised to go with it to provide a gameplay reason for questing again, or to extend the power curve of equipment further.

Today, the aspects that drove MMORPGs during the 2000s and early 2010s aren't as popular compared to mobile and live service games. Due to how long it took to create new content, MMORPGs would pad out their time by making experience hard to get, and the time it took to level up grew exponentially over the game. When people refer to grinding in an RPG, the MMORPG genre was

one of the most cited examples of it. The cost of developing and maintaining these games would price a lot of developers out of the market, and the ones who stayed had to earn enough money to maintain the game or run out of money for the studio.

With rare exception, MMORPGs were built entirely on abstract gameplay. For games that tried to have reflex-driven elements to them, connectivity issues and lag would often get in the way. There were also MMORPGs that were designed around social interaction and community as opposed to fighting and growing in power. A famous example would be *Second Life* developed by Linden Lab released in 2003. The entire game was designed around interacting with other people and was the first MMORPG to fully embrace allowing people to convert money in-game to their real-world currency. Today, besides the remaining MMORPGs from the 2000s, there are many mobile MMORPGs that combine the approach-ability and ease of play of mobile games, with the lengthy experiences and pro-gression of a MMORPG. One of the most popular is *Black Desert Online* by Pearl Abyss (released in 2014)

There is more to the design and UI/UX that is unique to MMORPGs, but for most of you reading this book, you are not going to have the budget and scope to build one, and I will save talking about them for a future Deep Dive. This is the genre that has been the most disrupted thanks to the rise of live service games and the mobile market. Today, there are hundreds of games with RPG systems and engagement that can be played for free without the need for a subscription. Launching a brand-new MMORPG for today is an uphill battle – not only do you have to compete with the remaining MMORPGs, but the mobile and live service market as well. There were attempts at other games in the 2010s, but only *Black Desert Online* is the one that is still popular among mainstream audiences.

6.5 The Height of Immersive Sims

While not exclusively an RPG, there is one subgenre that is viewed as the white whale of game developers. Immersive Sims (or immsims) are a unique style of game that is meant to have no right way of playing through it. Instead, the game is about providing the player with abilities and a reactive world that responds to them. While there are goals and objectives to achieve to move through the game, how the player accomplishes them is not set in stone.

As with a traditional RPG, the player is inhabiting a role or character in the game, but the mix of abstracted design and reflex-driven gameplay provides them with solutions that wouldn't fit a game that was just all abstraction or all reflex-based. Some of the most famous examples of immsims came from the 90s. I already mentioned *Ultima Underworld* in Section 6.2. Besides fighting enemies, the player could sneak around them, use their spells and items to interact with the world, and again, there was no one right way to play the game (Figure 6.11).

One of the most highly regarded immsims is the *System shock* series (first released in 1994 by Looking Glass Studios). In fact, Looking Glass Studios was

Figure 6.11

Immersive sims have a lot of their design elements based out of RPG abstraction and progression but are highly advanced in terms of how character interactions and abilities can affect the world around them, and why there are so few of them compared to other sub genres.

the combined studio of Blue Sky Productions (who made Underworld) and Learner Research. The player took on the role of a hacker who is trapped on a space station by an AI known as SHODAN. To escape, they must explore the station and figure out how to stop SHODAN's plans while finding new equipment and growing in power. Most (but not every) immsim features RPG progression and abstracted elements by allowing the player to upgrade their character in different ways. Instead of designing a world that only caters to using guns, or sneaking everywhere, the game allows the player to specialize how they want to make use of their preferred ways to play. If someone wanted to play the game more action-heavy, they would invest in skills that improved combat and gave them more defense. Or they could invest in better ways of moving through the world and avoid fighting when possible. Due to the limited ways that a player can upgrade their character, it is often not possible to learn and use every skill or ability in the game; this also makes immsims highly replayable.

The combination of both stealth and action gameplay has become very popular in immsims to provide two distinct styles of play. This would extend to series like *Thief* first released in 1998 by Looking Glass Studios and the *Hitman* series by Io Interactive (first released in 2000). Another famous immsim that needs to be mentioned is *Deus Ex* by Ion storm in 2000 as another game that would represent the heights of immsims. *Deus Ex* provided far more RPG character progression which created multiple ways of going through the game's stages beyond just combat. In today's market, Arkane Studios continues the tradition of immsims

Figure 6.12

Deathloop was another game released by Arkane in 2021, and the act of breaking the normal rules of engagement was built into the very gameplay, as the player was stuck in a timeloop and had to figure out the correct order to perform "the perfect run" to break the loop.

with their highly praised games like *Dishonored* (released in 2012), *Prey* (released in 2017), and more. The *Hitman* series is also still popular thanks to its variety of ways to play it and moving to a live service model with their latest entries.

Level design in immsims is a topic too advanced to get into in this book, but I do want to briefly talk about it. When designers talk about level design in immsims, they are often referred to as "dense." Meaning that the levels aren't overly large to explore or navigate but are designed around multiple ways of moving through them and to achieve the desired objective. Instead of providing the player with a huge number of skills and abilities to use, immsims focus on a small number, but they all have multiple uses either intended or unintended by the designer. One of the most popular pastimes of immsims is figuring out how to "break" the game by using abilities in unintended ways to skip levels or solve a solution in a creative way (Figure 6.12).

The immsim genre, and by extension immsim design, represents some of the most advanced ways of building a game. It requires not only a careful eye toward RPG and progression but making sure that the action of the game feels good and is supported by it. The reason why I call it a white whale is that it is very hard to do an immsim right, and even if you do succeed, the depth of the mechanics and systems can be hard to approach for new players of the genre. To create the systems and interactions for an immsim requires a very specific form of gameplay and design philosophy that is beyond the scope of this book.

6. Subgenres of RPGs

6.6 Creature and Hero Collectors

Of the subgenres discussed in this chapter, the creature, or monster, collector-style RPG is the smallest outside of *Pokémon* and *SMT* but still represents another aspect of RPG design. The framework of creature collectors has not really changed much since the days of *Pokémon* and *SMT* discussed in Chapter 4. However, even with the genre dominated by *Pokémon*, its design has since gone on to become a huge driver in mobile games as it is commonly referred to there as "hero collectors" (Figure 6.13).

Regardless, the hook of this kind of RPG isn't for the player to create and build a character themselves, but to cultivate a team, or teams, of characters who will do the fighting for them. The abstracted design is focused on the balance and differences between the different characters. For creature collectors, they often don't feature equipment that the creatures can use, apart from an accessory that could raise stats or give them a benefit.

Each game will have some way for the character to gain access to the creature after combat. I already discussed *Pokémon*'s method in Section 4.3. With the *SMT* games, the player can strike up a conversation with a demon, and after answering a few questions, the demon can decide to join them.

In a way, creature collectors are an extension of the party dynamics and design of dungeon crawlers but are aimed to be far more approachable compared to that genre. The ability to quickly swap characters in and out of your main party

Figure 6.13

Even though *Pokémon* has a lock on the market with creature collectors, the hero collector genre is massive on mobile, with games that often earn millions a month on people trying to collect rare characters off their gacha banners.

reduces the chance that the player is caught off guard by an enemy that completely counters them. The challenge of team building is figuring out what characters work the best together and, at the same time, can best directly counter the enemies they're up against. Parties can either fight in small groups at one time, or a battle may just be one creature at a time, with the defeated one being replaced by the next creature in the roster. Because of this, difficulty can be very swingy depending on what creatures the player has access to at a given moment. In the *SMT* games, a battle can go from being nigh impossible to a cakewalk simply by swapping party members.

Progression hinges on leveling up the creatures you collect and finding new ones in the field. From a balancing perspective, the creatures that are in each area should be able to be used against any major threats or challenges there, and every elemental type of creature in the game should have multiple creatures to build a party around. A lot of the design and balancing behind these games also applies to RPG design in general, and I will discuss this more in Chapter 9.

Hero collectors represent the shift toward mobile RPG design that I will be discussing at length in Section 8.3. As a quick introduction now, the hero collector genre is built on the monetization aspects and progression centered on getting new characters. While these games will often categorize characters by different classes or roles, the main selling point is that every character is considered a one-off: they will have utility or power unique to them. If there are

Figure 6.14

The biggest money makers for hero collectors is offering a limited-time character or one on a new rarity tier. When a character can only be acquired from a specific banner, regardless of how good they are, they will be the ones most players will spend the most to get. In *Arknight's* case (on the right), they release alternate versions of characters in the game with new abilities and roles.

6. Subgenres of RPGs

multiple characters who occupy the same role or similar power, the higher rarity ones will have a stronger variant of it (Figure 6.14). With a hero collector also being a live service game, the ones that become popular will never stop adding in new characters to collect. For more about the monetization aspects of this genre, you can find that in *Game Design Deep Dive: F2P*.

Creature and hero collector-styled games require more work when it comes to content creation – as you're not creating a game around one character, or a party of four or five, but dozens, potentially hundreds, or even an infinite number of characters if a game keeps having content added. Franchises like *Pokémon* and *SMT* have given up on the idea of transferring characters from one entry to the next, and each game features its own closed pool of characters to collect. For mobile games, they don't have sequels and instead keep supporting a game until it is no longer bringing in enough revenue to keep it going. When it comes to creating interesting and unique characters, the best hero collectors are worthy of being studied as a way of extrapolating the core gameplay loop out into a variety of directions.

7

Modern RPG Design

7.1 The Blurring of CRPG/JRPGs

At long last in this book, it's time to talk about how RPG design has changed from the 2010s to today. To recap, CRPG design up until this point was predominately focused on games where the player creates a unique character who is then free to explore and engage with the world at their leisure. While JRPG design focused on playing a fixed character and following a linear story. Both styles emphasize combat as one of the major gameplay interactions.

These two styles are still being made today, but the traditional aspects of both are no longer considered as popular or "required" in the latest examples. Over the years, the *Final Fantasy* series has moved away from traditional turn-based combat and is now more of a real-time RPG. We are seeing more CRPGs today that are about controlling a unique individual, or not even having a focus on combat and leveling up (Figure 7.1). The evolution of UI/UX of RPGs has also led to designers having to change how they are being presented – with the days of overly complicated systems behind us.

Starting from the 2000s, there was this period of both genres trying to incorporate more action-based or real-time gameplay. This was due to the rise in popularity of action games and action systems, evident by the rising popularity of

DOI: 10.1201/9781003331599-7

Figure 7.1

The 2010s saw a shift in RPG design that would reduce the complexity and pain points while integrating more real-time aspects and progression – giving the market a very different take on RPGs to this day.

genres like action-horror, first person shooters, and open world games. When the roguelike genre became more mainstream accepted in the 2010s, designers began to integrate the run-based focus and storytelling more into RPG design.

If you were to show a fan in the 80s and 90s of either genre the games that are coming out today, they might not recognize them as RPGs. This is on top of the dissemination of RPG systems to other genres that I will talk about in the next chapter. There is a reason why I've said repeatedly throughout this book that just studying the popular examples of CRPGs and JRPGs is not going to help as much making them today compared to other genres. The RPG genre has seen a split between the fans of traditional examples, and those that grew up on either the experimental or modernized design takes; this is like the adventure game genre and the changes seen over the 2010s. Understanding the systems, and the UI/UX, are more important for designing the games today.

7.2 Studying Soulslikes

A trend that upended RPG and modern game design in the 2010s was the breakout success of what is known as the "Soulslike" genre. Credited to From Software, this has gone on to represent their specific style of RPG design as kind of a melding between an action and an RPG game. While this style was first displayed with *King's Field*, it wasn't until *Demon's Souls* released in 2009 that the design had its first major hit, and then the formula was refined with *Dark Souls* released in 2011 that cemented this new style of RPG design for the mainstream market (Figure 7.2).

Figure 7.2

Just like other genres in the industry, while *Demon's Souls* was the first in the "souls-like" series by From Software, it was the second game with *Dark Souls* (this screenshot is from the remastered edition) that would set the foundation and many of the gameplay conventions that became the blueprint for soulslike design.

The concept is that the game itself is reflex-driven – the player's ability to control their character and understand the timing of combat is the most important aspect. However, the player's ability is supplemented by their choice of equipment and spells, allowing someone to play the game in different ways. One of the most understated aspects of how soulslikes changed action and RPG design was with how they were paced differently with combat. Examining action games and RPGs that were trying to mirror real-time combat, action games always focused on high-speed play, and in the 2000s with the popularity of series like *Devil May Cry* (first released in 2001 by Capcom), the action genre became very skill intensive. For RPGs that were trying to use real-time combat, or pausable real-time, they often controlled very slow, and the pacing would not feel right if you were trying to play them from an action point of view.

With From Software's approach, everything about the game's combat came down to the timing of animations. When a character is in their animation while performing any action, that cannot be interrupted. No matter how fast the player was at pushing buttons, it did not matter when it came to the recovery animations. The game would also do what is known as "input buffering," in which it will queue up the player's next action while an animation is playing. What that meant was if someone was just mashing attack and then had to quickly block, the game would queue up the attack first. This created a combat system that favored positioning and timing to not back up into a wall or try to swing a wide weapon

in a narrow hallway. The combat system was built around 1v1 fights, and any time someone was outnumbered they were in trouble.

Starting with *Dark Souls*, the series moved away from disconnected levels to everything taking place in one large environment. The level design has been praised thanks to a focus on making dense areas. The pattern of an area in a From Software game is to have multiple routes and areas to explore, while providing shortcuts that can be unlocked if the player makes it far enough – enabling them to save time and not have to repeat areas they've been in. This point was important thanks to the series' approach to dying. When the player dies, they drop all their experience/money on the ground and every enemy revives. If they can make it back to where they died, they'll get all those resources back; die before they get there, and they are gone forever.

The storytelling of the Souls games also stood out from other RPGs, both from the CRPG and JRPG side. Normally, these games are about the player trying to save the world or defeat some evil force threatening everyone. Here, the games feature a lot of lore about the history and destruction of the world that has happened long before the player ever arrives to the world. The player always controls someone in the lowest class who must grow above their status to get the world started again. The amount of backstory and history in each game, thanks to the details listed on every item, can lead to hours of discussion about what really happened.

The unique challenges and high skill gameplay attracted people to the series, and in 2022 with *Elden Ring*, From Software had their most successful game to date. While the previous games have all dabbled with being open to explore, this was the first time that they created a fully open world while still having their focused level design for specific set pieces and challenging combat (Figure 7.3). Over the 2010s, there have been attempts by other studios to create their own versions of this formula, with the most successful take being *Nioh* by Team Ninja (released in 2017). *Nioh* focused on being faster, and more combat intensive, than From Software's games. However, no one has managed to make a Soulslike better than From Software at the time of writing this book.

There is a lot more to the history and design of Soulslikes that will be discussed in a later Deep Dive, but I want to leave you with the important lessons from its success. *Demon's Souls* and the soulslike trend would go on to form the basis for how RPG design changed in the 2010s and why more action-based games would adopt RPG systems that I will talk about in the next chapter. Playing a soulslike is all about the player's skills; however, the RPG systems for gear and progression mean that if someone isn't good enough at the gameplay, they have other options. There are players who have gotten so good at these games, that they can beat them without even needing to level up their characters; some will only use specific weapons or builds, and their playthrough is just as valid as someone who needs to use the very best equipment to succeed.

While other action-based games were speeding up their combat and gameplay, the soulslikes slowed it down for action fans, but was noticeably faster for

Figure 7.3

Elden Ring's success was thanks to From Software having their cake and eat it too – giving players amazing handmade areas and challenges, and the entirety of the open world to explore and take in.

those coming from an RPG background. Regardless, everyone had to adapt to the pacing and speed of these games; oftentimes, people who didn't have the muscle memory of action games would have an easier time adapting to the changes and pacing of these games. The actual RPG systems in these games were nowhere near as complicated or as in-depth as a traditional CRPG, but they were enough to influence how someone could play through them. Going from a spell caster to a melee build in *Elden Ring* is almost like playing two different games; even switching between light, medium, and heavy weapons required the player to relearn the timing to best use them.

The impact From Software had on action design in the 2010s would be one of many examples of action games adopting RPG mechanics.

7.3 RPG Action Games

Back in Section 6.2, I discussed action RPGs that were RPGs designed around the faster pace of an action game. For this section, I am looking at things from the other end of the spectrum – action games that would be built on RPG rules and mechanics. The 2010s saw a grand adoption of RPG systems in many genres, and action or reflex-driven games was one of the most prominent.

Series like *Call of Duty* (developed by multiple studios, first release in 2003) would build their multiplayer design around progression and unlocks for players. It was no longer about just getting a new gun but unlocking the parts and gear to make your weapons tailored to you. This kind of customization is not

only critical for the best RPGs but would be a major appeal of this design that I will come back to striking the balance between action and abstraction in Section 8.2.

Keep in mind, every videogame is obviously built on numbers and statistics, but the change that occurred in the 2010s allowed the player to manipulate those statistics and have some control over how their options would behave. The merging of RPG and action design's best example would come from the *Borderlands* series developed by Gearbox Software (first released in 2009) (Figure 7.4). *Borderlands* was pitched as a "Role Playing Shooter," where even though the game was played as a first-person shooter, it featured character progression and procedural loot generation like an ARPG. How this worked was that the game featured several basic gun types – pistol, SMG, shotgun, etc. Those guns would then have their attributes adjusted based on the character's level and what fictional gun manufacturer they came from. Each manufacturer acted as a modifier that guaranteed certain effects on a gun. Each one of the playable characters was considered a "class" with their own skill trees, special moves, and weapon preference to build around.

Another equipment-focused series that grew in popularity was *Monster Hunter* (first released in 2004 by Capcom). The game was played completely in real-time, with the pursuit of crafting better weapons and equipment being the focus of the progression. Since then, the series has been expanded across multiple entries, spinoffs, and their most successful game to date was *Monster Hunter World* released in 2018.

Figure 7.4

The *Borderlands* franchise was the first to take many aspects of RPG progression and procedural equipment design and marry that to an entirely action/reflex-driven design. And this would arguably begin the trend of integrating RPG systems with action design.

The idea of using the player's weapons and equipment as a progression system would grow over the 2010s and evolve into what is commonly referred to as a "gear rating" system. Even though the player was controlling their character in real-time, how that character behaved and their ability to fight was dictated by the gear they were wearing. Each piece of gear would have a level or score associated with it. The actual strength of the character became either the sum of all individual parts, or the average level that they were wearing. If the character's gear rating or gear level was lower than the strength of the enemies, the player would find it a lot harder to fight or even become literally impossible if the difference is too high (Figure 7.5). Conversely, if the character gear level is higher than the enemies, then those enemies would be far easier to defeat. Many action franchises that grew over the 2010s would implement systems like this to try and improve the lengths of their games with RPG mechanics. Popular examples include *Assassin's Creed* (developed by Ubisoft and first released in 2007; first game with gear rating was *Origins* in 2017), *Tom Clancy's: The Division* (developed by Massive Entertainment and released in 2016), and the *God of War* reboot (developed by Santa Monica Studio and released in 2018).

While these systems did extend the playtime of the games they were put into, they also created an artificial difficulty spike for playing them. With the souls-likes discussed in the previous section, the gear would provide the player with

Figure 7.5

What became the logical next step for RPG design in action games was to create systems to limit the player based on the gear they were using. Gear rating systems can be endlessly scaled (like in *The Division* on the left) or used to gate the player's ability to explore (like *God of War: Ragnarök*, released in 2022, on the right). I am personally not a fan of this design, as it often used to restrict the player's options to whatever is the highest gear score and doesn't provide any interesting choices.

7. Modern RPG Design

different builds they could play around, and their skill was still the main factor as to whether they would succeed. In these games, it did not matter what the skill level of the player was at – if their gear was too low, they would not be able to win. This also created a sense of dissonance in games that tried to be realistic on one hand, but on the other, you could shoot someone in the face with a gun and they wouldn't even flinch from it if the gun was too low of a level.

While RPG design has changed dramatically over the 2010s, so has action-based games. Today, it is rare to see an action game released without any kind of RPG progression for it. In the best scenarios, they can provide more choices to the player and allow them to build a character exactly how they like it. The problem is when the game is entirely balanced on a character's gear, and the player is punished by it. Here, the best course of action isn't to build their character how they want it, but to always push for the highest levels or ratings of gear, as that's the only way they will be able to keep progressing. The same issue I mentioned in Section 5.3 when it comes to long-term play applies here – numbers for the sake of numbers do not create meaningful progression. It is a difficult line to walk when integrating RPG design into any genre, but there are far more examples to talk about in this book.

Action-based RPGs represent a new model, along with tying them to rogue-like or run-based designs, such as *Returnal* by Housemarque (first released in 2021). Even though these games are for action fans first and foremost, the added depth and complexity from the RPG systems can provide a more fulfilling, and approachable, experience for a larger fanbase. I will be discussing approachability and how it relates to UI/UX in Section 9.8.

7.4 RPG Maker and Indie Development

For every major genre, I must discuss the impact Indie developers have had on it during the 2010s. In my first deep dive on platformers, I spoke about how the genre was one of the most popular ones to develop as a first game due to its history and supposed easiness of design. The #2 genre is by far RPGs, and that is for slightly different reasons.

There is a greater discussion about the game industry in terms of providing editing software for games that does not require a programming background. The *Super Mario Maker* franchise by Nintendo (first released in 2015) was the first time that fans of platformers had a way of designing Mario levels without the need of understanding programming. The developers of **kaizo** mods and hacks have been using their own developed software/editor, but because it occupies the same legality as the use of emulation, I won't be naming it here.

Conversely, fans of JRPGs have had their own legal software editor for years. *RPG Maker*, originally developed by Kadokawa, has been a franchise built solely as an editing software for JRPGs (Figure 7.6). Since the first version in 2003, there have been iterations of it released every few years. While writing this book in 2023, the most recent version out is *RPG Maker MZ*, with a new iteration: *RPG*

Figure 7.6

The *RPG Maker* series is the only commercially developed editing software for a specific game genre. While many don't view it as a way to break into traditional game development, it has become the basis for either unique RPGs or developers wanting to tell their own story without needing a programming and art background.

Maker Unite, due out in 2023. The series is built on one goal – to provide an easy-to-use software to allow anyone to make JRPGs in the 8 and 16-bit style. What's important to realize is that while the *RPG Maker* software is in fact its own game engine, it does not have the functionality to create a variety of games like Unity, Gamemaker, and others. Instead, the power and flexibility of the engine is designed so that if someone wants to create a basic JRPG, or experiment with unique **aesthetics** and designs in the JRPG style, they can use the engine for it. It is by far the easiest to learn if you don't have a programming background.

At this point, it is impossible to give you an estimate of the number of indie games that have used *RPG Maker* over the past 20 years. Like the adventure game genre that also has a free engine in the form of *Adventure Game Studio*, many of the games released never made it to the mainstream market. While some of the many games have been released on Steam, most *RPG Maker* games can be found on the site Itch.io. Despite the limitation of the JRPG aesthetic, that has not stopped designers from getting creative. Some games just focus on the story, others may try to make a horror game, to traditional and nontraditional JRPGs.

A few examples of successful games that have used some iteration of an *RPG Maker* engine include the following. *To the Moon* was an emotionally driven story about helping someone find peace before they die and was released in 2011 by Freebird Games. *Lisa: The Painful* was released in 2014 by Dingaling Productions and stood out by combining 2D platforming, JRPG combat, and a dark story. *Jimmy and the Pulsating Mass* by Kasey Ozymy was released in 2018 and focused

7. Modern RPG Design

Figure 7.7

RPG Maker, like any engine or editing software, is something that you get back what you put into it. While there have been a lot of games that just tried to copy existing RPGs, there are those that went above and beyond like *Fear & Hunger 2* pictured here. (Please note, the game is meant for adults with extreme imagery and situations which I'm purposely not showing screenshots of in this book.)

on exploring the dreams of a child with a very dark twist. For one of the darkest and hardest RPGs, there is *Fear & Hunger* developed by Miro Haverinen released in 2018. *Omori* by OMOcat LLC released in 2020 had a beautiful children's drawing aesthetic coupled with a dark story. These examples are just a minuscule amount of the games that have been built with *RPG Maker*.

There is a continued debate among game designers as to whether using *RPG Maker* as opposed to learning a full game engine would be better from a career point-of-view. And while studios aren't looking for *RPG Maker* designers, it has proven to be a great tool to develop games with and has arguably given far more people a chance at making a videogame compared to more powerful and complicated game engines that exist (Figure 7.7). Having *RPG Maker* as the foundation for a game removes a lot of the time and energy needed building the basic assets and functionality of your code, and the use of third-party editing software to develop games around will come up in future Deep Dives.

7.5 The Wonders of *The Witcher*

In this chapter, I spoke about how From Software would redefine RPGs and JRPG design on consoles thanks to the *Dark Souls* series. Looking on the PC and CRPG side, it had its own franchise and mega hit that would change the genre in the form of *The Witcher* by CD Projekt (with the developer side now known as CD

Projekt Red). The first game was released in 2007 and, admittedly by the developer, was released in such a poor state that they had to do a re-release with an enhanced edition in 2008. The games are based off the hit fantasy book series "The Witcher" by Andrzej Sapkowski. Taking place in a fantasy world where humans coexist with magical and fantasy beings, the player controls Geralt of Rivia who is a witcher – a human who has been mutated to fight monsters and attempt to keep the peace between the human and fantasy folk.

What separated *The Witcher* from other CRPGs was both the world and our hero Geralt (Figure 7.8). The world of *The Witcher* may take inspiration from many fantasy series and sources but exists as a much darker place. The books describe the long history of how humans came to this world, and I have personally not read any of them yet. Humans and fantasy beings don't generally trust each other, and Geralt is often called in to mediate a situation. Geralt is not the standard fantasy hero and will often change what side he supports based on what is going on and has a disdain for people who persecute others.

The games themselves, while taking place in the world and feature many characters from the books, are not directly based on the stories there. In interviews and talks with the developers, they take place after the events of the books, but certain quests may reference or be based off stories from them. Like other open world RPGs, the game space is built around the main quest and storyline that the player must do, and a variety of side content and smaller stories to find.

Figure 7.8

The Witcher franchise has come a very long way in less than a decade with CD Projekt Red's design rapidly growing between the three main entries. The open world of the third game allows players to not only decide how Geralt grows and responds to incidents but provides the space to be filled with multiple side stories and vignettes for players to uncover.

Right now, there are three games in the series with sequels released in 2011 and 2015, respectively. As I'm writing this, the developers are planning on remaking the first game to bring it up to the quality and gameplay style that were in the sequels, and a fourth game is in development. The main evolution of the design from the first game to the third was expanding the game space to make it an open world. While the player can explore for side quests, there is always a main quest for them to be going after. All combat is done in real-time, as the player is free to use Geralt's weapons and magical signs to aid them in battle. A big aspect of the game is preparing for battles by drinking specialty potions that must be crafted beforehand. These recipes can be found or bought and are there to give the player a much-needed edge while fighting humans or monsters.

The success of the games has not only transformed CD Projekt into one of the standout development studios in the world but has also elevated the entire Witcher brand as well. Over the 2010s, the franchise has been expanded with the standalone CCG *Gwent* first released in 2017, shows developed for Netflix, and fans are waiting for any news about what's next after the remaster of *The Witcher 1*.

The takeaways from the success of *The Witcher* showed that the market and design for RPGs has changed, and that it's no longer locked to just the big names of the industry. You can have a well-developed plot with a fixed protagonist in a CRPG. Even though players could decide how Geralt would respond in certain situations, there were no morality sliders, and his personality was also constant across the games. *The Witcher* would be just one of the many examples of games from smaller and unknown teams that would go on to big things thanks to the rising indie space.

7.6 The Unique Indie RPGs of the 2010s

In 7.4 I briefly talked about the indie space using the popular game engine *RPG Maker*, but the impact of indie development on RPG design stretches much further. In the span of 10 years, indie development grew into a legitimate and now permanent option for game developers to make a living in (Figure 7.9).

When it comes to RPG design and thanks to *RPG Maker* and Itch.io, there is no way I can tell you exactly how many RPGs came from the indie space in the 2010s. For developers trying to make a name for themselves, we would see some RPGs that attempted to mirror the design of classic CRPGs and JRPGs, and those purposely designed to try and elevate in a different direction. To that last point, one of the biggest trends from indie developers was adopting roguelike design and applying it to all varieties of games. As with every historical chapter in this series, for every series I am mentioning, there are dozens more examples that even I haven't heard about. And for the sake of having some consistency, I am only going to be mentioning games in this section that either used RPG systems as the focus or were designed specifically as some form of an RPG.

Figure 7.9

Indie development has led to many games seemingly coming out of nowhere to huge success and being able to compete with major studios for praise, like *Disco Elysium*.

Discussing indie RPGs, I would lose my credibility in the space if I did not mention Spiderweb Software and Jeff Vogel. Since the 90s, Spiderweb Software has been releasing a variety of CRPGs designed heavily on player choice and turn-based combat. Each series takes place in its own unique world, and he has started making remastered versions of them as Kickstarter campaigns available for modern PCs. His latest series is *Queen's Wish* released in 2019, and there is a remaster based on one of his earlier franchises *Geneforge 1: Mutagen* released in 2021. As of writing this book, a successful Kickstarter to remaster the second game in the *Geneforge* franchise was done in 2023 (Figure 7.10).

Soldak Entertainment is another longstanding indie developer, focusing more on ARPG design. Their major claim to fame with their design is for having very extensive character progression and gameplay built on procedural quests. Instead of quests being fixed on each play, the game will generate them based on what is happening in the world, with some quests acting as punishments for not completing an earlier one. This can lead to a play of the game going in vastly different directions depending on what quests the player is able to finish and which ones they fail. The latest game from them is *Drox Operative 2* released in 2021.

Larian Studios has been around for a long time and have made a variety of games. One of their first niche successes was the *Divine Divinity* series (first released in 2002). The series balanced the depth and storytelling of a CRPG, with the playability of an ARPG. Their most successful entries would come with *Divinity: Original Sin* 1 and 2 released in 2014 and 2017, respectively. Featuring more CRPG design and party-based combat, both games would go on to be

Figure 7.10

Spiderweb Software continues to make traditional CRPGs with a focus on story and character choices, but it does stand as a tough lesson for new developers, that this particular style is no longer the most popular for consumers today – and something that will be discussed in Chapter 10.

considered some of the best RPGs released. They are now working on *Baldur's Gate 3* which was released in 2023.

Returning to the *Heroes of Might and Magic* and strategy RPG style in Section 6.3, one of my favorites was *King's Bounty: The Legend* released in 2008 by Katauri Interactive. Considered a revival of the original *King's Bounty* released in 1990 by Jon Van Caneghem and New World Computing. With Legend, players would explore the overworld as their chosen hero who would use armies that consisted of different units in turn-based battles. The hero's stats would affect the strength of their armies and how many of each type they could field in battle. Each unit had their own special powers and traits that affected how they behaved in combat, with certain races that would fight better or worse together.

Besides longstanding studios and franchises, there have been several breakout successes in the RPG space from indie developers. In 2015, two vastly different takes on RPG design were released to critical acclaim. In February, *Darkest Dungeon* by Redhook Studios came out. Combining aspects of roguelike, dungeon crawler, and RPG design, along with a Lovecraftian aesthetic, the game won fans thanks to its challenging gameplay. The player would manage characters of different classes to build four-person parties to investigate the remains of their former estate. Each mission was procedurally generated, and players had to manage the health, hunger, and sanity of their party members. If a party member died in the dungeon, they were permanently removed from the playthrough. In 2023, the sequel was released featuring a completely different structure and campaign progression.

Figure 7.11

The reach of *Undertale* is perhaps the largest of any indie game to date, thanks to memorable characters, unforgettable situations, and the twists that the story takes. And while *Deltarune* is only a few chapters in while writing it, it is certainly shaping up to be another winner.

In September of 2015, one of the biggest indie games to be released of all time came out with *Undertale* by Toby Fox (Figure 7.11). *Undertale* was designed as both honoring RPGs, while deconstructing their major game systems at the same time. The player controlled a child who one day fell into a pit and found themselves in a world of monsters. To return home, they must make their way through the kingdom to escape. The first thing that stood out was how battles played out. Instead of fighting enemies in a traditional turn-based mode, every enemy attack took the form of a shoot-em-up section where the player can only dodge a myriad of bullets and other hazards to avoid taking damage.

Besides the amazing music, *Undertale's* story is one of the most unique out of any game. To explain it would also be giving away the game's major twist which I do not want to do here. The only thing I will say is that the game's use of morality and how it not only affects the player, but the world around them, is one of the best. Since its release, the game is one of the most recognizable indie games on the planet – it has been ported to every major platform, and the music and characters have even been added to Nintendo's flagship game: *Super Smash Brothers Ultimate* (released in 2018). As of right now, Toby is working on a follow-up called *Deltarune* which is being released in chapter format, with parts 1 and 2 available at the time of authoring this book.

The use of noncombat-related abilities and options in RPGs have always been a secondary feature of their gameplay loop, but with the release of *Disco Elysium* in 2019 by ZA/UM, this was an RPG built entirely without combat. Taking place

in an original world by the game's designer and author Robert Kurvitz, it became one of the most celebrated games thanks to its original design and story. The player controlled a police officer, who after having the mother of all hangovers, completely forgets everything about him and his life. While trying to piece together who they are, they are also charged with investigating a murder and dealing with an eclectic cast of characters.

Players are free to build their protagonist out of different personality traits. These traits are in the form of forces in your mind that will speak up while you are doing things to offer their own unique perspective on the task at hand. The game was designed from the ground up to offer multiple ways of experiencing it based on the choices the player makes, and what skills they want to invest in (Figure 7.12). Even though there was no combat, it is possible to lose if your character suffers too much damage to their health and mental state. Events and situations can be solved using different options, with said options weighted by the respective trait and how much the player has invested in it. This was an example of an RPG that felt the closest to the freedom and exploration that tabletop games were famous for. No matter how the player chose to play, there were no wrong choices or dead ends that could occur. The success led to the studio winning multiple awards in 2019. However, at the time of drafting this book, the series' future is up in the air after the original members of ZA/UM were removed from the studio by investors, and a legal battle that fans outside of the studio don't know what it means for the property or the creators. *Disco Elysium* was the proof for

Figure 7.12

The character creator of *Disco Elysium* is set up to allow for multiple ways of playing that affects what the player will see and their options. What's important to note is that there is not one trait that the game says is the best; each one has the potential for helping, or messing with, the player's investigation.

the market that you could design a game with RPG progression and design while removing or changing a lot of what people considered to be the core aspects of an RPG and still succeed.

One last style of indie RPG that also focuses on narrative and choice over combat is the visual novel genre. Visual novels come in all shapes and sizes, and not every visual novel has RPG elements. Some are just about following the story from start to finish with no interaction by the player. The ones that have RPG systems tend to focus on being similar to the style of a "choose your own adventure" book – where the player can find multiple endings based on the choices they made and how they built their character. What these games do is focus on a set period of in-game time that the game takes place in. Every period of time, the player decides what their character is going to do or who they will interact with. Doing tasks will gradually raise the character's attributes related to the job, and those stats will come into play when major events happen to dictate whether the character succeeds or fails. There is no set standard for a visual novel – there are those built around comedy, exploring sexuality, horror, love; just about any and every kind of theme is on the table. For the reader, the most recognizable visual novel from the indie space would be the game *Doki Doki Literature Club* released in 2017 as a free game from Team Salvato. Like *Undertale*, the game became famous thanks to the story and the twists that it took, that I won't spoil either. A popular form of storytelling used by indie developers today is to tell their story in the form of a visual novel but use other mechanics and genre types for the actual gameplay, such as the developer Project Moon.

Indie developers have not only kept the original spirit of both CRPG and JRPG styles alive, but have also done fantastic work in making new and unique takes in the genre. They are also the reason why this book became so long and difficult to write. Trying to give you the exact systems and mechanics to make an RPG today is impossible, as every RPG mentioned in this section, let alone the ones I didn't cover, each did something different than the rest. What I hope you take away from this is just how much of a blank canvas the RPG genre has become.

7.7 What Do RPGs Look Like Today?

Even though some of the major franchises of the 90s are still around, the market and design of RPGs have changed dramatically over the 2010s. I already mentioned action-based RPGs in Section 7.3, and the AAA side of the industry has embraced this after seeing the success of *The Witcher* series. *Final Fantasy*, despite being one of the pioneers of the original style of JRPG, Square Enix has since changed into more action designs over the 2010s (Figure 7.13). The first part of the *Final Fantasy 7* remake released in 2020 is entirely built from the ground up with completely new gameplay and real-time combat. Today, making a classic JRPG is considered niche, with Square Enix one of the few major studios publishing them, such as *Octopath Traveler* released in 2018 by Acquire. Another casualty

Figure 7.13

If there is any studio that shows how much RPG design and the market has changed, look no further than Square Enix. On the left is the original gameplay of *Final Fantasy 7*, and on the right is the remake that had part 1 released in 2022 with real-time combat and an altered story compared to the original.

was Nintendo officially ending their Game Boy/Nintendo DS handheld line. The handhelds, once again, thanks to their cheaper cost of development, became the home of numerous classic and niche genres. Without it, smaller developers have lost a popular platform for these games.

On the PC side, as I mentioned with Indie development, RPGs are very much alive and kicking in their different subgenres. Just like the platformer genre mentioned in *Game Design Deep Dive: Platformers*, the RPG genre and developers have had to raise the bar of their designs to get noticed these days. An interesting change that happened over the 2010s has been Japanese studios no longer ignoring computers for their games – with many major series getting PC versions at launch, and studios like Nippon Ichi and Square Enix porting their classic console games to the PC. The increased power and functionality of game engines today have given smaller teams the opportunity to try making open world RPGs and soulslikes. There are also countless examples of traditional and nontraditional CRPGs that have been developed by smaller teams. As an interesting point, while *Dungeons and Dragons* is still popular, it is no longer the de facto choice for CRPGs – with many designers now creating their own original settings or working with other IPs.

And of course, there is the mobile market which many of the biggest and most profitable games featuring RPG design in some fashion. Due to the enormity of it, I will be discussing it more in Section 8.3.

As with any game genre, RPGs evolved out of a necessity to keep growing. Just releasing a tried-and-true JRPG or CRPG game today will have an established fanbase, but one that will not grow any larger. Returning to the *RPG Maker* games, one of the reasons why a lot of them did not reach the mainstream is that many of them just feel like playing the older examples of the genre, with no iterating done to the formula. This is where the importance of UI/UX comes in that I will be going into detail about in Section 9.8.

The positive of this change is that people are more willing now to look at RPGs of any type that are doing something new and different with the formula, as this was not the case in the 90s through the 2000s. The negative for the reader is that the market for RPGs is so diverse that it's near impossible to tell you what mechanics and designs must be in your game. This will come back into focus in Chapter 9 when I start detailing some of the many systems and mechanics that have been used in RPGs and RPG-based designs.

8

Putting RPGs Everywhere

8.1 How and When Everything Became an RPG

The original concept of RPGs was that they were their own genre – with unique mechanics and qualifiers to them. Looking at the market today, the use of RPG systems and mechanics has now spread to almost every genre. In a way, the term "RPG" can stand for actual examples of it, but it could just as also be considered a thematic or style of game, like how the horror and roguelike genres have had their systems and themes adopted (Figure 8.1).

There is no denying that if the 2000s was the period where action and reflex-driven design was the star, that abstracted and RPG design took that crown in the 2010s. The first question we need to answer about this is simple, why?

I'll be discussing more specifics about the design in Chapter 9, but there are several elements that led to the popularity of RPG systems. As I've talked about in earlier chapters, RPG systems provide an option for players to get through a game without having to rely only on their reflexes. While some may view this as "cheapening" the experience, the approachability that RPG systems can bring to a game can provide an alternative of just getting stuck and frustrated at a section. Even though hardcore fans of soulslikes will say that the only way to play them

DOI: 10.1201/9781003331599-8

Figure 8.1

The success of live service and RPG design on mobile has led to a chase by AAA studios to try and capitalize on it with their own live service and progression systems. Which led to *Marvel's Avengers* (developed by Crystal Dynamics) completely losing out to *Genshin Impact* in 2020 in terms of market appeal.

is to "git gud," From Software has been offering alternate strategies in each game culminating with *Elden Ring*. It's not about how much or how little you use these systems, but that they are there to help people who need them.

The next point is that RPG progression has, and ever will be, a powerful and addictive driver to play a game. When I say "addictive" in this context, this is not calling RPGs bad, but simply pointing out how effective they are at retaining engagement. When it comes to the psychology of playing a game, people are often driven by different reasons for playing – this led to the creation and use of the "Bartle Test" to measure different kinds of players. Regardless of the type, people want to see progress in any way, shape, or form. Reflex-driven games are about internal progression – you, as the player, become better at the game: you're dying less, you're figuring out enemy patterns, and the game is getting easy because of it.

Internal progression has a limit that varies from person to person, and if someone gets to their limit and can't go on, they're not going to be able to finish the game. Using RPG progression makes it external and to the character or characters that the player is controlling. What the player is doing moment-to-moment does not change, but their character that was doing 20 points of damage is now doing 4,000 points of damage. Part of the progression that MMORPGs have used is in the form of improving the quality and look of gear as someone goes through the game. It's not uncommon to start a MMORPG wearing nothing but rags, to look like a model at the Met Gala by the end of the game. Anything that grows in power that the player can see and experience allows them to chart where they

Figure 8.2

When I say anything can have RPG progression tied to it, I mean literally anything. There is an entire market of "simulator" games on just about every subject imaginable – such as *Power Wash Simulator* (released in 2021 by Futurlab).

were and where they are now. It has been definitively proven at this point just how effective seeing numbers go up are at keeping someone interested – as evident by the entire idle game genre. Being able to show where the player was when they started power-wise, to where they are now, makes them excited to see what's next. And the beauty of RPG progression like this is that it can be attached to literally any aspect of a character or object in a game. I have seen RPG systems used in everything from cooking and preparing food, to climbing a mountain, digging holes, dating, and countless other examples (Figure 8.2).

Building off that last point, RPG progression provides a form of customization that can enrich and improve the depth of any videogame it gets added to. In *Game Design Deep Dive: F2P* and Section 8.3 in this book talking about mobile games, one of the drivers for how the mobile market has exploded was increasing the amount of customization and control the player has over whatever it is they are controlling. There is a difference in just telling the player to use equipment X, Y, and Z on a character, and letting a player pick and choose what items they want for their character. This gets at the depth of RPG design, and the myriad of ways that someone could create a character or a party for an RPG. It's no longer about just the characters fighting the bad guy or a car trying to win a race, but your own personally created and customized strategies and characters trying to win.

So far in this section I've talked about the benefits from the player's point of view, but there is a huge reason for their popularity among designers and publishers. Role-Playing Games provide one thing that no reflex-driven game can sustain – scaling. There is an infinite number of numbers and that mean no end

to RPG progression. While many MMOs and live service games have an endcap for character or account level, that doesn't mean that the RPG progression stops. Every MMORPG that gets an expansion will introduce new and better gear; as a live service game ages, new gear, or even new rarity tiers can be added. Some mobile games don't even have to create new characters, if the highest tier was a five-star character, now there are six-star versions. If people are staying with the game and its earning revenue, a live service game with RPG progression could be supported indefinitely. However, before anyone thinks that this is just a get rich quick scheme, there are limitations to this that I will discuss in the next section.

The beauty about progression from a monetization standpoint is that even itself can be tied to RPG progression to motivate someone to spend or interact with it. The integration of season passes, or battle pass, content in live service games is proof of this. A battle pass is a collection of missions or ranks that the player can go up during a given length of the game, usually at minimum 1 month. Each level of the battle pass will reward the player with anything from unique cosmetic options to in-game resources, with players who buy the battle pass getting more for each level. Anything that the player can display as proof of making progress or committing to a game like this can not only keep them invested in a game but reduces the chance they'll stop playing and give up all that stuff. Again, this is why tying monetization to progression systems can be viewed as unethical, and a major aspect of my discussion on ethical design in *Game Design Deep Dive: F2P*.

8.2 The Impossible Balance between Action and Abstraction

Throughout this book I've talked about the differences between reflex-driven and abstracted-based design, but it's now time to talk about what that means from the player's and, by extension, the consumer's point of view. Certain genres are diametrically opposed to one another in terms of the consumer's expectations and wants from it. Action and RPG design are one such example, and it's crucial to understand what the genres are like at their extremes (Figure 8.3).

Reflex-driven games put the player's own skill level front and center; there should be nothing in the game that inhibits the player's ability to go through it. The most extreme example of this would be action games with no RPG systems, or any kind of competitive game based off an action game. Competitive and action fans don't want the game to be telling them that they can't do something; with competitive players outright blocking or ignoring anything that adds RPG progression and scale to the gameplay of a competitive title.

For action-based RPGs, fans are willing to use RPG progression if it doesn't get in the way of the reflex-driven gameplay. Returning to soulslikes as I discussed earlier, there are people who can play them at the point where they can ignore all the RPG systems or only use the minimally, and there are those that require every advantage that they can get.

Figure 8.3

Despite the popularity of mixing RPG progression in games today, the extreme ends of action and abstracted gameplay are still very rooted in terms of what the fanbase wants out of their gameplay, and that audience is going to be a harder sell on examples that try to mix the designs.

On the extreme side for RPG design, fans are looking for an experience that is about making them think. It is not about how fast someone reacts but making the best moves and decisions to win. When examining the gameplay itself, traditional CRPGs and JRPGs were not known for overly complex moment-to-moment gameplay – it was more about following the story or the long-term goal of building a character or party. As design evolved into the late 90s through the 2000s, is where the split between the two occurred – with more JRPGs being released around vastly different mechanics and systems. Traditional CRPGs were no longer as popular compared to open world RPGs, with many developers basing their games off the *Elder Scrolls* formula. Instead of being about complicated character development and party dynamics, it was more about the player inhabiting a character within that world and exploring it.

When RPGs began to add in more action-based design, or become real-time instead of turn-based, fans enjoyed this depending on their preference for the reflex-driven aspects. It wasn't until the 2000s and the 2010s when RPGs started to focus on faster combat. However, once a game is no longer turn-based, the decision-making aspect becomes downplayed, because there is no way for a real-time game to present the same number of options and decisions per turn that would work while real-time with one exception. A popular option for a game to have its cake and eat it too in this regard is to have a game built on real-time gameplay but have all the options in combat to have cooldowns before they can

be used again. By doing this, no matter how fast the player is, they still need to play at the pacing of the game and when they can use skills again. This is also where pausable real-time can help in providing faster combat, but still allowing someone to stop in the middle and make tactical choices.

Here is the crucial detail about action and abstracted design that I touched on earlier in the book – no matter how good you are as a designer; it is not possible to create a game that is perfectly 50:50 between the two designs. Part of the reason for the push to integrate RPG systems into everything has been a chase by developers and publishers to create "the perfect game": a title that can appeal to everyone. The push to create blockbuster cinematic games from the AAA is also a part of this. If someone can make a game with an engrossing story, high octane action, and the scaling and progression of an RPG, then it would appeal to everyone, right?

The truth of the matter is that it won't. Any successful game is built on the designer knowing who their audience is and what they are looking for from a gameplay perspective. A misconception when it comes to marketing a game is that if your game is both action and RPG driven, then it will appeal to both groups. That is not how it works, if you build a game that features elements of both, then you are limiting your market to fans who specifically want both designs. The UI/UX elements of each genre must be carefully examined: as fans of each will expect certain details and quality of life features.

One of my favorite games of all time was *The World Ends with You* by Square Enix and released in 2007 for the Nintendo DS. It is very much a game that combined both designs, along with several original concepts, to make a unique experience. The action side came with each character having their own rules and interactions for combat, and the player having to find and equip different skills that they would use against the various enemies. The game was unique and also very hard to control and played nothing like any other RPG on the market. While the game became a cult classic, it also undersold at the time and was considered a failure by the studio until they tried again with *The World Ends with You Neo* released in 2021.

The major qualifiers of both genres are the very same reasons why fans of one won't particularly like to play an example of the other. An action fan doesn't want to play a game where no matter how good they are at the game, they are being hamstrung by RPG progression. An RPG fan doesn't want to play a game that is all about quick reaction time and no room for story or tactical thinking. Even games like the *Borderland* series that tried to merge first-person-shooting with RPG progression still landed on the side of being action-driven.

Earlier in Section 5.3, I touched briefly on the major limitation of RPG design, and that is also a factor when trying to combine action and abstracted gameplay together. The use of scale in RPGs will eventually have diminishing returns on player interest. If the only thing that the developer is adding is just higher numbers on content that's already in the game, players will grow bored of doing the same exact thing (Figure 8.4). While RPG progression does keep people engaged,

Figure 8.4

We have a tale of two different live service Marvel games. *Marvel's Avengers* (released in 2020 by Crystal Dynamics) did eventually add in new characters and some new storylines, but not at the same rate and quality that is seen from mobile games, and the content and gameplay that was there was too repetitive to engage people long-term. While *Marvel Snap* (released in 2022 by Second Dinner) has put out new cards at a constant pace that continue to change the game, and at the same time, worked on larger updates to improve the UI/UX of the title and was considered one of the best live service games released in 2022.

it is not the miracle cure to video game fatigue. As the designer, you still need to create content and challenges that the player can use their RPG progression on beyond just making harder versions of what's already there. This is also why it can become difficult to create a live service game without having a plan for where it will develop. The best mobile games are not about just adding in better units and harder content but creating original content and characters that grows the game in a new direction.

No matter how much people try to add RPG systems to any other genre, if you want your game to work for your intended audience, you need to be able to understand the best ways of integrating RPG systems so that it adds to the game without hurting the gameplay that people are looking for, and I will be discussing the positive aspects of RPG design more in Chapter 9.

As a final example of this, *Warframe* by *Digital Extremes* and first released in 2014 was designed first and foremost as a high-speed third-person shooter. The primary gameplay loop is movement and combat-focused, and that aspect is well done and has attracted and cultivated a huge fanbase. The RPG layer of it is all about customizing your character with all kinds of weapons, power-up cards, unlocking new warframes with their own unique powers, and more. The RPG layer is the primary driver for progression in the game, but it does not

Figure 8.5

The open-world genre is another one that has integrated RPG progression into it. From finding and crafting better equipment, leveling up by performing tasks and fighting, and a standard perk tree for passive improvements. In these games, the RPG systems increase the amount of time someone spends in the game, but debatably, is not improving the moment-to-moment gameplay.

detract or downplay the action focus, and this is where the combination of action and abstracted design work the best. The long form progression feeds into the moment-to-moment gameplay, and while it's not a part of the core gameplay loop, it supplements and greatly extends the game. If *Warframe* had no RPG systems in it whatsoever, it would still be a great action game, but it would also be one with far less playtime and development going into it.

Unless you are making an RPG, using RPG design in another genre requires careful attention to how they impact your core gameplay loop (Figure 8.5). You do not want to focus so much on long-term progression that it makes the start of your game feel poor to play. Just like with the roguelike genre and qualifiers I mentioned in that Deep Dive, putting RPG mechanics and systems in your game doesn't automatically make it a better title, and even still, it doesn't make it an RPG. In Section 10.1, I'll discuss more about the actual defining of an RPG and why it has become so muddied over 20 years now.

8.3 The Mobile Game Market

The culmination of pushing RPG design into any kind of genre can be seen in the mobile game market. Again, for a more detailed talk about monetization and mobile design, please read *Game Design Deep Dive: F2P*.

The 2010s saw with it the growth and changing of the mobile market and mobile design. In my deep dive book, I discussed how the mobile market right now is kind of in its third generation of design – evolving from simple games aimed at people who don't play games, to advanced titles meant to attract hardcore gamers for hours on end. In Section 8.1, I laid out the major trends and aspects that both attract people to RPGs, and why they are so popular to integrate from a development perspective.

The best mobile games take this to the logical extreme – with games that are both designed around short-form interactions with long-term progression and systems. The idea is to create a game that is enjoyable to play a round, match, level, etc., for a few minutes at a time, and then greatly extend that with multiple forms of RPG progression. One of the most lucrative genres on mobile is the hero collector/gacha genre (Figure 8.6). On the simple side, there are plenty of idle RPGs where the player just sets up teams of characters and watch them fight with no further interaction. Advanced examples provide unique gameplay where the player is actively engaged with their chosen team, and the pursuit of stronger characters and equipment form the monetization.

As the title for this chapter laid out, this is how we began to see RPG design everywhere. From tower defense games like *Arknights* (released in 2019 by Hypergryph), fighting games like *Marvel: Contest of Champions* (released in

Gambling is entertainment, an activity done purely for fun; thus, all the sadness and pain brought to you must be sublimated into dance.

Figure 8.6

The hero collector/gacha market continues to be one of the most profitable in the mobile space. With successful games bankrolling their respective studios for years like miHoYo with *Genshin Impact*. And this is something that Project Moon is trying to achieve with their latest game *Limbus Company* (released in 2023).

2014 by Kabam), open world action with *Genshin Impact* (released in 2020 by miHoYo), and countless other examples. There are even mobile games designed to play literally like classic JRPG titles with the inclusion of monetization and gachas. In Section 8.1, I said that the best examples of RPG progression could theoretically be extended and supported indefinitely, and the mobile games that have become major successes over the 2010s are still being updated.

The mobile market in this respect is vastly ahead of AAA developers and publishers when it comes to integrating RPG systems and live service monetization into their games, for better and worse. Many of the "best" examples of this also use predatory and unethical monetization practices that I discussed in my F2P book. The hook is that the game itself should be enjoyable to play for seconds, minutes, hours, etc. without ever spending one cent, but that the attraction of getting better characters, more options, and so on will drive someone to the gacha or monetization aspect of it.

Mobile games fully understand the addictive nature I mentioned of progression and acquiring a six-star character, and being able to see them tear through content is the hook that gacha designers are striving for. The best mobile games know that you can't just keep selling someone on more power and having nothing to do. Games like *Arknights* and *Genshin Impact* design their characters to be unique – while they still fill certain preset roles, their abilities and utility they offer vastly differ from character to character. New updates add new areas to

Figure 8.7

Gacha developers know that limited time events, special characters, etc., are big-ticket purchases for fans and spenders on their game. *Arknights* is no exception and will often put out limited-time banners every 3–6 months, with the feature character unobtainable on any other banner.

explore, new enemies to fight, and more rewards for the player to go after. They understand that it's not just about adding new characters but giving the player a reason to collect and use them. One of the major changes in mobile RPG design over the back half of the 2010s has been moving away from having the player just play as one character. Today, mobile games are about building teams of characters much like the dungeon crawlers I've mentioned throughout this book. Instead of having one character be the best, it's about coming up with teams of characters that synergize together. In return, it makes the attractor of new characters that much stronger – if I'm building a team around thunder damage and a new thunder character is out, I'm going to go heavily on that banner because it would fit my team. However, if it's a water character, I know I'm not going to have to chase after it. And while there may be advantages for getting multiple copies of a character, the role of the banner reward is that once someone acquires that character, they don't necessarily need to keep spending on it (Figure 8.7).

When you combine the addictive nature of RPGs with the psychology and pull of mobile games and monetization, it is very powerful and arguably cause for concern. There are games where people have literally spent thousands of dollars to acquire just one character, and as I talked about in my F2P book, I feel the industry is going to reach a point where either they need to curtail the more abusive monetization practices, or face government regulation doing it for them. In terms of the mobile market, the one developer that has become the most recognizable both in and outside of it is miHiYo. While writing this book, their next game in the *Honkai* series *Honkai: Star Rail* was released in 2023 and quickly became one of the most profitable mobile games released.

9

Advanced RPG Design

9.1 Understanding the Market for RPGs

Throughout this book I've talked about how much the RPG genre has changed over 40 years, and while this is not a marketing book, it's important to understand how the market has an impact on the designs of genres.

For RPGs today, there are four broad categories of fanbases that will gravitate toward RPG-based design. The first are people interested in the story and worldbuilding the game has to offer. These are fans of open world styled or story-focused RPGs, where it's less about complicated systems or involved gameplay, and more about the act of exploring the world and following the plot. If there is combat, it is generally kept on the simpler side. There is a healthy market of people who want to play low stakes/casual games in the form of a "slice of life" story – where the character is just living in this world and not necessarily focusing on combat, while having RPG systems used to progress in other jobs and gameplay loops (Figure 9.1).

Fans of traditional CRPGs are still out there, and there are games released from indie developers every year that cater to them much like traditional roguelikes. For these games, there is a greater focus on character/party development

DOI: 10.1201/9781003331599-9

Figure 9.1

Not every RPG needs to be a life and death struggle like *Elden Ring*. One of the most successful games of the 2010s was *Stardew Valley*, a slice-of-life game about running a farm and interacting with the locals (released in 2016 by Concerned Ape).

and gameplay. These games do have detailed storylines as well, but the exploration is in service to the goals of the game as opposed to exploring for exploration's sake. While these games can feature large game spaces, they will still be smaller compared to the open world style of games like *Skyrim*. In terms of character control, there are games that focus on just one character, or an entire party of characters.

Traditional JRPG design is still being supported by indie developers, once again thanks to the *RPG Maker* series. There are plenty of games that are designed either as direct homages or those that try to do some basic iterating on the base design. This is one area where due to the focus on unique systems and mechanics, there is a lot of room to do something different in it.

What's important to understand is that both traditional designs are not as popular with mainstream audiences as they were during the 90s and 2000s. This is due to the number of pain points, and why modern designers have iterated further that I will be discussing in Section 9.8. I also want to clarify that there is a difference between a traditional JRPG and CRPG from a major IP, and one from an unknown studio. No matter how popular the *Dragon Quest* series is today, making an indie take on it with the same design is not going to be as well received.

The final group of fans has been the growing audience of games that have combined RPG systems into other genres – whether it's an action game, driving, shooting, and so on. This is the group that is the least interested in the traditional designs of RPGs, like the change in the roguelike genre. This is also where the

Figure 9.2

Bioware's *Anthem* was considered one of the worst games released and the biggest failure by the studio; so much so, that there were stories and an exposé breaking down what went wrong. Despite their extensive background with RPG design, the game stayed in development for too long trying to figure out how to build an action game around their RPG structure. When it was released, the combination of third-person shooter and RPG progression didn't work well for the people who played it.

mobile game market has excelled at combining just about everything with RPG design and monetization. As I've talked about in earlier chapters, these kinds of games are built on a well-designed core gameplay loop that the RPG systems can extend; it's not about making an RPG and shoehorning the other genre's mechanics and systems into it. That last point is important to understand, just like how making your game procedurally generated won't fix bad design, adding RPG systems to bad gameplay will not make it good or fix your issues.

For you reading this, there is a lot of opportunities and space to explore with the major concepts and designs of RPGs that I will be discussing in this chapter. Just remember that if your goal is "genre X with RPG mechanics," you need to research that genre to understand what does and doesn't work in it. Your game must be enjoyable without the RPG systems (Figure 9.2). A common design trap I've seen designers fall into is thinking that the RPG systems will take the place of confusing gameplay or a poor UX, and that never works. If your game isn't enjoyable without the RPG systems and elements, they're not going to make that better.

9.2 Creating Choices through Customization

Before I talk about some of the basic rules for balancing RPG design, a major aspect of the overall design comes with customization. Since the very beginning of the RPG genre, giving the player the ability to customize their experience has

been a critical aspect to its success and one of the major differences between RPGs and other genres. Returning to tabletop and MMORPGs for a second, part of their appeal is that the player is not just playing a stock character, or someone made by the designer, but being able to inhabit the world as a character of their own creation.

Character creation also involves being able to personalize them, and the concepts of customization and **personalization** are often conflated. The difference between the two is that customization refers to anything that directly impacts the gameplay or options available to the player, and personalization changes the look of a character and has no impact on the actual mechanics of the game. Regardless, fans will want plenty of ways to personalize their characters.

Throughout this book, I've talked about some of the systems that go into customization, and I want to reiterate them here. The first thing you need to decide is how involved will the customization be, which will lead to discussing balancing in Sections 9.5 and 9.6. The most basic level of being able to customize a character is with the use of equipment, and the progression itself will be tied to the gear that a character has on (Figure 9.3).

For many JRPGs released over the past 40 years, if they are story driven, the player may not even be able to customize any aspect of their characters. At most, they may only be able to pick who will form their active party in combat. The CRPG side has always been more involved with customization thanks to its tabletop roots, and this comes with being able to literally design a character from

Figure 9.3

Customization is all about providing many different ways of experiencing a game, and the *Monster Hunter* franchise is one of the best. Each one of the game's different weapon types behaves completely differently from one another. It's unlikely that a player will enjoy every weapon, but they are sure to at least find one favorite.

scratch. How much detail you have with a character creator, and what will impact the gameplay, is entirely up to you. Some games will have the fantasy race and gender affect character attributes, while many modern games tend to start every character at the same baseline at the beginning and leave race and gender as personalization options so that someone doesn't feel pressured to change how their character looks for more bonuses.

From a development standpoint, personalizing a character can greatly vary in terms of its utility and scope. For smaller games, or those with simple in-game models, the player may just be able to choose from a few basic outfits, the primary and secondary color of their clothes, and that's it. For larger titles, especially 3D games, there are some character creators that allow the player to adjust the exact curvature of their character's face. In games where the player is designing a character that's supposed to be their avatar, those will have more powerful character creators.

Every RPG by its design will have attributes attached to every character, every weapon, and every enemy. This is where it can be very easy to be overwhelmed by your own design. Attributes will dictate a character's ability in different situations and can be used as a gating mechanic that I'll discuss further down. Attributes can be broadly separated into two categories – innate and equipment-based. Innate attributes are the ones that define the characters in your world and their abilities. At the absolute minimum, you're going to need a health or vitality attribute that determines whether a character is still able to fight or not. The reason why I phrased it like that is that some games don't want to deal with the concept of death or killing characters, especially if a game is aimed at younger audiences. Your "health" attribute could just as easily be called "bravery," and when it runs out, the character flees the fight (Figure 9.4).

Here is a quick list of some of the most used attributes for characters in an RPG:

- Health: The sum total of the amount of damage a character can take before being defeated
- Magic Points (or MP): Used to cast spells, use special abilities, and more. Can also be called mana, energy, and various other names
- Strength: Affects how hard the player can hit when using physical weapons
- Intelligence: Affects the potency of spells and magical-based attacks
- Dexterity: Affects the character's probability of hitting an enemy
- Physical Defense: The character's ability to resist physical-type damage and reduce the amount they take from an attack
- Magical Defense: The character's ability to resist magical-type damage and reduce the amount they take from an attack.

Please note that the standard definitions for these stats are not set in stone either – depending on the combat and systems in your game, the stats could affect things differently. In RPGs that have an emphasis on different ways of completing quests

Figure 9.4

The beauty of abstracted design is that everything can be represented by the RPG systems in different ways. For games aimed at a younger audience, you can show and represent combat in various ways that don't involve the actual act of hurting characters or any gratuitous forms of violence.

or exploring, they will further branch out their attributes with some that are related to personality or other character traits: Charisma, Perception, and many more. These attributes will be used in respective situations to determine the chance the player has of succeeding. By having different options tied to different attributes, it means that the player should have a way through a given situation with some combination of attributes. From a balancing standpoint, you do not want to make a particular character attribute required, as that creates the possibility of someone getting stuck in your game because they didn't know about it. Some games make these attributes locked once they are set up at character creation to make the player take on challenges best suited to their role. Other games may allow them to raise these attributes over time, or wear gear that influences them. Speaking of gear, another use of character attributes in games where the player can upgrade them is to tie them to requirements for gear. Such as a two-handed sword needs at least 14 strength or the character can't use it. There are no set rules for how many or how few attributes you want to have in your game. For RPGs that are aimed for casual or new fans, they may only have two or three attributes. In *Paper Mario* (developed by Intelligent System and first released in 2000 in Japan), Mario only had three attributes that could be leveled up – Health, Flower Power (the game's version of mana), and Badge Power that determined the number of equipable badges the player could wear at one time.

Equipment-based attributes are those that are tied to the equipment that a character can wear and, depending on the game's design, may also include innate

stats like giving a character more health as an example. In this respect, the character's baseline attributes are simply there to allow them to put on equipment, which the equipment itself provides the biggest boost to their attributes and the ability to fight. For this category, there is no set list of attributes you could feature in your game, and it's going to be dependent on how complicated you want your game to be. Here is, in no order, just some of the many kinds of attributes that could be featured on equipment.

- Damage: The amount of damage done when attacking (weapon-specific)
- Damage Type: The type of damage the weapon will do
- Physical Defense: The higher this attribute is, the less damage a character takes from physical-type attacks
- Magical Defense: The higher this attribute is, the less damage a character takes from magical-type attacks
- Aliment Resistance: For the different aliments in your game, gear can reduce the chance of it affecting a character or outright make them immune to it
- Accuracy: This attribute modifies the chance for a character to hit another character during combat
- Dodge: This attribute gives a character a chance at dodging specific kinds of attacks

I want to emphasize that the examples I listed are just the tip of the iceberg, and not only are there many more, but none of these are required to be in your game. Part of the complexity and depth of RPGs is just how involved they can get with their interactions and rules for combat and encounters, and the attributes that you build your game around will greatly influence that (Figure 9.5). How attributes will impact combat is dependent on the underlining systems you are working with. I will discuss more about gear design in Section 9.5. If you are building a game where there is no combat, then those specific attributes won't be necessary, and you can just focus on attributes related to the challenge in your game. For games built from frameworks like D&D, they will base their rules on whatever version they are using. When designing an RPG, this is something entirely up to you, and there is no right or wrong way with this system when creating the underlining rules. For the consumer playing your game, it is often considered good UI to present the information as cleanly as possible without being bogged down with too much detail. I'll be returning to this point in Section 9.8.

In Section 5.2, I touched on the concept of classes and job systems in RPGs. This is another aspect that you can choose to put in or ignore for your game. For RPGs that focus on unique individuals, like JRPGs, they may just have each character be a class onto themselves – with unique abilities and pros and cons for using them. If you are allowing the player to create a character or characters, this will be something you need to decide whether to include it.

Figure 9.5

Many CRPGs and CRPG-inspired games have very extensive systems for how characters behave and the impact of different equipment and attributes on the gameplay. For titles like *Baldur's Gate 3*, using the *D&D* 5e ruleset is the driving factor for their character designs and situations.

Classes and jobs, as I discussed earlier, can either be locked to a character once they are built, or can be swapped around; again, this is on a game-by-game basis. The impact of the class will determine how a character will grow and could affect their base stats further. For RPGs that introduce special abilities, spells, etc., another attribute that becomes a baseline requirement is a resource for using these abilities. The most common name is magic power or "MP," but games have used many different variations and naming conventions over the years. For games without MP, the skill itself may have a cooldown period before someone can use it again.

Class design is a massive topic and is built heavily around the balancing and design of your game that will be discussed in 9.5 and 9.6. Earlier in the book I mentioned the "holy trinity" concept of having a tank, healer, and damage dealer for parties, but many RPGs today design more interesting classes that can perform different utilities (Figure 9.6). The reason why balancing is important in this respect is that what the player can do will be dependent on the enemies and their respective skills. If you don't want to lock a character into a specific role, but still provide players with a guide for their character, another option is to create archetypes. Class archetypes provide the player with a preset character in terms of attributes and starting gear and skills to then build from there. This is the style that From Software has used for their soulslikes while providing players with the option to start with a character who doesn't specialize in anything and is just a blank slate to build from.

Figure 9.6

Games like *Darkest Dungeon* that go with unique class designs will build each character to fill a few specific roles on the team, so that a player is not pigeonholed into only taking specific characters. With the Occultist pictured here, he can either be set up to do damage against eldritch enemies, or act as a support/healer for the team.

When designing different kinds of gear, this is another area where the only limit is on the amount of time you want to dedicate to it. Some games just feature a linear progression of gear based on where the player is in the game, this is where the progression of going from common rags to over-the-top outfits from MMORPGs comes from. In this case, there is no choice to how gear works, the player is always going to be looking at the next tier to make their characters stronger. For games that feature procedurally generated gear like the ARPG genre, the customization comes in with the additional attributes and modifiers that can show up on a weapon. If you're building a gunslinger who also does fire damage, then any equipment you want to wear should enhance fire-based damage, and this is separate from the base utility of the gear. The other option is to design gear that is varied based on different playstyles or classes. This can be done explicitly by stating that certain gear can only be used by set classes, or indirectly by having gear with specific attribute bonuses that would be tied to certain classes.

Gear, like attributes, has no fixed rules for what must be attached to them. In Section 9.5, I'll talk more about how gear factors into progression, but it is possible to make gear very simple in your game. For casual RPGs, gear can be attached to story progression at fixed points – with their purpose is to make the character stronger or unlock a new ability. Instead of the player having to buy new gear, the gear is just linear growth. Returning to *Paper Mario*, Mario's combat ability was enhanced by finding new shoes and hammers over the course of the journey, but these occurred at fixed points and the player couldn't just buy new gear.

One detail that hasn't been discussed yet in this section is if it's okay to lower a character's attributes. Many games will have spells or abilities that can weaken a character for a set period, or gear that will enhance one attribute at the cost of another. Again, this is going to be dependent on the design of your game and the balancing you want to have in it.

Another popular aspect of character customization is with the use of "perks" or passive bonuses. The difference between a perk and a skill is that skills are direct abilities that a player can use or apply to a character – learning fire magic, how to heal, etc. The use of perks is to provide a passive benefit that can further customize how a character behaves, and there are no limits for how far you could go with them. A good example of this would be *Path of Exile* that had minor perks and major perks (Figure 9.7). The major ones would fundamentally change how a character would behave from that point on – often giving them a major advantage and disadvantage. For high level play in the game, these major perks defined a specific build and strategy, but could easily backfire if the player didn't properly build their character and strategy beforehand. Perks are either defined by the specific class/job, be unique to specific characters, or come from a general-ized pool that every character can take from. In games that allow the player to swap the job/class of characters, it may be possible to transfer passives (or even skills in some cases) from one job to another to create hybrid characters. For games that focus heavily on the mechanics and combat systems, this can lead to more customization and depth for players who want to go this route. While

Figure 9.7

The *Path of Exile* skill tree is famous at this point for its size and depth for char-acter development and progression. While the smaller nodes are simply there to increase the attributes of a character, the larger nodes are set up with unique benefits that players can create entire builds around.

there may not be a limit to the number of passives a character can learn, games will often have a limit on the number of active passives that can be attached at one time.

For this section, the most important point to understand is that the more customization you offer the player will lead to more work for you in terms of balancing and designing your game. For first-time designers, you should try to keep customization as basic as you can while you're trying to learn and build an RPG in the first place. It is very easy to overcomplicate your first game with all the systems that are being discussed in this chapter. Every choice should bring something to the table when playing your game, and if it doesn't, then it either needs to be reworked or removed from the game.

What I've discussed in this section is just a facet of the many ways and designs you can build an RPG around. What makes RPGs hard to talk about is that the genre doesn't really have any "foundational" mechanics and systems anymore. Except for traditional CRPGs and JRPGs, once you start studying RPGs systems, while games can have similar aspects like combat, leveling, etc., you're going to quickly find that franchises tend to go in their own direction with their systems. This is not like the platformer genre where there are distinct mechanics and qualifiers that you must do, or your game won't be considered an example of it. And it's this diversity of design that will set up the final chapter of this book and where does the genre go from here.

9.3 Combat System Creation

Combat systems greatly vary between all the RPGs out there. Once you've established how the characters in your world will behave, the next step is determining how combat will work, and even if your game will have combat to begin with. Combat can be one of the most involved systems in an RPG, because there are no fixed rules for it. Because "combat" could take the form of other game genres and designs, such as *Undertales'* bullet hell dodging, for the sake of staying on topic, I'm only going to be discussing combat systems and examples that are used in standard RPGs (Figure 9.8). If you do want to experiment with other genres' game systems, you will need to approach them focusing on making a version of them that is good to play and that can fit with the rest of the RPG design.

For this section, I want to talk about a few key areas that you need to consider and will be a factor for your combat system. The first is the number of characters the player can control at one time. The larger the player's party is, the more options they can use during a fight. For real-time RPGs, often the player can only control one character at a time, but there are ways of still having group interactions. Returning to the concept of pausable real-time, this is how designers can give the player direct control but still allow them to order other characters around. Some games will let the other party members be controlled by the AI, with the player able to sometimes set up conditional commands for

Figure 9.8

Turn-based or real-time? Tactical or simple? If you are designing an original RPG or RPG-inspired game today, there are no rules for how you should start building it or what needs to be there. Once you figure out how combat will play out, you can then start thinking about the different options and what does balance look like in your game.

them to use. A popular one would be if the player's health falls below X, then the character should heal the player. *Final Fantasy 12* turned this system into its own form of progression with the "gambit system." As the game progressed, players would find "gambits" which were conditional statements that could be attached to characters to issue them commands. While it started off simple, it was possible to set up very advanced ordering to have your party work in precise order for your strategy. However, a system like this was also cumbersome to use, and many consumers prefer having the AI be intelligent on its own without further work from them.

The larger the player's controllable party is, the more enemies and larger encounters you can design. For tactical games, a major design point is that the player is always fighting groups larger than theirs, and it will be up to proper planning and decision-making to win. The more characters participating in a fight also means the longer a fight will be, and why many RPGs designed today will have the quality-of-life feature to increase the animation speed of combat to get through it faster. From a balancing standpoint, larger parties means more interactions between different skills and the variety of tactics that can be performed. However, even with faster animation, large parties can slow down a game when the player must issue individual commands for 5+ party members each turn. Having an "auto play" or the game just repeating the last command issue is another quality of life feature I'll talk about in Section 9.7.

Something that sounds very simple, but definitely not, is deciding what the player can do during a given round of combat. Again, this is a point that greatly differs based on the type of RPG and complexity you are aiming for with your design. Here is another quick list of popular options that designers have used for CRPG and JRPG design:

- Attack – A character performs a default attack with their chosen weapon.
- Skill/Magic – A character uses one of their special abilities or magic powers that will typically use up MP or energy.
- Defend – A character braces for the next attack and reduces the amount of damage taken until it is their turn again.
- Move – The character can move on the field within their movement range.
- Use Item – The character uses an item from either the party's inventory or their own.
- Run-away – The party attempts to escape the battle.

Attacking is the most basic command in any combat-heavy RPG, but there are some not-so-subtle details that you will need to consider when building your combat system. The first is how damage will be calculated. This is also a factor with balancing your game that I'll talk more about in Section 9.7. The basic example is that whatever the attack attribute is for a character or gear is the actual damage. You will then need to calculate if there's a defense or armor stat and how that reduces or mitigates damage. In this area, a simple example is to simply subtract the defensive stat from the offensive one to determine how much damage is done. I will discuss the idea of having different damage types further down and how it relates to damage calculation.

Part of the mechanic of attacking is whether there are other factors that go into the hit itself. Some games will dictate that an attack will always hit unless there is another factor at work, such as an ailment that causes it to miss, or a skill that makes the character unhittable. Other games will factor this based on attributes of the weapon, character attacking and defending, or all the above. A missed attack is worse than one that is blocked for the attacker, as it means no damage was done to that character.

This is where the design division between tactical RPGs and more traditional ones comes into play. Many SRPG and tactical games are designed heavily around the act of evading or ways of reducing that chance for the attacker. Positioning, as I will discuss more in this section, can also affect the chance of hitting an enemy (Figure 9.9). Many tactical games will have it that if a character is attacked directly in the back, there is no way for that character to evade.

On the other end, there is the decision to include what is known as "critical hits." A critical hit has a chance of occurring either based on the character, weapon, or other factors like skills and bonuses, and represents an attack doing far more damage than it would normally do. This is another aspect where there

Figure 9.9

Positioning is one of many different factors that can mean different things depending on the design. Some developers don't like how it can greatly slow down the pacing of combat having to adjust the facing of characters, but it can be vitally important in games where the player's information is based on their unit's line of sight. In *Tactics Ogre: Reborn* (released in 2022 by Square Enix), characters hit on the back or sides take more damage and are easier to hit than attacking them in the front.

is no set rule for what a critical can do; some games could make it 125% of the attack, 200%, or any other percentage. What makes this polarizing for RPGs of any type is that if the player can use it in the battle system, so can the enemies. If a critical hit is too consistent and does too much damage, there is the possibility that the player's team/character could be wiped out before they even have a chance. A critical can be tied to just about every element that can occur in combat: a critical hit, critical spells, critical healing, it's entirely up to the designer for how much the impact of critical hits factor into the gameplay.

The skills/magic option encompasses any special abilities, class-specific powers, spells, etc. that a character can perform. The basic functionality is the same as performing an attack. To highlight the power of spells/skills, most RPGs that have a separate attack and magic/skill command will make them unavoidable by the opposing character, but that doesn't mean that there aren't any games that have spell evasion. For games that have a separate resource for using skills, like the ones I mentioned in the last section, the resource would be used to activate the skill. As a form of balancing, some games will have skills that require several turns to charge up that will be discussed more in Section 9.6. A special exception for skills is games that don't have a separate resource for using skills/spells. In this case, there may be a cooldown period before the skill can be used again, or a limited number of times a skill can be used during each individual battle.

Depending on how tactical the game is, you may need to set up the UI to properly show elements like attack range, does the skill correspond to an enemy weakness, and even just what damage it will do to an enemy; this will be discussed with UI in Section 9.8.

Defend or "defense" can mean different things based on the kind of design the game is going for. The most common usage is that a character doesn't attack for their turn, and instead greatly raises their defensive stats to reduce the next source of damage taken until their turn comes around. With that said, defending can confer different benefits based on the design in question. For games that have a focus on attacks that take multiple turns to charge, defending may be the only way for a character to survive it without being heavily over leveled. Some games allow defending to also block any status aliments or debuffs for that turn. In *XCOM* 1 and 2, because the games focused entirely on dodging and avoiding damage instead of reducing it, the player's main defensive option: "hunker down" raises their evasion chance and prevents any attack from causing critical damage.

Another role of defense is with the notion of "taunting" – which draws attacks to a specific character, ideally the one with the largest defense. For games that have a class dedicated to being the "tank" or designated blocker, they will often have skills designed to draw the enemy's aggression or "aggro" to them for a specific number of turns. This can also be given to enemies, so that the player cannot attack anyone other than the taunting enemy. Having ways of shielding or protecting defense-light characters is an important aspect of balancing your game. Without it, weaker characters would just end up being killed before they could get away or stop the enemy. Positioning can also be a form of defense, even in turn-based RPGs, and I'll discuss that further down below (Figure 9.10).

The move command is for games where the player can move individual units or the entire group around the map. This is only a feature in turn-based games, as in real-time, the characters are always moving. This does have huge ramifications for how you will build your combat system and I'll go into detail further down.

The "use item" command is another option that by itself is very simple. A character is free to use an item to aid them during combat. The two most common systems seen in all RPG designs is to either have a universal "party inventory," or a smaller inventory for each individual character. The universal option is popular for non-tactical games and allows the player to always be able to use an item if their party needs it. The individual system is used for tactical games and often features items that have more utility or specialized purposes to affect the character holding it, the environment around them, or fighting enemies. In *XCOM 2*, one of the most important early game items were flashbangs that could be deployed to prevent enemies from being able to do anything while being disoriented. Due to their effectiveness, the player had a limit of how many they could bring into a mission.

The "run-away" option allows the player to retreat from a fight if it's not going their way. Due to the abstraction of RPG design, there is always the chance that the player fights something that is too strong for their party, or the RNG can

Figure 9.10

The formation of a player's party is another way of having positioning without having movement. In *Labyrinth of Galleria: The Moon Society*, formations in the vanguard are more likely to be targeted by enemies, and different weapon types work better in specific positions. Positioning like this also helps when creating party dynamics, as certain classes/roles may only work in either the front or back position in a game.

spiral out of control and put the player in a bad spot. Being able to retreat has been balanced in many ways over the history of the genre. Some games allow the player to literally retreat any time, in any fight, with no penalties for doing so. Other games will make it a percentage chance, and if it fails, the player will have to try again next round. For bosses and special encounters, the player may not be allowed to retreat at all from them. What happens to the enemy is also varied by the design. If the game is about random encounters, the specific enemy group that the player ran away from is gone. For games with fixed encounters, the enemies may either preserve any damage done to them or be fully healed; again, this is design dependent.

One thing is for sure, in any RPG, the player should always have the option to escape from a normal fight if it's going badly. Even real-time games will often let the player leave an enemy's engagement area as a way of retreating, often letting the enemy fully recover when they return to fight. If the player has no way of escaping from combat, then they are always at risk of having to restart at a save point and lose progress.

The next set of details is how combat plays out, and there are quite a few options that have been done in the past. The first is the classic turn-based, which has several variations. The original is known as an "I Go, You Go" style – where one team performs all its actions, then the other, and then the round resets. Some

games will base turn order on a speed attribute – where the fastest characters will perform their actions before the slower members on either side can do theirs. This is also related to the use of the timeline system I mentioned in Section 4.2.

A pseudo form of turn-based combat is known as an "Active Time Battle," or ATB, that was coined by Squaresoft during the 90s. Every character, including the enemies, has an action gauge that fills up over time. Whenever a gauge fills up, that character can perform an action, and the gauge resets afterward. In this respect, there are no actual "turns" as every character is waiting for their chance to perform an action. This system hasn't been used as much in modern games, as any skill that can speed up or slow down a character could easily give one side a huge advantage. This system would be iterated on and turned into an actual timeline that I mentioned earlier in the book. In this respect, the ability to speed up or slow down a character's action became an essential strategy.

On the real-time side, even though there is more going on, that doesn't mean that you can't have decision-making. Earlier in the book and chapter I discussed pausable real-time combat that acts as the middle ground between real-time and turn-based. Most real-time RPGs will institute cooldowns on specific skills or options that the player can use to balance the game and prevent them from just using their best skill repeatedly.

The concept of an active time battle may not be used as much in turn-based RPGs, but there is a form of this in real-time games. In this case, the player can move around and avoid damage real-time, but when it's time to activate a skill or perform an action, the game will pause like a turn-based game to give the player a chance to properly set things up. An example of this was in the game *Transistor* by Supergiant Games released in 2014.

What the player can do on a given turn or at one time is the summation of your combat system. The most standard format with the "I Go, You Go" style mentioned above is that every character can perform one "action" per turn of combat. Said action is anything that is on their general command list. There can be special skills that give someone more actions per turn, or something that doesn't count as a regular action, and many designers will design boss encounters where they will have more actions than a regular enemy. In games that are more tactical, the design may split up the actions into two or more groups based on the gameplay. I'll discuss movement further down, but a format popularized by tactical strategy games is to give a character two actions per turn – move around on the field and perform an action. For games where movement and positioning are pivotal, this kind of setup is required because if the player must take an entire turn to move and nothing else, that will slow down the game dramatically.

With this two-command setup, another decision you need to factor into your design is if ordering matters. In games where it doesn't, a player can attack, then move their character out of range of the opponent or into cover where it is safer. Again, the speed of combat and how long you want each fight to last is going to be a factor when it comes to the UX of your game. Many games will use a simple form where performing an attack or skill will end the character's turn, but they

may move one time before performing that action. Other games may simply give the character "two actions," and they can perform any combination of them during their turn. That means they could attack twice, move twice, attack then move, move then attack. Whatever you decide for your game, often will be mirrored by the enemies and encounters you put in. For this setup, there is more to talk about in terms of abilities and actions that fit tactical games, but that would be more on topic when I cover strategy games or just tactical games in a future book.

Speaking of movement, you will need to decide if movement is an aspect in your combat system. This "simple" question has been one of the major ways that RPGs of all time have splintered off from the major names and traditional JRPGs and CRPGs. Obviously, if your game is built on real-time combat, then everyone is always going to be moving around. In a standard turn based JRPG, the player and the enemies are lined up and there is no movement whatsoever in combat. The next step up in complexity is having positioning in your game – based on where the character is placed will determine how likely they are to be hit and what weapons or skills they can use. This can also be a factor in enemy design with having stronger or more annoying enemies in the back row or being shielded by other enemies that the player must get around to attack them. For games that make use of positioning, they will have attacks that can get around enemy placements, or ways of moving and repositioning characters to leave them open for attack. Positioning can be used as another way of defending characters. By having your weaker characters in the back, they are less likely to get hit or may not be possible to be attacked while the front row is still alive. You will also need to decide if both sides can move characters out of their formation, such as with the *Darkest Dungeon*. Moving characters in this respect can be very powerful – allowing one side to put their opponent in a position where they can't attack or move a weaker enemy into the right range for attacking.

The next iteration for movement is having actual movement and characters represented on a board or field. This is where another character attribute must be included in your game "Movement" that dictates how far a character can move on their turn. Depending on the complexity of your game, the basic movement system is building it around a grid format – with characters able to move a certain number of squares each turn. Games in 3D may opt for movement represented by a distance, and the character can move a certain distance each turn. Movement can often be altered based on the character's class, skills, equipment, or being affected by certain skills to forcibly move a character.

For tactical strategy games, an often-used mechanic is what is known as a "zone of control." Tactical strategy games are built around positioning in keeping your strongest defensive characters in front of your weaker characters. The problem with movement in wide areas is that there is normally no way to stop an enemy from getting around your units to strike at your weakest characters, a problem that has plagued the *Fire Emblem* series for some time. The basic solution is to surround weak units with strong units to create a human shield, but other games build this into the design itself with a zone of control. The zone of

control around a character prevents the enemy from going through the spaces directly connected to a stationary character without any penalty. When a unit tries to do this, or attempts to disengage from the enemy, they are penalized by one free hit from the unit they are running from.

One of the most popular systems that is used by mobile RPGs, and a lot of RPG design in general for combat, is a "rock-paper-scissors" balance (Figure 9.11). Every character has some kind of identifier to it; this could be an element, an alignment, weapon type, class, etc. Every identifier is strong against an opposing one and is weak to another. This "weakness" can come in many ways – taking increased damage, suffering attack penalties when fighting them, and so on. Some games make this just a minor inconvenience, while others have their entire balance based on having characters fight against those that they counter. Unlike the *Shin Megami Tensei* games where there are ways to block or mitigate a weakness, this system does not do that, with one exception being boss-class enemies who may not be weak to anything depending on the game. The first game I could think of that made it this explicit would be the original *Fire Emblem*, but many strategy and tactical games have used systems like this over the past 40 years. Some games may add more features such as items or gear that break the normal rules of balance – for example: giving a "rock" unit a weapon that now makes them strong against "paper" instead of "scissors."

Figure 9.11

Rock-paper-scissors balance has been the foundation of many RPGs. In *Persona 5 Royal* (released in 2019 by Atlus), a character who is hit by their weakness is stunned for the current round, which can lead to one side getting an advantage if they knock down the entire team. It can also lead to the player being rewarded by building a team to specifically counter the enemy, or punished if they bring the wrong characters to a fight.

If you decide to have this kind of system, or any special rules for combat, you will need to factor that into the enemy's behavior and whether or not they can capitalize on it also. Part of the complications of unique elements in combat systems is when a game has asymmetrical balance – with one side having unique options or factors compared to the other. Returning to *Darkest Dungeon*, the player's characters specifically have a second way of being attacked known as "stress damage." If a character's stress gets too high, they can suffer a massive debuff, and if it maxes out, they will automatically die. The enemies do not take stress damage, and part of the overall balancing that went into the combat system and enemy design was enemies who were more dangerous for their physical damage or their stress damage. I will discuss more about factoring in unique skills or tactics in Section 9.6.

Another facet that is both as part of the combat system and of your overall design is if your game will feature action commands. Again, an action command gives the player a reward for properly timing a button press either before they finish an attack, or just before an enemy attacks them. Advanced examples will turn the action command into a quick minigame that the player must perform to get the most, or any, damage. Some titles will use this as a little bonus reward for skilled players, while other games may make this practically required to stand a chance. The advantage of this system is that it adds a little more depth to your combat. However, correctly timing button presses can be reflex intensive and become tiresome over the course of the entire game. A popular UX option is to have an "auto complete" option so that the game will always do the correct input for those that want it.

This is just a basic list of fundamentals that are universal with RPG design and its various subgenres. But there are games that feature completely original systems like the press turn system mentioned with *Shin Megami Tensei*. Just like the last chapter, there are no required elements of combat in RPGs today. However, part of understanding the evolution of UI/UX that I will talk about in Section 9.8 is that many of the trends and features that popularized the best CRPGs/JRPGs in the past are now considered frustrating elements and pain points for consumers today. With combat, you need to make sure that your system is as easy to understand and enjoyable to play, as it will be something people will be continuously doing in your game. Don't be afraid to experiment with original systems if you keep the actual combat pace fast.

Just because games have done things one way, doesn't make them automatically the best for your game. If you are interested in creating an original system for combat in your game, be sure to playtest it frequently to make sure that people are enjoying it. Another major aspect of game design today is that uniqueness doesn't automatically mean great. I have played many games that have featured unique and never seen before systems that end up feeling cumbersome and frustrating to use. As I said at the start of this section, if you want to include combat, or any kind of system, that is often featured in a different genre, you need to make sure that it is enjoyable in of itself before you can start figuring out how it will

integrate into the rest of your game. With that said, balance and combat go hand-in-hand, and I'll be returning to how does balancing work with numerous skills and characters in Sections 9.5 and 9.6.

9.4 Enemy and Encounter Design

Each section in this chapter does not have any fixed rules for how they should be designed, and enemies and encounters are one of the most diverse. Before you even design one enemy in your game, you need to decide how do encounters work in your game.

The oldest methods are random encounters. Once again, as the player moves around on the map or where they can be attacked, the game is doing a random check to see if the player should be attacked, when the check passes, the player is put into a fight. Later examples would provide the player with an on-screen indicator to show the likelihood of an attack. The longer the player goes without being attacked, the indicator will issue a warning, and at some point, a fight is inevitable.

Fixed encounters occur in games where the player can see the enemy or enemies while exploring the world. Running into them on the field will start a fight and keeping away from them will prevent combat from happening. Some titles will literally have a fixed number of possible encounters in the entire game. This way, if the player clears out an area of enemies, they are rewarded by being able to move through there without any threats. Other games will preserve the state of an area while the player is in it. Once they save their game or leave and return, the enemies will repopulate (Figure 9.12). For games that allow the player to see the enemy in the world, this also provides the opportunity for the player to interact with enemies before combat starts. Many games will give the player's team a free turn if they're the ones who initiate combat with an attack on the field or running into the enemy's back. Likewise, if the enemy hits first, then they get a free turn before the player can go.

While this decision sounds very simple at first, it will have huge ramifications on how your game is played and balanced. Random encounters are useful if there is a focus on gathering materials and items from enemies as a form of progression. However, random encounters can become tiresome if they occur too frequently. Having fixed encounters also means there is a literal point where the player cannot gain experience or level up through combat anymore, and that will have to be considered when balancing enemies and boss fights. This is not a problem if your game only rewards experience on completing quests as opposed to fighting enemies. However, without enemies to fight, it also means that there is a limit on how much money the player will have to buy items and gear with (if your game has them in the first place) and what will be their max level for any given section.

Another option for encounter design is allowing the player themselves to decide when to have a fight. Many JRPGs have items that can be used to either raise or lower the encounter rate for a fixed period – allowing the player to quickly get into fights or run through an area, respectively. Being able to set the frequency

Figure 9.12

Random or fixed encounters is another decision that will impact how your game is played. With *Jack Move* on the left (released in 2022 by So Romantic), it uses the traditional random encounter system, with the option to lower or raise the chance of fighting. *Chained Echoes* (released in 2022 by Matthias Linda) has enemies moving around on the field that players can try to avoid.

of attacks manually has become a UX option for RPGs today. A somewhat used method is that the enemies on the map are passive, and the player themselves is the one who decides when and what to fight. Returning to *The World Ends with You*, the player could run around gathering enemy encounters before fighting them one group at a time; the more fights at once, the greater the rewards if they win.

With that said, it's finally time to talk about the actual enemies in your game. For every RPG ever made, there is an infinite well of inspiration and designs to draw from when coming up with the aesthetics of your enemies. From a design point of view, you first need to think about the basic attributes of an enemy and where they fit within the world of the game.

Every RPG, regardless of if it's open world or not, has a path through it – the player starts in an area, then they move to the next in relation to the story and quests. Every area should have its own enemies of varying power to fight. This also includes special areas like dungeons and caves that have their own map to explore, complete with specific enemies to fight. For the artwork, older RPGs in terms of enemy design may just use the same enemy models but change their color palette to indicate different versions of them. Today, most RPGs will just have a unique model for every enemy.

As I said in the last section, combat and balance are linked together, and that is also dependent on the enemy designs. Every enemy must be assigned different values for their attributes, with enemy types getting progressively stronger as the

player moves to later areas. Enemies can also be given skills or abilities – either ones that the player can also use, or original ones unique to them. When assigning abilities to enemies, be aware of what options and items the player has access to at that given point in time. Let's say for example that you introduce in area two enemies that can petrify a character and makes them unusable until it is cured. If you wait until area three to introduce ways of curing it, that will become frustrating for players who won't have any way of dealing with it.

You can use skill design to add further complexity to enemies, especially bosses (Figure 9.13). A key aspect of the challenge in every *Shin Megami Tensei* game is having bosses who have their own abilities that can break the normal rules of engagement. This can include everything from giving itself more turns, multiplying itself, changing its resistances, inflicting unique status aliments, and much more. There is no limit in this respect when it comes to enemy designs in RPGs. While this can be harder to do in action or real-time RPGs, you can still create unique fights and those that could even use the environment itself to fight the player.

In terms of the AI or logic the enemies will use, this is something that again differs from game to game. The most basic example is having the enemy perform a fixed pattern of commands every fight – such as "attack, cast poison, defend" and repeat. Advanced examples will have a random pattern: where the game will

Figure 9.13

Boss encounters greatly vary between games and studios. How far you push any unique aspects of the fight will affect the complexity and difficulty of it. In some games, the boss fights are more puzzle-like – where the player must figure out how to win given their unique capabilities. In other games, it's all about the stats of the player's characters. For a good example on how far you can push boss design in abstract games, *Library of Ruina* (released in 2021 by Project Moon) is a fantastic example of enemy diversity and advanced design.

9. Advanced RPG Design

pick the next ability either at random or with specific conditions like "don't use the same option twice in a row." For games built on tactical strategy or movement, there will also need to be logic to determine how/if the enemy will engage the player's units. Some games will have the enemy only move when a player's unit is within range; other games will just set the AI to start tracking and engaging the player.

Specifically for tactical games, you will need to create the rules that the AI will use when making decisions during its turn. This is something a bit off topic for this book and would be something I would examine when we get to a turn-based strategy design edition. Figuring out how good the AI is at the game will determine the difficulty of your game. If every turn, the AI is always making the best decision, it could make the game unbeatable for casual players. The most advanced example would be creating a neural network of all the possible commands and logic that the AI could use, so that they are in some respect actually playing their own game against the player. This is something that is reserved for very advanced tactical games and is far beyond the work that you would need to do for an RPG.

Another aspect is whether the player and/or the AI have access to unique powers and abilities that give them different rules of engagement. One of the major design aspects of *XCOM: Enemy Unknown* and *XCOM 2* is that the player's characters learn special class abilities that allow them to circumvent the normal ways to attack enemies and enemies who can do the same. Some strategy game designers will use AI learning and neural networks to develop the logic they want the AI to use. Again, with this book focusing on RPGs, this is a topic too advanced to delve further into here. For games where a boss encounter is supposed to be unique or a one-off, that encounter may have rules for how it behaves or what the player can do exclusive to that one fight. A good example of this to study would be *Library of Ruina*. The game combined deck building and RPG design for its various systems, with many boss fights that were built as their own unique rules for the player to approach. Keep in mind that the more unique a fight is, the more careful you will need to be when balancing the aspects of it with the rules and abilities that the player can use.

This chapter is called "enemy and encounter design" for a reason, regardless of if your game is turn-based or real-time, you need to think about how enemies will encounter the player. This becomes a part of the balance of your game, as you need to consider what the player can do at any given time vs. the enemies they are going to fight against. In turn-based games built on random encounters, the designers will create different combinations of enemy groups that can occur in any given area. The reason is that if you don't do this, you could end up in a situation where a four-person team must fight 99 dragons at one time. Encounters can have a different chance of happening to reflect their difficulty. Determining the difficulty of an encounter can be tricky based on the skills and stats of the enemies you have.

Let's imagine four different enemies as an example:
Enemy 1: Forest Ogre

- Health: 300
- Attack: 75
- Defense: 50
- Skills: Bash – Does 150% damage to one unit. Giant Swing – Does 87% damage to the whole party

Enemy 2: Plague Viper

- Health 90
- Attack 45
- Defense 10
- Skills: Poison Bite – Does 70% damage to one unit and causes poison. Death Bile – When defeated – spread poison to all your party members.

Enemy 3: Ruined Necromancer

- Health: 120
- Attack: 15
- Defense: 0
- Skills: Life steal – Does 200% damage and all damage done will turn to healing. Raise Dead – Can bring back defeated units at 50% health.

Enemy 4: Skeleton Guard

- Health 200
- Attack 9
- Defense 60
- Skills: Shield formation – Blocks incoming damage for one character for three turns. Shield bash – Does 100% damage to one unit.

Let's imagine the player's party has an average stat allocation of health at 120, attack at 30, and defense at 20. With those attributes in play, the ogre is by far the most credible threat in terms of raw damage. However, the necromancer has the most annoying ability to bring back defeated enemies. Imagine if an encounter featured the ogre, the guard, and the necromancer at the same time. The guard could prevent players from targeting the ogre, allowing it to do the most damage. If the player manages to defeat the ogre in between shield formations, then the necromancer could just bring it back as if the player did nothing at all to it. For the viper, this enemy could prove to be disastrous based on how strong poison is in the game (a topic I'll be saving for the next section), and the necromancer

could bring it back to life if they were in the same party. Another dangerous party combination would be multiple ogres who could each use their group-hitting skill one after another to wipe out the player's party before they could respond.

How enemy skills can work with each other is vital to consider as the designer. This is why in many cases, certain enemies will never be a part of the same group to avoid situations like this, or they could be saved for an optional challenge if the player wants to test themselves. Regarding the number of enemies per group, this needs to be balanced against what the player's party can look like. If the player can only field three units at a time, having them fight 6 or more enemies may be too much. For games where the player's party size can change based on the story, areas may have their encounters tweaked to reflect the party available. You can also try to create in-game lore reasons for enemy groups to try and base your philosophy around.

Here are a few examples of enemy encounters against a four-person party that could work that I came up with, and feel free to come up with your own.

1. One necromancer
2. One ogre
3. One viper
4. One guard
5. Three vipers, one necromancer
6. One necromancer, four guards
7. One necromancer, two guards, and a viper
8. One ogre, three vipers
9. Two necromancers, two vipers
10. Two ogres, one viper
11. Two guards, a viper, and two skeletons
12. One necromancer, three skeletons

Pay attention to the first four on the list as I did that on purpose. For onboarding, you may want to have an encounter purposely designed to teach the player about the new enemies in an area, even tweak the random encounter to prioritize those before any others.

In the last section, I mentioned how different RPGs may use weaknesses as an addition to their combat design. If you do decide to implement a system where there are explicit bonuses for targeting characters with the right damage type, that will also become a factor when designing encounters. Let's say as an example that a game is going to use a three-element rock-paper-scissors system for damage types:

- Water Beats Fire
- Fire Beats Earth
- Earth Beats Water

When you are creating enemy groups, you will need to factor which elements are going to go together based on their resistances. Let's say that an enemy group consists of both fire and earth-type enemies. In this respect, the player could only bring in water and earth-type to try and counter them, but that would still leave characters who are susceptible to one kind of attack. This is also why for any game that features advanced systems and rules for how the player can engage in combat, they need to be heavily examined when you are balancing and designing enemy encounters.

Boss design balance in turn-based RPGs is a tough topic. As I mentioned further up with *Library of Ruina*, each boss was considered a complete one-off – requiring the player to completely rebuild their teams and strategies for each fight. In most RPGs however, the player is either dealing with a team they created at the start or working with characters whose abilities and skills are defined by the designer. When creating bosses in this case, you must always balance a boss fight on the potential team compositions and builds in your game, and this must work all the way to the game's final boss. There's a huge difference between making a boss that resists attacks, and one that is outright immune. If you design a boss that has its own rules or elements to it, make sure that you are conveying that to the player, as a popular design from many developers is to create a final boss that purposely breaks the normal rules of engagement in the game.

Figure 9.14

Real-time combat requires an entirely different mindset and philosophy when building the gameplay and enemy encounters. Factoring in the player's ability to avoid all damage by dodging (if that is an option in your game) will need to be taken into account when building enemy attacks. In *Elden Ring*, many bosses have attacks that you cannot just take those hits, and you must dodge out of the way or be killed.

Real-time games require a different mentality and approach to designing enemies and encounters that will also be dependent on the player's ability to move, defend, and avoid attacks (Figure 9.14). If you design every enemy to shoot multiple projectiles at varying intervals and patterns, there is no way for the player to be able to engage safely without giving them some way of dodging through them. Many real-time and action RPGs like this will provide the player with some form of defensive skill – such as dodging and gaining invulnerability frames. Invulnerability frames is a concept from action games where the player's character will not take any damage while performing an action with those frames.

The more enemies the player must fight at one time has to be weighted with the kind of combat and design you want for your game. For many fast-paced action RPGs, they are designed around the player always being outnumbered and using skills meant to hit multiple enemies at one time. In *Diablo 3*, players could easily be swarmed 15 or 20 to 1 as a normal encounter. Just as easily as that could work in one game, another action RPG may make fighting four enemies, or even just two, a hard time depending on how combat is designed. A lot of the design around enemy encounters here can also be applied to general action games. A core component of enemy mitigation is if the option is there to interrupt enemies with attacks. In action games, being able to hit an enemy and stop their attack or prevent them from starting allows the player to safely attack them. Games will often program their enemies to automatically launch an attack after a few hits or become immune to being interrupted which is a mechanic referred to as "super armor" to launch the attack.

Once again, there are no hard rules for how you must design enemies in real-time RPGs, and there are a variety of ways to create original enemies and increase the challenge. A popular pastime of ARPG designers is to take normal enemies and make more dangerous variants of them called "elites." An elite version will have higher base stats compared to the normal one and could come with special modifiers like rare weapons that make them harder. The rewards for killing them would be more experience and a greater chance of finding equipment.

A big difference between real-time and turn-based you need be aware of is how moving in real-time impacts the RPG design. In a turn-based RPG, when a character attacks another, the underlining mechanics will dictate if the attack hits. For real-time games, if an enemy swings their weapon at the player's character, and during the animation, the player moves out of the attack range, even if the attack was set to connect and do damage, the character should not take any damage. The reason why I put it like this was because of *Diablo 3*. In the original version of it, the designers "buffered" attacks so that once an attack was launched, regardless of where the player's character was or if they moved away, the attack would still connect. If enemies were faster than the player, there was literally no way to avoid taking damage, and this system was eventually corrected with a later patch.

For ARPGs, positioning and placement is often not as focused on compared to just having groups of enemies in an area ready to pounce on the player. Due to

many ARPGs using procedurally generated environments, this is often the easier way instead of creating encounters by hand. Again, the size of the enemy groups must be in relation to the power level and skills that the player has access to. If every player's skill could hit 10+ enemies easily, then you want encounters to be as big as possible that your game's engine can handle.

Boss encounters in real-time RPGs can be frustrating to deal with. As a boss, they will routinely ignore or resist any kind of skill that stops them from attacking, and this will come up with discussing skill balancing in Section 9.6. If the boss can generate minions or fill the screen with projectiles, it can become punishing to fight them with a melee-focused build. As with turn-based fights, these kinds of bosses can make use of a random pattern for their attacks, with advanced examples we can see by From Software with their boss designs. Every boss in the *Dark Souls* series is made up of multiple attacks and patterns that the game will choose randomly, but also dependent on other factors, such as the enemy's distance from the player, what was the last attack they did, how much health they have left, and others. The concept was to create a dynamic fight with an enemy that the player can't just memorize what they will do each time but have to adapt to the different patterns and attacks. It's also why for modern ARPGs or just real-time action games, characters should come by default with a way to defend or avoid damage besides just moving, or attempting to move, out of the way (Figure 9.15).

Figure 9.15

Defensive moves, and the ability to defend, greatly differs in real-time action games. In the *Nioh* series by Team Ninja, characters can perform dodges, blocks, parrying, and in the second game, a special counterattack, to avoid damage. The effectiveness of each is dependent on how the player customized their character and the type of equipment they're using – as heavier weight makes it harder to evade.

In games where gear acts as a form of progression, you want to avoid designing bosses as just "number checks" – that if the player's character found great gear they automatically win, and if they don't, they can't possibly beat the fight. Modern examples or ARPG design have moved away from just having stats dictate everything and have implemented more reaction-based challenges. There are bosses who have access to at least one attack that is very telegraphed, but also highly damaging, and the player must do what they can to avoid that, or it could easily kill them regardless of their overall stats.

There is an ebb and flow to real-time combat that draws heavily from the action genre that I will come back to when I cover action in a future deep dive. For this book, when designing interesting encounters in real time, you want the player to be able to accurately know when it's "safe" to engage with an enemy or boss. Maybe they can stun or interrupt the enemy out of its attack, or after a powerful move, the enemy is momentarily docile to indicate they should be hit. However, returning to the point about action and abstraction, the more reflex-driven you make an RPG, the more you will alienate fans who prefer turn-based design and planning. There are, however, ways of providing tactical considerations that I will discuss with UI/UX in Section 9.8.

9.5 Advanced RPG Progression

Balancing RPG design is a massive topic, and something that isn't possible for me to talk about in detail about every RPG genre variant that's out there. As I've discussed in this chapter already, every aspect of a RPG's systems is connected to each other, and why balancing must be closely examined. I want to focus specifically on the core philosophies of RPG balance which can be applied to most RPG systems with rare exceptions in the following two sections.

Let's start with leveling and growing in power as it is one of the core tenants of RPG progression. Building from what I talked about in Section 5.3, RPG design is inherently built on the concept of abstracted, or in-game, progression. The act of leveling up greatly differs between RPGs, and this is dependent on how fast you want the player to obtain power.

The primary means of gaining levels is through earning experience. "Experience" can be tied to any action that you want. The most popular and recognized is obviously combat – the player defeats an enemy and gains experience. As I'll discuss further down, you can have games where combat is not the primary driver for experience. What you need to decide for your game is whether there is an endless supply of experience or a fixed cap. For games with random encounters, there is no end to the number of battles, and by extension, amount of experience they could earn. For games that tie experience to completing specific events or actions, there is a hard cap as to the number of those in the game.

Figure 9.16

From Software has had a habit of putting in stronger enemies compared to the others in their environments to act as warnings for players. However, if someone knows what they're doing, they can defeat them earlier in the game to get far more experience than the other enemies.

Starting with combat games and endless experience. As I discussed earlier in the book, games will often have different ways of determining the experience earned, but the more dangerous a fight is compared to the character's level should net them more experience (Figure 9.16). This can be achieved by setting the experience of stronger enemies higher, or scaling the experience earned based on the difference of levels. At some point in any RPG with infinite experience, the leveling will slow down dramatically. The reason is that as the character levels up, the amount of experience needed to reach the next level grows progressively larger. There will come a time when enemies are no longer growing in strength or levels, meaning that the amount of experience earned is not increasing to go with the increased requirements. The exception is if we're talking about a live service game that continues to be supported with new content, and by extension, new enemies at ever increasingly higher levels.

Many RPG designers institute what is known as a "soft cap" when it comes to leveling and progression – that the attributes or stats earned will get so small that it is no longer worth it to level up a character, and this will coincide with the player reaching the final challenges in the game. Another example of having a soft cap is that by reducing the amount of experience earned as a character out levels the enemies around them, means that it will become astronomically longer to level up fighting weaker enemies, and in return, it will push the player to go to harder areas to continue the progression of leveling up. A popular

implementation is to have multiple soft caps as a player levels up in different attributes as a way to "force them" to level up their character evenly. Here's an example:

- Level 30 strength – increases damage by 5%
- Level 31 strength – increases damage by 5%
- Level 32–39 strength – increases damage by 1%
- Level 40 strength – increases damage by 5%

While this can work, there will always be people who will just keep forcing the stat increases if they are going for a specific build.

A hard cap literally means that there is a max level the player can reach or how much they can add to an attribute, and once they achieve it, they will not progress anymore in that respect. This is often used in mobile-styled games or any live service title with end game content, but it is also in single player RPGs as well. Once the player hits the cap, their only way to keep growing in power will come from other systems. Live services games may raise the level cap as time goes on when adding in new content to give the player something new to chase after.

For games where combat is not the focus, or even at all in the game, you're going to need to think about earning experience differently. As I mentioned, experience in these games are tied to fixed events that are placed by you in the world. In these kinds of games, both the amount of experience points and the number of possible levels the player can reach are far smaller compared to other RPGs. To compensate, leveling up may reward the player with multiple points to apply to their character as opposed to just one. For RPGs that aren't combat-focused, they are built on the player, and by extension their character, experiencing the world in their own unique way. For most people who play these games, they are not going to create a character who can literally do everything and, instead, focus on making a character that they like to experience the content in the way they want (Figure 9.17). But just like with everything else with gameplay, there will be people who will try to build the ultimate character. From a balancing point of view, you want to design encounters and games with multiple ways of clearing them, and not explicitly punish someone who wants to build a character in a specific way.

For many JRPGs and CRPGs that focus on combat and fighting, the fighting itself is the gatekeeper for new content – if the story is at the point where the player must fight a boss, then everything else is put on hold until that boss is defeated. This is where random encounters come in to keep pushing the player's characters into fighting and gaining experience to level up. For games that don't focus exclusively on combat, other tasks may reward the player with experience or having their own respective levels. One of the aspects behind Bethesda's takes on RPGs with *The Elder Scrolls* was that the player would gain experience in respective attributes by performing tasks related to it – IE: jumping up and down would increase agility.

Figure 9.17

When repeatable combat is not the focus of your game, it will require a different mindset and approach to progression. In *Betrayal at Club Low*, encounters can be repeated if the player fails, and they will always earn money/experience regardless of the outcome. This means even though the game has a fixed number of ways to get experience, there will always be opportunities to get more if the player gets stuck somewhere.

While this is realistic and simple to understand, it's not without its problems. Part of the challenge of balancing leveling up is how it relates to the enemies and situations at hand. A controversial aspect of *The Elder Scrolls* gameplay is how the games "scale" content. Scaling in this respect is adjusting the stats and enemy types the player sees so that they are always supposed to be fighting enemies of equal or slightly greater ability to them. The problem is that the system in the past judged the player's ability based on their overall character level which is tied to the levels of their abilities.

Let's use a basic version of this to explain the problem, where every level in an attribute equals one character level. Player A has a level 10 character made up of the following attributes:

- Level 6 Sword Mastery
- Level 2 Stamina
- Level 1 Archery
- Level 1 Sneaking

This character is obviously designed to be a sword user and gains increased damage and utility using swords. If the game is scaling enemy encounters for character levels ranging from 8 to 13, this character may have a little trouble, but they should be able to handle the enemies if they are scaled this way.

9. Advanced RPG Design

With that said, here's player B with their level 10 character:

- Level 3 Barter
- Level 2 Trader
- Level 2 Blacksmith
- Level 1 Stamina
- Level 1 Dagger Mastery
- Level 1 Potion Maker

This character has far more skills and can do more in the world itself. However, being considered a level 10 character and forced to fight enemies at the same scale as player A, they would not have the same ability to fight, but nevertheless, they would be up against those stronger enemies. In this respect, trying to make a more diverse character is punished by the rules of the game, and that is something that every RPG designer must not do with their progression systems. To combat this, the scaling was eased back in *Skyrim* and focused more on a larger range of enemy encounters, so that the player could also find enemies who were weaker than them just as they could find stronger opponents.

As the designer, you need to figure out how you want the impact of leveling and progression to affect the character and the situations they fight. When you provide the player with huge increases to their stats when leveling up, that makes leveling incredibly important to making any progress in the game. As I've discussed earlier in the book, some RPGs will require the player to manually add stat and skill points on level up, and other ones will just do it for them. For a lot of idle-based games, this is where the focus on numbers comes in. Some RPGs use leveling as a gating mechanic for new skills and abilities; in this respect, leveling doesn't grant the player more power, but it does mean more utility (Figure 9.18). The act of leveling up is an important aspect of the RPG progression curve – the player should be feeling that every level their characters are getting better in some respect. One way to ruin the progression is to tell the player that leveling only matters every 10 levels instead of every level. The one exception is if the leveling of your game is meant to be fast. Many MMORPGs and mobile games today design their quest and experience structure to rapidly level a player's character or their account as quickly as possible. This allows a player to see new content, access new systems, and catch up to their friend fast. At some point, the leveling will slow down as already mentioned. Many mobile RPGs provide the player with items that reward a lot of experience, or just instantly level up a character, as a reward for completing daily or weekly tasks. For these games, they will often have dozens of characters that all will require leveling to be usable.

If your game is not combat-driven, you should avoid any forms of gatekeeping that stop someone from seeing the story. Because the player can't just go out and get a lot of experience to overcome a challenge, you want to make sure that every

Figure 9.18

In action RPGS, the character's level is not what determines how strong they are, but the skills they have unlocked and the gear that they're using. In *Diablo 3*, the main upgrade leveling gives the player access to more skills and passives that they can build their character around.

encounter or potential roadblock has multiple ways of achieving a solution, and the more ways you come up with, the better. When you are designing encounters, you should always remember that how you specifically will build a character to get through it can be completely different from other people. This is part of the aspect that I touched on with immersive sims in Section 6.5, and how players can figure out solutions and workarounds that the designers may not originally intended.

So far in this section, leveling has been defined as growing in power, but what does that mean within the rules of the game? Different RPGs factor leveling into the overall progression in different ways. A few paragraphs up I spoke about it directly, if one character is level 5, and another one is level 10, the level 10 will all but destroy the level 5 character. Part of the discussion and balancing that was done to make more games use RPG systems back in Chapter 8 was to make this quite literal with the gear rating system. It does not matter if one player is a perfect marksman in a game like *The Division*, if their gear rating level is too low compared to their opponent, the opponent could just walk over to them and defeat them in a few hits.

When leveling is tied to utility instead of direct power, it often leads to more interesting choices for the player. In *Arknights*, the major form of progression for characters is getting them to higher promotions, with the max being "Elite 2." The reason is that at elite 2, six-star characters unlock all their passive talents and their third unique skill, which often, but not always, is their defining ability to use in combat. While leveling them up beyond that to the level cap does increase their

stats, for most content in the game, it's more about the utility and using characters correctly instead of what numbers they bring. These games also will feature a hard cap on leveling that does two things. It prevents the player from just being able to spend resources and brute force a fight with higher stats. From a design standpoint, it gives the design team the exact limit of power that a player can bring into an encounter, and can factor that in with designing content. Another point about *Arknights*, despite the game now being over 3 years old while writing this book, the developers have not raised the level cap at all, and they design content to not specifically require the best characters or fully leveled up ones.

With that said, what about games that combat is not the focus, how does leveling and progression work there? When the game is not focusing on constant fighting, it makes the act of leveling and gaining said levels harder and more important. For non-combat games, there should be very specific methods of gaining experience, and the individual methods are not repeated. If the player gains experience for the event of cracking a safe, they're not going to then earn experience returning to the cracked safe and opening it up again, but there could be other safes out there. With games like *Disco Elysium*, this creates a hard cap as to the number of ways a character can grow over the game's length. Instead of leveling up granting the player more power, it becomes a way of adding more options the player can experience over the game. If the player levels up "burglary" as a skill, and a situation offers them the option to break into a house to collect evidence, that's one path they could take and see how that plays out. However, let's imagine that another route is to convince someone to give you the evidence. For that player, their "negotiation" skill may be too low to do this. Instead of the game just putting up a brick wall and saying "you may not continue," this simply means that specific road is inaccessible, but there should be other methods of playing. This will also frame the next section talking about how you balance skills and options in an RPG game. You do not want to put the player into a position where there is no option for them to keep playing. A possible workaround is to have an activity that is always there that provides very little experience, or if a player fails a task, they still earn some experience from it.

As I've talked about in this section, leveling is the means of a character getting better, and different designers have used different methods of creating it. Some tabletop games only increase attributes like health and mana on leveling up, while maybe rarely letting the player add another point to one of their core attributes. Early ARPGs allowed for full stat choices at leveling up. The format that was popularized by *Diablo 2* was every level would give the player points to apply to their attributes, and one skill point that could be used to either strengthen an existing skill or unlock a new one on their skill tree. The consequence of this system, or any system that lets the player make all the choices, is that it gives them the possibility of making the wrong choice and ruining their character. For many JRPG-styled games, leveling up does increase attributes or unlock new abilities, but the game itself dictates that with no further input by the player.

Another form of leveling used as gatekeeping besides to skills is tying it to equipment use. The use of equipment is another aspect of RPG progression that greatly differs from game to game and design to design. There are RPGs that don't tie experience or leveling to gear, and instead use money or in-game resources as a pseudo form of experience. In a game like this, a player could pick up the game's most powerful weapon within 5 minutes of starting and use it to quickly make progress, or that weapon could cost five million in-game dollars, and it will take time completing quests and earning money before they can use it. When equipment use is directly tied to leveling up, it essentially creates a second progression curve of the player acquiring stronger gear when it becomes unlocked to further boost their abilities (Figure 9.19).

Returning to the use of scaling content, recent ARPGs have used it along with procedural generation to make a smoother progression curve revolving around equipment. When a game is set to generate gear with a loot table, the first thing it looks at is the character's level to determine what level range of gear to pull from. Games will have different loot tables based on level ranges like 1–5, 6–9, 10–15, 16–20, etc., based on the overall progression of the game. A simpler version is to say that items generated will only be at levels 1, 6, 10, 20, and so on. If the game is designed that at level 21, the player will get access to some amazing new power or ability, gear values for that specific level range may be noticeably higher to

Figure 9.19

Tying equipment directly to the player's progression has become more popular over the 2010s. With many action RPGs explicitly locking certain weapons and armor types behind what level the character is at. In *Deep Sky Derelicts* (released in 2018 by Snowhound Games), the gear the characters wear directly affects what cards they can use in combat. Meaning that the better or rarer the gear is, the better the cards and more diverse strategies the player can do.

coincide with the greater power gain. With *Diablo 3*'s end game and the content added with its major expansion, the level cap grew from 60 to 70. For those new nine levels of experience, the game used two additional loot table scales: 61–69, and 70. The jump going from level 60 (the old cap) to level 61 (the start of the expansion content) was massive, and so was the jump from 69 to 70. The reason was that at level 70, that is the final point that a character is going to reach, and then that progression system is closed. Once a character hits 70, the goal then becomes to get access to the newly unlocked "Ancient" sets of gear and legendary gems which becomes the primary progression driver for the rest of the player's time spent with that character.

When you are deciding the scale on which equipment can generate, you want to keep it comparable to the enemies that the player is fighting at that level. Regarding loot tables, each progressively higher table that the player's character will be drawing from will go substantially higher than the previous. However, the previous range should have the possibility of being comparable to the higher. Here's what I mean: let's say loot table B can generate gear with a potential power of 5,000–8,000, loot table A, which is lower, could have a potential scale of 4,000–6,000 (Figure 9.20). The reason is that if the player is not getting lucky with randomized

Figure 9.20

This screenshot from *Wolcen* is a perfect demonstration of when loot tables are not properly scaled. The weapon on the left was generated on a loot table 12 levels higher than the weapon on the right, both are the same rarity, and yet the weapon on the right is still better when it comes to the damage it is doing. At this point in the game, a weapon two or three tables higher than the other should be substantially more powerful. There is a problem in a loot-dependent game if players are still using the same gear hours later and have not found a replacement, unless they are already at the level cap.

drops from table B when it first unlocks, there is still the chance that the A gear can still help the player out with the current content they are facing. This is also where the option of having shops that update their inventory based on the player's level can come in to give the player a short-term boost of buying generic gear that is there simply for the power boost, to help them fight enemies for better gear.

Another aspect of gear and equipment is how do they impact the character itself. If we're talking about a game entirely focused on the character's attributes and stats, the equipment itself acts as a stat booster. Here, a level 50 character using the best gear possible could stand evenly with a higher-level character who is not using any gear. In this respect, gear is simply a means to add more points to the attributes of a character but does not change how that character behaves. *Diablo 3* featured a similar system, where the only point of gear outside of special set pieces was to boost a character's attributes, with one primary attribute determined by the class itself that would directly affect damage.

When skills and unique abilities are put into the equation, equipment can act as an additional condition for using a specific skill – such as all healing spells require a staff, sword skills require a sword, and so on. As I mentioned discussing ARPG design, some modern ARPGs turn the weapons themselves into classes, so that using a shotgun would give the player access to different skills and utility compared to a machine gun, or a sword and so on. How specific or wide the skills are is dependent on the game's design, and something I'll talk about in the next section.

For games that have embraced a gear rating system, which again, means that the power of the gear dictates the actual level or strength of the character, equipment literally is the progression of the game. A game like *God of War 2018* had the gear rating from the very first moment of playing, while *The Division* series uses gear rating as the end game progression after the player reaches the level cap. As I've talked about, while this does provide an easy-to-understand method of power, it also creates artificial progression and difficulty. The problem that all these games have with a gear rating is that they focus on a given average as the determination of the player's rating. In *God of War 2018*, if the player was wearing level 5 gear, and just one level 4 piece of gear, then the game would treat them as a level 4 character, preventing them from fighting enemies that were too high in level. In *The Division*, each tier of gear became fixed, and you couldn't find gear of a higher tier until you reached a specific point in the previous which was collecting the highest rating for each equipment slot. These games would benefit from having a larger range in terms of gear rating, so that the player is not chasing down one piece of equipment needed to move up.

However, there is a case of the power of gear being too wide. In *Diablo 3*, the original version generated gear, even at the max level, within a very wide spectrum. For a hypothetical example, a sword could drop that could do between 10,000 and 40,000 damage. While 40,000 is a huge deal, the chance that a player was going to get that was minuscule. In fact, it was easy to see that the original system was balanced around the developers trying to have a system where players could buy and sell items for real money, with Blizzard getting a cut of it. It

wasn't until their massive balance patch that the range was reduced, so, for that hypothetical, the range became 30,000–40,000 instead.

This section has focused on the power curve and progression of RPG design, and as a designer, it's something that you need to be constantly thinking about when it comes to everything you design for your game. The reason why developers have switched to scaling enemies and gear based on the character's level was to provide an easier frame of reference in terms of the average power and utility a character can have at any given time. If the equipment and attribute scales for the player's characters from levels 10–20 have a minimum of 1,000 damage to 4,000 damage, you can use that when balancing the enemies in terms of how easy or hard you want to make a given encounter. The more ways a player has access to power up their character, inherently means more ways for them to either break your game or ruin their character. Many modern RPGs will provide the player with an easy way to reset their character's attributes and skills, or "respec" to let them rebuild them another way. This is polarizing among fans who like the idea of their character and choices being permanent, but it also represents a gulf between traditional and modern RPG fans.

Like gear, the player's own skills should grow to keep up with the strength of the enemies. This can either be done by introducing stronger versions of skills or designing your skills with scaling; both will be touched on in the next section. You do not want a particular play style or skill type to no longer have functionality in certain areas of your game. Many RPG designers balance their skills around hard counters – as in giving characters immunity to certain types of damage. If the player is free to build their character any way they see fit, it is possible to be put into a situation where they cannot progress due to their choices. Look for ways to provide the player with alternative solutions through areas or give them the option to invest in a variety of abilities.

One final point about leveling for this section is tying it to account or system unlocks. A popular trend in mobile games is to have an account level that directly gains experience as someone completes challenges, daily quests, and more. Hitting certain levels can unlock additional systems, more events, provide more daily resources, and more. This is popular for two reasons. For the player, it provides the dopamine rush of getting a new level and having a reward to go with it. For the designer, it provides an easy to define and design progress gate to lock advanced systems and content from the player until they reach that point. Regardless, outside of possibly refreshing daily energy, most mobile games will have a point where leveling doesn't unlock anything new but could still provide bonus currency and resources as a reward.

9.6 Basic Rules of RPG Balancing

Sections 9.5 and 9.6 are some of the longest ones in this book due to how important they are when it comes to learning and applying RPG design. Balancing skill

design takes us directly into the abstracted nature of RPGs and RPG gameplay. As I've talked about throughout this book, abstracted gameplay means that the player themselves is not the factor in terms of the effectiveness of the skill or ability. There is one exception when we are discussing real-time RPG design that I will talk about further down.

For turn-based games, as the designer, you will not only need to create skills but also balance them within the design and nature of your game. Like creating the different attributes for characters that I discussed in Section 9.2, every skill can be made up of different properties and there is no required list. With that said, here are some examples of popular properties that designers have used and what they would impact:

- Attack/Recovery Strength – how much damage does the skill do, or how much does it recover?
- Type of Damage – What kind of damage does the skill do?
- Cost – How much does it cost to use the skill?
- Cooldown – How long before the skill can be used again?
- Range – How far away can the skill hit and/or the number of targets?
- Chance to Hit – What is the chance that the skill will hit/affect a character?
- Duration – How long do the properties of the skill last?

When designing skills and abilities for your game, you should be asking the following questions: What kind of playstyles do I want in my game? How can a player get past my challenges? The playstyle is built from the types of classes/jobs in your game. For every playstyle you want, there should be corresponding abilities and gear that someone can use. When designing skills for your game, the playstyles should be used as rough guides for how someone should be playing your game. Playstyles should have viability from beginning to end, and their respective skills should be useful throughout the game (Figure 9.21).

For every challenge/enemy/boss, you want as many options as possible as solutions for getting around it. The worst thing to do from a balancing standpoint is to give the player freedom to customize every inch of their character and party, but then introduce fixed encounters all designed around only one way to win. This goes back to the balancing challenge of combat and enemy designs I discussed in Section 9.3.

A basic rule of thumb when balancing a skill is that the strength or potency of a skill should be relative to the cost of using it. If a small healing spell that targets a single character costs 4 MP, a spell that fully heals your entire party shouldn't cost 5 MP, as there would never be a reason for the former to be used. Part of how balancing in RPGs has evolved over time is trying to have fewer skills and abilities but making their impact more pronounced and vital. You can still have skills that act as upgrades if they are part of the same chain

Figure 9.21

JRPG skill design typically goes wide, but not deep, with their skills. Focusing on a few select abilities, and then progressively introducing stronger versions that serve to replace the older ones. In the *Shin Megami Tensei* and *Persona* series, each elemental spell has different naming variations to represent the better versions of it. "Garu" is the standard wind spell, and "magaru" is the area of effect version of it. And the strongest wind spell is called "Panta Rhei" which the best spells are usually reserved to specific personas.

of skills: small fireball -> medium fireball -> large fireball. In this case, each upgrade to fireball does more damage than the previous but comes at a larger cost. However, there may be cases where the player will want to use a weaker version if it means saving MP rather than doing more damage than needed to finish off an enemy.

Just because MP is the common cost for skills, doesn't mean it's the only one that you can use. Some games have skills that cost a character's health instead of MP; others may require the player to use up an item as part of the payment. The rules of balancing are still in place: the more expensive or costly it is to use a skill, the better it should be. Speaking of expensive, a popular mechanic in JRPGs today is to have characters who can cast an ultimate or special ability. This skill is oftentimes far stronger and offers more utility than anything else in the game. To compensate, characters can only use it after a special meter fills up; oftentimes by attacking or performing actions.

One major shift that has happened to RPG design from the 80s to 2000s and then from the 2010s to today is with the concept of scaling skills. Traditionally, any kind of skill in an RPG had a fixed impact – 500 points of damage, 300 points of healing, etc. The problem with fixed numbers is that it gives every skill an expiration date for when they are no longer viable. Healing for 300 points of

damage sounds like a lot when enemies do 30 points per hit, but when you're fighting enemies who can hit for 10,000 damage, 300 is not going to cut it. This is where the idea of having upgraded versions of the skills mentioned above did come in, but it still left a lot of skills just taking up space. What modern developers do now is that they have a smaller pool of skills, but all their actual impacts scale with the player. Instead of a fireball that does 100 points of damage, that fireball could be set to do 75% of the character's attack attribute, or some other stat associated with it. This way, a skill's potential grows with the character, which means there will never be a period where the effectiveness of a skill will no longer be useful for the current situation. This change has helped healing skills and items a lot, so that healing is now percentage-based from a character's max health. For example: if a character has a max health of 10,000, and a healing spell will recover 45% of their health, they will get 4,500 of their health back.

The benefits of a scaling system are worth studying for any RPG designer. It allows you to come up with more varieties of skills, as you won't need to set a fixed value for their impact. It provides an uncomplicated way to upgrade them, as I'll talk about upgrading skills further down. For overall progression, this makes attribute and gear-based progression more important and easier to parse for the player. The better the gear leads to higher attributes which then means

Figure 9.22

Many CRPG and tabletop inspired games today focus on a smaller number of skills and abilities but make each one stand out, so that there is a huge decision between picking skill A or skill B for a character. In the *XCOM* games from Firaxis, what skills you choose from each skill tree radically affects what that person can do.

9. Advanced RPG Design

that their skills are now better. Fixed numbers can still work if the game is focusing on small number philosophy, and the values for characters and skills are kept consistent (Figure 9.22).

As I've mentioned when it comes to rock-paper-scissors-styled balancing, different attacks and skills can be assigned a property or damage type depending on the game. Returning to the Press Turn system from *Shin Megami Tensei*, this was the backbone of that system. How far you want to go with it is entirely up to you and the complexity you want to build your system around. Just remember, part of balancing when it comes to RPG-based systems is that for everything that the player can do and respond to, so should the enemies. You do not want to design a system that punishes the player based on damage type, but then leave that off for boss fights and elite encounters. What the *SMT* developers will often do is either make a boss with one weakness, or depending on the difficulty of the fight, the boss has no weak element, but will take full damage from specific damage types. Even then, some of the games have items and skills that can raise or lower a character's damage resistance as an alternative.

The cooldown of an ability is an interesting one and is not featured in every kind of RPG. A cooldown simply means that there is a period of time before a player can use a skill again during combat. Most games that feature cooldowns will reserve them for stronger skills/ultimate abilities, where it would be a balancing problem if the player could just use them every turn with no penalty. Having it tied to every skill means that the player must use a character's full set of abilities during a fight. As with the cost, the longer the cooldown associated with a skill, the stronger that skill should be. Tying a cooldown to skill use is a common practice in real-time RPGs to provide some measure of control when the player is moving, attacking, and defending all at the same time. In this situation, the player is always given at least one skill that has no cooldown, often referred to as the primary attack, so that there is never a period where the player literally cannot attack an enemy.

The reverse of a cooldown would be a "buildup" or "charge" stat for a skill. In this case, after the player chooses to use a skill, the character will spend a certain number of turns before they will use it. For enemies who have their own charge, this is viewed as a way for the player to know that they should defend or try and beat the enemy before they cast a strong attack. For a charge skill to be considered worth it to use, it should be far stronger compared to similar skills, as losing out on a turn or multiple turns is a huge loss to the player's strategy. For RPGs that use a timeline system, timing the activation of skills becomes an important element of play. Being able to use a skill that stops an enemy from using theirs or synergize with another character's skill can oftentimes be vital to winning. Real-time games can also make use of charging attacks – where the strength, range, and impact can differ based on how long the player charges the attack to a fixed extent.

The range of a skill is heavily dependent on the design and structure of your game. For simpler games, the range could either be set at an entire party or just a single character. As RPG design evolved with positioning, and battles

Figure 9.23

For this example from *Darkest Dungeon 2*, I want to focus on the skill at the bottom and the UI that show the player from what position the character must be in to use it, and what positions it can target on the right. The decision to have positional skills, movement in combat, and so on are major factors to both the combat system of your design and how you will balance your game going forward. Adding them in during the middle of development or in beta will require a complete rebalancing of your design.

taking place in an entire field, the concept of range has also changed. In *Darkest Dungeon*, battles took place on a 2D view with the player's characters on the left and the enemies on the right. Every skill in the game has a different range, and a required position to be used (Figure 9.23). This played into the personality and style of the different characters – with heavy frontline characters having skills that can only be used in position 1 and position 2 for example. For games that take place on an entire field, the range of a skill turns into various attack patterns based on different number and positioning of tiles. For games where there are no tiles, the range becomes a 3D representation on the map.

Part of the balancing of a skill when it comes to range is the number of characters that it can hit. If a skill does 200 points of damage to one enemy vs. another on that does 120 to multiple, the latter can be huge in games where you have a lot of characters fighting at the same time. A golden rule of playing any RPG or tactical game is that an enemy that has 1 point of health is just as dangerous as one with 1,000. Unless health has a proportional effect on dealing damage, the player always wants to eliminate as many enemies as they can as fast as they can. Spending three turns to attack and defeat one enemy, or spend four turns to kill 8 enemies, which strategy sounds better? However, if this is a game where every character has huge health pools, and there are only

a few characters fighting at once, then using a stronger attack to take one turn away from the opposing force would be better.

In real-time games, the range of a skill is always based around the position of the character that the player is controlling. Different attacks can have very different attack ranges that must also take into account the design of the game. Many ARPGs tend to favor range attacks, as they are safer to use, keep the player out of direct content with the enemy, and allow them to target troublesome enemies first. Therefore, melee, or close-ranged combat, is oftentimes balance around having more defensive skills and close-ranged skills doing more damage to compensate for fighting in the enemy's attack range.

So far in this section I've focused on combat and doing damage as the definition of the skill, but there are other categories including utility skills and defensive skills that must be factored when balancing (Figure 9.24). The same basic principle applies – the more effective the skill, the higher the cost of using it. However, the rate that damage-dealing skills grow and become more expensive is different compared to utility and defensive skills. With utility, the skill is offering something that by itself may not do a lot, but combined with other skills could very well break the balance of your game. A good example are skills that change the properties or characters – attack buffs, defense buffs, speed up turns, increase evasion, and so on. When you have skills that change the basic elements

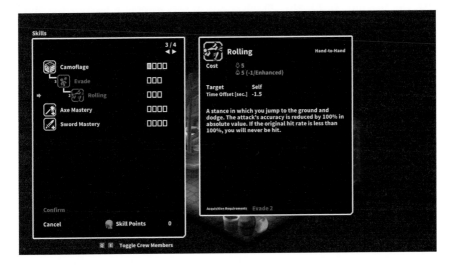

Figure 9.24

Defensive abilities greatly vary in terms of utility and balance in games. In *Potato Flowers in Full Bloom* (released in 2022 by Pom Pom Games), defensive skills can allow a character to become literally unhittable depending on the attack. In other games, this could be game breaking, but with the player's resources limited, these skills must be used at the right time during combat.

of a character like that, you need to be careful about how potent they are and how required they are to win. Returning to the *SMT* franchise, in a few of the games, being able to apply attack down and accuracy down debuffs to bosses ranged from severely reducing their difficulty to being absolutely required to stand a chance in some of the harder fights. For skills that are meant to cover a specific threat or aliment – cure poison, cure petrify, etc., you can't increase their potency because the skill itself only applies when a character is being affected by it. In this regard, better versions of utility skills can affect more characters to a certain point, and I will discuss upgrades further down. A popular addition to utility skills that cure aliments that some designers have used is that the skill not only can remove the condition, but grants the character resistance to it for a specific period of time. Stopping the condition before it becomes a problem can be another way of balancing the game, especially if there are skills that can instantly kill a character.

Speaking of instant kill skills, this is another polarizing concept for RPGs. Instant kill skills are those that are designed to do 100% of a character's health as damage, obviously, a one-hit kill. There are variations of this concept including an RPG staple known as "petrify," where a character turns to stone and is technically considered dead until they are cured. While many RPGs from the 2000s and earlier had these skills, they are not considered as popular for newer designed games. From a balancing point of view, how does someone make a skill that can instantly defeat any opponent fair to use, without rendering the other skills useless? The *Shin Megami Tensei* games did this both good and bad in my opinion. There are different instant kill skills that can be used to specific enemies. If an enemy is weak to that kind of attack, the instant kill is a guaranteed hit; otherwise, it is based on probability. However, it was possible for the enemy to use it on the player's character, and in the games where if the player character dies the entire game is over, this led to a lot of deaths that players could not do anything about. Having ways to mitigate it on the player character's parts is one option if you want to give it to the enemies and not the player. Unless the point of a boss fight is to use a specific instant kill skill or item, designers will make bosses always immune to them.

Defensive skills serve one goal – to mitigate the incoming damage a character is about to receive. This can be done by either raising the defense of a character so that the skill hits less or allowing a character to dodge a skill and therefore reducing the damage to 0. In real-time RPGs today, many of them will either have unlockable evasive skills or give a character a starting one – such as the From Software staple of a dodge roll in their soulslikes. In turn-based games that have evasive skills, the evasion can either be absolute – use this skill and you automatically dodge the next attack, or stat-based – use this skill to raise your dodge chance by 25%. Due to the number of enemies that can attack during a real-time game, being able to dodge enemy projectiles and stronger attacks is almost required in these games. In turn-based games, evasive skills can be very powerful but can also be fickle if they are percentage or attribute-based. Being

able to reduce a powerful attack down to 0 damage at the cost of not having another action that turn is a big gamble but can be very effective based on how that skill is designed.

For real-time RPGs that have evasive skills, they use a mechanic popularized by action games known as invincibility frames or I-Frames. During the animation of the skill, there will be specific frames where the character becomes immune to damage. In all the soulslikes, when the character is in the middle of their roll, and the character is kind of off the ground, that is the I-frame portion of the dodge. For high skill-based games, this could be a tenth of a second, while other games may go longer to make it easier. With proper timing, it is possible for a player to dodge almost any attack unless it lasts longer than the I-frame of the skill.

The chance to hit applies to games where the individual skill itself has the chance as opposed to the character or weapon, they are using. This is mainly accounted for in tactical games and serves as another balancing point for the designer. A skill can be balanced around doing high damage, but has a low chance of hitting, or a skill that is guaranteed to hit, but does less damage than a normal attack. A popular ploy that some designers use is to give a character a ludicrous skill – this attack does 10,000% damage but only has 1% of hitting. It can be possible to boost that probability, or it may just be left in as a real last-ditch option.

A major point when it comes to balancing utility skills that you need to figure out while designing your game is whether or not a skill can be used on any enemy. Many JRPGs in the past had skills that could severely weaken an enemy or outright kill them instantly but made boss encounters completely immune to them. As I talked about further up, part of the refining of RPG balance is that every skill should have utility throughout the game, even against bosses. If a skill can't be used during a boss fight, then it's not going to factor in as much compared to one that does. As I discussed in the last section on enemy design, there are ways of reducing the effectiveness of a skill without removing it completely as an option. Such as giving an enemy increased resistance to a skill or giving the enemy the power to cure themselves.

The duration of a skill primarily factors into utility-based skills, as the duration of an attack skill is the actual attack itself. Duration matters when looking at turn-based games, because every turn where a character is not doing damage, is another turn where the enemy gets to do theirs. From a point on utility, you typically don't want a skill to only last one turn, as that means to keep that skill going, one character is effectively removed from fighting. Likewise a good skill shouldn't have infinite duration, as that could be overpowered. A good metric is to look at the average length of a fight turn-wise and use that as a point of measuring. As a start, 3–4 turns are often a good minimum.

For real-time games, duration is literally tied to seconds or minutes depending on the skill. Many action RPGs have used passive buffs that have infinite time but take a portion of the character's MP as an example. Longer skills are often balanced with having longer cooldowns to emphasize that there is a proper timing to using them.

Skill trees are a huge aspect of balancing skills and directing the overall progression of a character. A skill tree represents different paths or options that a player can go through in terms of upgrading a character/party. Each path represents a potential playstyle with sometimes offshoots that can affect a skill. In games with unique characters, they may be built around their own specific skill trees, such as the playable characters in the *Borderlands* series (Figure 9.25). In Chapter 8, where I discussed how every game became an RPG, the use of skill trees as a form of progression is one such example. Many action and open world games use skill tree progression to try and give an element of customization. However, for a skill tree to work as a form of RPG development, there must be different viable paths that confer unique abilities. If the "tree" is just a linear line that is unlocking abilities or content, that is not a skill tree, and it does not count as a form of RPG design. Skill trees are typically set up so that it's not possible in one play through to completely unlock and upgrade every node on it, and it is often better for character customization to specialize on a strategy rather than try to invest in everything. With that said, it should always be possible in a single playthrough to get to the end of at least one tree depending on the size of the game. The most extreme example of a skill tree would be *Path of Exile* that features one of the largest put into a game.

Figure 9.25

Good skill trees provide the player with different builds and playstyles that they must decide which ones to focus on, such as in *Borderlands 2*. The problem that a lot of developers have is when the skill tree is simply there to make the character functional, and that the whole point of the tree is to limit the order in which the player will eventually get everything, such as in games like *Dying Light* (released in 2015 by Techland) and other open world-styled games.

The next point is on the concept of upgrading skills. While not every RPG-based game has this, being able to take a skill and make it better is another form of progression which is dependent on the game. Many mobile RPGs will allow the player to do daily events and challenges to unlock the materials needed to upgrade each character's skills. In single-player games, the earnable skill points that a player gets by leveling up could be applied to an already unlocked skill to upgrade it. There are two ways of upgrading a skill that developers can use – improving the base capabilities of it or changing the utility of said skill. For the former, this is about changing the innate stats of a skill and making it better as a result – raising the impact of it, lowering the cooldown, or reducing the cost. Changing the utility is about adding on to what the skill does to make it fundamentally better – improving the range, adding more debuffs or buffs to it, making it heal more aliments, and other examples. To keep things in check, these modifiers occur less frequently or there may be a limit to the number of skill modifiers a skill can have on at one point. How far you want to extend the ability to upgrade skills is entirely on you. With the concept of scaling skills, upgrades in this respect mean that the skill will draw more power from the character's stats. For example: a level one lightning shock could have a damage value of 125% of the character's magic power; a level two lightning shock could raise that up to 135%.

The more ways you can implement customization via your skills will give your game more depth, but at the same time, greatly impact the difficulty of trying to balance it. You want to avoid having any one skill that is always required, just as not having any skills no one wants to take. It is also possible to design skills that have similar effects for different classes or playstyles to offer utility. Here are three examples of offering healing that each fit different ways of playing.

1. Holy Light
 - Type: Magic
 - Cost: 20 MP
 - Range: 1
 - Effect: Heals selected party member for 30% of their max health
2. Cheerleading
 - Type: Buff
 - Cost: 10 MP
 - Range: Entire Party
 - Duration: 4 Turns
 - Effect: While this buff is in effect, party members heal 15% of their max health every time they receive a buff
3. Life Drain
 - Type: Attack
 - Cost: 17 MP
 - Range: One enemy
 - Damage: 110% of character's attack attribute
 - Effect: Every time attack hits, recover 8% of damage done as health

With these three examples, we have different ways of providing healing that can fit a different strategy or class. The less reliant a player is on having one specific class or one specific skill will make your game more interesting to play. When balancing a class that is considered the main role in doing something vs. one that is more of a jack of all trades, the main role class will usually get the best or most powerful versions of those skills. If we're talking about healers as an example, a "medic" or whoever would be the primary healer will get access to the best healing spells in the game. This is to offset the advantage of a class made up of two different skill types in that they bring more utility to their role.

When deciding the order in which characters can get new skills, you want them to at least bring some kind of value to the party or be useful at the very start. There is a tendency from some RPG designers to make characters inherently weaker at the start to then boost them to game breaking levels through skills if the player can keep them alive long enough – such as with the earlier *Fire Emblem* games. This is debatably not a good form of balance, and it has led to many a player not properly leveling up the right characters and suffering for it when they reach the later chapters of the game.

I mentioned equipment balance in Section 9.5, but another basic aspect of balancing is how items are designed in your game. The impact and utility greatly vary between real-time and turn-based designs. You will need to decide the following for your items:

- Are they consumable or can be reused?
- What is their impact?
- Is there a downside to using them?

The difference between reusable and consumable items will have a huge impact on the balance and general playability of your title. Having reusable items means that the player is less inclined to hoard them and are free to use them whenever they want. There could be other balancing considerations to them, such as the number of times they can be used before needing to be charged, or having a cooldown before the player can use them again. Consumable items are usually more potent in their utility with the obvious downside of them being consumed when used.

The role of items in any RPG is to provide utility that either is not accessible any other way, or to be used as a substitute for not having a specific skill. If the player is poisoned, they could use a curing spell or an "antidote" item for the same effect. Depending on the game, there may be items that provide a negative to using them that the player must weigh when deciding on taking it. Just like with skill design in today's market, many items in games today now have an impact based on percentage as opposed to a set number to retain their utility throughout the entire game.

In turn-based games, item utility needs to be important to the situation at hand, because the player is giving up any other action that turns to use it. For these games, an item may offer multiple forms of utility or have an impact that extends out to multiple turns. This will have to be looked at when designing your combat system. In the *Darkest Dungeon 2*, items were redesigned to go with the new combat system and offered a variety of utilities based on the item used. Each turn, a character could use one item a piece without using up their action, with the limitation that every item had a fixed number of uses before being consumed.

The most common rule when it comes to item balancing and design is that the more important an item is to the basic play of your game, the cheaper and easier to acquire it should be. If your game has a mechanic where the player needs lighting to survive when exploring the world at night, then torches should be easily acquired. When games make basic items too expensive or too hard to find, it can lead to the player ending up in an unwinnable position if they are not able to restock the common items they need to just survive in the world.

One of the subtle improvements *Dark Souls* made to RPG design was taking the act of consuming healing items and making it a permanent resource in the form of the estus flask. As long as the player recharged it at bonfires, they would always have access to a readily available source of healing who could be upgraded over the course of playing. While the player did have to manage the individual uses, they were never punished in the long-term for healing too much.

That last line is the final point for item usage and balancing in your game. The ideal use of items is to provide the player with short-term utility as opposed to long-term punishment for running out (Figure 9.26). Many RPGs in the past would have items that the player was always in fear of using because they were so limited, and why it led to the hoarding syndrome in these games. The goal of items is to be able to use them, not hold on to them for an encounter or situation that may never happen. If you make your items easy to acquire or restock, it will free the player up to use them more. The worst possible situation when it comes to item balancing and design is if the player feels like they are being punished for using items. Unless your game is meant to be replayed multiple times, you don't want the player to reach a point where they are unable to recoup their items and is forced to restart, as most people will just give up on the game instead.

Depending on your design, equipment can factor into the balancing and use of skills in different ways. The simplest is that certain skills can only be used with specific weapon or equipment types. If you have a skill called "sword spin," then someone who is using guns can't equip that skill. Returning to the concept of percentage-based skills, the power of the equipment can directly translate into the power of a skill if said skill's ability pulls from a specific value on the character's equipment.

While not the same as skills, passive modifiers that can be attached to gear will also need to be balanced within your game. Again, there is no limit or fixed list of possible modifiers you can include. The main consideration when it comes to modifiers is if there is a hard limit on how much of it can be put on a single

Figure 9.26

The fundamental change that From Software implemented in *Dark Souls* and then to all their soulslikes by making healing always replenishable completely changed the design and balancing of games going forward. The player never has to worry long-term about running out of healing items, and progression then became tied to finding upgrades to the ability to heal which we can see in *Elden Ring* here.

character. Let's imagine that you have a modifier that can appear on equipment called "damage reduction" which negates a percentage of the damage from each attack. Could it be possible for someone to get enough of this via different gear to take it to 100% – thereby making that character literally immune to all damage. Many titles will balance powerful modifiers by either having a fixed limit or setting individual values so low that even collecting it on every possible piece of equipment still won't be game breaking. And speaking of game breaking, that takes us to the next section and what you need to consider with all the balancing and skill design you are doing in your game.

9.7 To Break or Not Break Your Design

Instead of making the previous sections even longer than they are now, I wanted to separate one final aspect of balancing your game's design – is it okay to allow people to break your game? "Breaking" in this respect is by using the skills and abilities in a game to remove all challenge and difficulty from it. A classic example of this was from *The Elder Scrolls Oblivion*. One of the things players could do in the game was attach modifiers to equipment to give them new functionality. If a player could attach enough "invisibility" modifiers to their gear, they could become 100% invisible to every enemy in the entire game.

Throughout this chapter I've talked about the beauty and nightmare that comes with allowing players to customize their experience. Just as someone could ruin a game, they could also stumble upon (or look it up online) the perfect way to build a character or use skills that nothing you designed in your game can compete with. For a good lesson in this, you can watch any speedrunner who plays RPGs to see just how many ways a popular RPG could be torn apart by someone who knows how it all works.

In my Deep Dives on F2P design and collectible card games, I mentioned "meta play" or "meta game" design, which at the simplest level are the popular and least popular trends in a game, and how it's a constant struggle by live service designers to keep their game from having a best way to play. For single-player games however, it's a different discussion. There are no rankings, prize money, or competition to consider if there is an intentional or unintentionally broken strategy. Some series fully embrace this, such as the *Disgaea* games, where it is possible with knowledge and time to build completely overpowered characters and gear far beyond anything that the game would be able to challenge (Figure 9.27).

However, part of your job as the designer is to make your game as accommodating as possible for the market. While there will always be people committed to breaking your game and seeing everything, statistically speaking, they are always the smallest percentage of your fan base. The proof of this are the achievement

Figure 9.27

The *Disgaea* series is famous at this point for the number of ways it allows someone to break it. We could argue that it does trivialize the main gameplay loop, but this is the MO of the series, and it's better to have it in as a bonus, rather than balance your game under the assumption/requirement that the player is going to break it to win.

rates we can track using sites that aggregate that data. With steam specifically, there is always drop-off or player churn that happens in games; no matter how popular they are. For the most extreme achievements, clear rates for them can sometimes be less than a tenth of a percent of people who played the game.

What makes RPGs particularly unique in this respect is that the difficulty curve for them is not as focused on the player as I've talked about when it comes to abstracted design. Getting stuck at a boss in a turn-based game cannot be overcome by the player hitting buttons faster or reading patterns but will come down to the abstraction at play. This is also why traditional RPGs today tend to have a lot of player churn among newer players and people who didn't grow up with them, as they don't provide alternatives for getting past an encounter besides just grinding more stats and levels. However, if your game does have systems in place that allow someone to keep powering up and circumvent the difficulty, people will do that to gain any advantage possible, even to the point that they're not enjoying the game anymore.

Your goal should be to make a game as balanced as possible. The two most common areas where someone would stop playing an RPG are getting stuck in a situation with no way to continue other than to grind, or due to UI/UX problems that make the experience not enjoyable that I will talk about in the next section.

If there is something that is game-breaking, but it is very hard to pull off, most designers will leave that in as a kind of Easter egg to be found. The worst thing you can do in terms of balance is purposely design your game to require those options to have any chance at winning. A popular design that many JRPG designers have done over the years is to have a final hidden boss that just breaks the rules in terms of its abilities and attributes. They're designed as kind of a final test, but it is not possible to beat them without exploiting every trick in the book to have a chance. In one of the *SMT* games, the hidden boss in it could do 10,000 damage with a single attack, which doesn't sound bad, except that character health maxes out at 9,999. Some players like these kinds of challenges as a way of rewarding the expert players who master the game. This is also where difficulty design can come in to provide different experiences for people who want it, and that I will return to in the next section.

Just remember that the harder the main game is, the more people who will leave if it gets too difficult. And again, the market you're aiming for in terms of difficulty is a factor as well. The *Fear & Hunger* games I mentioned earlier have attracted fans of incredibly difficult RPG experiences, and the developer is fully aware of the fact that the series is not going to become a mainstream success (Figure 9.28). This is also why it is important to work on the UI/UX of your game, as there is a difference between a game that is hard due to a challenge vs. one that is simply hard to learn.

Sometimes, players can discover game-breaking strategies that you as the designer did not intend to have in them. When this occurs, you'll need to decide

Figure 9.28

The *Fear & Hunger* series as I talked about earlier in the book is unique among RPGs for both its difficulty and the mature subject matter. There are game-breaking strategies in it that experts make use of, but it is a game where a new player is going to fail a lot trying to learn the game before they can actually make an attempt at winning.

whether to leave it in or do something about its effectiveness. This is far harder than it sounds – taking away something that people like or relied on to play your game can be viewed as an act of betrayal. As I said further up, not everyone is going to like to play your game the hardest way, and having options that everyone can use, and enjoy using, is important. When a situation like this occurs, look at why someone is using a particular strategy versus the intended one(s), is there a way to make the other strategy more appealing? It is considered good design to avoid reducing the effectiveness of an option, and instead buff the other ones. However, if something is so good that it completely breaks your game's content, and it's easy to perform, then you may have to do something about this. And what we're talking about here is specifically for single-player games; multiplayer and competitive games have very different rules when it comes to balancing and game-breaking options that are off-topic here.

Part of the distinction between Indie and AAA RPGs has been a greater focus on unique or puzzle-like mechanics and systems on the Indie side. In these games, half the challenge of them is figuring out what are the rules and best practices for playing, and the other half is the actual play. These kinds of games are typically the ones where they're hard until they're not. Once the player "solves" what the game is asking of them, then the experience becomes far easier. It's these RPGs that tend to have the most game-breaking strategies

for the player to find, but often are far harder for new players when starting out. This is a great segway into the next section, as understanding what it's like to play your game as a new player is an important step to examining the UI/UX of your title.

9.8 UI (and UX) by the Numbers

User interface or UI design is one of the most important aspects to learn about a game's design for new and prospective designers and is something that the Deep Dive series will be covering in each book starting now.

For RPGs, because of their abstracted nature, UI design is very important as it's the only way for someone to understand what all those numbers and symbols are going to mean. Since this is the first entry in the series that I'm talking about UI, it's important to have a quick primer on what this is and some of the more important universal concepts.

The user interface refers to how someone is going to interact with your game and is made up of the controller or keyboard and mouse setup, and the on-screen elements that are referred to as the graphical user interface or **GUI**.

The UI itself in this respect is a bit easier to talk about compared to reflex-driven games thanks to the slower nature of turn-based games. You want the

Figure 9.29

For the actual turn-based RPG gameplay, you will always need at minimum three separate screens/GUIs. One for world exploration, that typically has the least displayed information for aesthetic reasons. An inventory/menu system to provide details on everything, and the actual combat GUI that the player will use when it is time to fight. And how you design and display all three will greatly differ based on the kind of RPG you are making.

player to be able to hit all essential buttons or keys without needing to shift their hands around. For real-time RPG design, which requires some specific considerations, I'll discuss further down.

Every game has a "main screen" GUI that represents the screen or play mode they're going to be seeing for most of the experience (Figure 9.29). For turn-based RPGs, due to their nature of separating combat and exploration, there will always be an additional screen setup specifically for combat. Due to the amount of information needed in these games, a big aspect of improving RPG design over the past 20 years or so has been with the UX or "user experience." In older RPGs, information like enemy weaknesses, figuring out the amount of damage that the player is giving or receiving, and even just simple turn orders were often left to the player to figure out. With modern RPG design, even those that try to emulate retro games, being able to show the player this kind of information has been a major step toward improving the approachability of RPGs.

To facilitate this, developers will make use of dynamic GUI elements that update based on the relevant situation. For instance: having an indicator if the player is attacking an enemy with a type of attack that is strong or weak against the enemy. Allowing the game to accurately calculate in real-time what is going to happen during a turn is a powerful tool for giving the player the exact information they need (Figure 9.30). Some may argue that this is a way of the game

Figure 9:30

Dynamic GUIs become necessary for advanced RPGs with their own unique ruleset. In *Star Renegades* (released in 2020 by Massive Damage Inc.), a huge aspect is manipulating the timeline that you can see on the top of the screen to delay and stop enemy attacks. Such as this one that is set to do massive damage to my team on the left.

playing itself, however, what these GUI elements are providing is information for the player to then decide what to do during the turn. Even still, when I talk about accessibility further down, having the game auto-play may not be a bad thing for some people. From a UX standpoint, you do not want the player to have to spend each turn doing math calculations when the game can just provide that information for them.

When you are designing different GUIs and screen layouts, at minimum, you are going to need to come up with and implement the following screens for your game:

- Title Screen: Allows the player to start a new game, continue an existing file, and adjust options
- Options Screen: Allows the player to reconfigure features like volume, screen resolution, adjust accessibility options, and more
- Main Game Screen: The main view of the game where the player will interact with the world and characters in it
- Battle Screen: For turn-based games. The screen the player will view and issue commands when fighting enemies
- Inventory/Equip Screen: Depending on the design, it is possible to combine these two or keep them separate. The inventory screen is for viewing all items and equipment collected in the game and using recovery items. The equip screen is where the player can put equipment on their respective characters and see the respective changes
- Subsystem Screens: For games that feature additional layers of customization or minigames, like skill trees and collecting quests, these screens show those relevant pieces of information

For some designers reading this, you may scoff at me including elements like an options and title screen in this list, but there are developers out there who still don't include basic functionality like this in their games.

The main screen can have as much or as little relevant information on it depending on the design. Some games keep this as minimalistic as possible – showing no information whatsoever and just focusing on characters in the world. Others may opt-in to show basic information like the statuses of the player's characters. Depending on the complexity of the game, you may want to show things like a quest log or quest pointer so that the player knows where to go, a mini-map of the general surroundings, and even a compass. The more details you have on the main screen, the more cluttered it can become. As a tip, try to keep only the most relevant information on the main screen. In recent years, more AAA developers have made their main screen GUIs configurable – allowing someone to turn on or off various elements of the GUI as they so please.

For RPGs on the PC where there are far more keys to keep track of, the main screen will often have on-screen buttons for different menus along with their corresponding key press shortcut. Shortcuts, or "hotkeys," are an essential aspect of good and streamlined UI design. A hotkey is a button, key press, or multiple key presses

at once, that will perform an on-screen command, such as accessing the map, using a healing item, ending a turn, and so on. This is an aspect of UI design whereas the designer, you can go as much or as little as you choose. Most players will not use every hotkey, but maybe will focus on a few essential ones like using a potion. From a UX standpoint, it's better to have them in your game and not need them, than to need them and not have them available. If there is a command that someone will perform quite frequently, like unequipping a lot of items, there should always be a hotkey for it. You can use playtesting as a way of seeing what elements of your game should have hotkeys associated with them – if play testers are constantly having to do something or showing frustration at a specific set of actions.

Setting up the main screen can be done in different ways. Some developers will use a "framing" style, where UI information elements are set in frames across the screen, while the actual gameplay screen is just a facet of the overall main screen. Another option is to have UI elements "floating" or layered on top of the gameplay screen in different areas of the screen. This is a decision that is going to be dependent on the kind of RPG you are making and the skill of your UI designer and artists. As a special consideration for novice designers reading this, part of the aesthetics of your UI is making sure to use fonts and textbox designs that fit within your game. Just using the stock templates that come with your game engine of choice can hurt the look of it when consumers are checking store pages.

For combat, the combat screen UI is divided into two parts – the commands that the player can perform, and the on-screen elements that provide the player with information. In Section 9.3, I detailed a basic list of the commands that a character can perform during their turn. On your UI, there should be a way to issue any commands that a character can do. In terms of information, the UI should provide the player with everything and anything that is relevant to the combat situation – health of characters and whose turn it is at the bare minimum. If your game has any unique aspects of mechanics to its combat – such as a timeline or press turn system, then there must be relevant information to those aspects on the screen (Figure 9.31). The idea is that outside of probability (whether that's in your game or not), the player should have all the information they need to calculate the outcome of their actions once they are done issuing orders. And if your game does have probability as a factor to combat, then it should be outlined what exactly is the chance for a skill to hit and if there are any additional modifiers that are affecting those results. When playtesting your game, if testers are commenting that they don't understand why a certain action happened, or something didn't happen, that is something you should look at with your UI. For people to learn how to play a game, they need to be given enough information to follow what is happening on-screen. Without proper information, the player is just hitting buttons and not understanding anything else.

This is also where the use of dynamic GUI elements is most used by designers. Dynamic elements referred to tooltips or information that updates in real-time based on what commands the player is currently choosing. As an example, if the player is choosing what attack or spell from the menu, the on-screen GUI

Figure 9.31

Here is the combat screen from *Chained Echoes*, you can see how the GUI elements are framed around the four corners of the screen, and that information is necessary for reading what is happening during combat. This could be considered a little much as well, as there is a lot of text on the screen, but again, how much or how little information you are going to show depends on the combat systems in your game.

for the enemy can update to show how much damage the respective skill will do, does the enemy take more or less damage from it, or even going as far as breaking down the exact elements that are being factored for the result. Dynamic GUI design becomes more essential in games that feature different rules or elements to how combat works. Returning to the games that make use of a timeline system, the timeline itself should update dynamically as the player is deciding what commands to use – allowing someone to know before they confirm their orders how will the timeline change. The best way to consider what GUI elements should update dynamically is to look at what information is the most relevant when making decisions during a turn. As I said further up, the player should not be doing advanced math calculations or have to view information outside your game in order to be able to play it.

For games that feature overly elaborate animations and/or a lot of characters fighting per turn, an essential quality of life feature is to have an "increase animation speed" option or allow the player to skip them. While it may not sound time consuming the first time someone watches it, on the 2,000th time viewing the same set of animations it can start to feel boring.

For the inventory and equip screen, these two elements are very important to get right from a GUI perspective, as the player will be using them frequently. Some games will combine the two into one screen to view and manage items and

equip gear, while others will separate them. For the inventory side, you want the player to be able to quickly manage what items they have, sort and find specific categories, set up hotkey use (if that option is in your game), and use said items on your team. For equipment, the player needs to be able to quickly find and sort equipment by type/party member and overall power, be able to view the differences between gear that's equipped with what's in the inventory, and be able to do this for every party member available. The player needs to be able to quickly identify what is the best possible gear for their character(s), and why many modern RPGs simply have an "auto equip" feature. The auto equip will equip a character based on their stats, class, and try to come as close as possible to being optimal.

Subsystems or subgames is the idea of having other gameplay systems that while not directly related to the core gameplay loop can influence it and vice versa. This is something that can be as big or as little in your game as you see fit. Some games use subsystems as a diversion from the main game; others can tie major upgrades or special rewards that can help someone to these systems. A famous example I already mentioned was the *Triple Triad* card game in *Final Fantasy 8*. Another fan-favorite example is the variety of additional content in each of the *Yakuza* games (developed by Ryu Ga Gotoku Studio), with each game having multiple subsystems and mini-games to go through. For many games today, there is the ever popular "fishing" minigame or being able to cook food to help your party out. This is one of those areas where there are no requirements that you need to adhere to when building your game. However, for every unique system that you want to include, there must be a corresponding GUI and UI/UX work done for it. For more about subsystems in general, I will discuss them in Section 9.10.

For real-time games, having a good GUI and UI are paramount since the player is always going to be engaging with the game. Earlier in this book I brought up games that use pausable real-time for issuing commands or targeting skills, and this is one way of providing turn-based decision-making with real-time results. In any real-time game where the player must switch control or issues commands to multiple characters besides their main, this is all but required to give them the control they need to be able to multitask. Setting up AI commands as I mentioned in 9.3 is another option, but just like with everything else included in GUI and UI discussions, if you want to implement it, the system needs to be as easy to use as possible for the consumer.

Hotkeys and shortcuts are vitally important as well for real-time RPGs, the most common being an easy way to activate skills and use any healing or recovery items. For many real-time RPGs, they will have something known as a "quick bar" or "hotbar" GUI. This element can be configured with different items or skills that can be assigned to hot keys on the keyboard or gamepad. In the *Souls* games, there is a hotbar on the bottom left that can be set up with different items or spells that the player can use during combat. In games where someone can use multiple skills at any one time, a hotbar is required to give the player easy access to them in the heat of combat, with some action RPGs giving the player multiple hotbars they could setup.

Figure 9.32

Games that are played in real-time heavily rely on visual and audio indicators to provide feedback to the player instantly. In the recent *God of War* games, there are indicators for what kind of defensive move to use, when enemies perform area of effect attacks, and audio warnings for specific situations as well.

While both real-time and turn-based RPGs can make use of symbology as I'll discuss further down, real-time games heavily rely on visual and audio cues to help the player (Figure 9.32). This section also relates to reflex-driven games as well. When there are a lot of things going on in the middle of combat, it's important to provide the player with alerts for important events: the player is about to run out of health, the enemy is performing a super strong attack, a piece of ground is going to become dangerous, and so on. Part of developing the aesthetics and the GUI of your game is being able to inform the player using the aesthetics and graphical effects in real-time. Another popular example is using different colors to denote if an attack is doing more or less damage to an enemy due to their armor type.

There are several aspects of good UI design that are true no matter what kind of game, or RPG, you are designing. One of them is with the use of tooltips or a "help feature." One of the challenges of playing an RPG is that it can be easy to forget rules or what the player should be doing if someone takes an extended break from it. Having tutorial messages that someone can refer to is one option. Tooltips are another required aspect of good GUI design – as they provide the player with instant information about a specific topic or element on the screen. For any RPG with character or equipment attributes, a good GUI feature is having tooltips that define what each attribute is and how it affects the character.

A universal aspect of improving your UI is understanding and developing symbology for your game. Symbols are a popular shorthand to give the player

9. Advanced RPG Design

information without needing to explain it in text. The fewer words you need to explain a concept to the player will make your UI easier to parse. Symbols can be used to denote aliments, types of attacks, turn order, advantages/disadvantages, and so on. The challenge for you as the designer is coming up with symbols that are easy to follow, each one is different from one another, and that they make sense for the aesthetic of your game. If you're going to use color as a part of your symbology, make sure that you are using colors that stick out from one another – such as red, green, blue, as opposed to light blue, medium light blue, and so on.

One other aspect of UI design is that responsiveness is a modern factor in good UI design. Many older RPGs had very slow menus, movement, and combat, due to having low frames per second, or FPS, because of the limitations of hardware power. Today, you do not want your game to be controlled slowly, or a system or menu that people are going to be using constantly to be cumbersome or slow. Speedy performance is another detail of having a good UX. For entering and exiting the inventory or any subsystem menu, this should be as fast as possible considering how often people will use them. This is where there is a greater conversation on aesthetics/pushing the hardware vs. streamlining and reducing to improve performance that is too big for just this book.

There is one topic about UX with RPGs that isn't discussed as much: difficulty settings. When I talk about genres that are built on action and reflex-driven design in future Deep Dives, this topic will be far more in-depth. With abstracted design as mentioned, it's not about the player's ability in most cases that will determine success, but the numbers and abstraction of characters and equipment. Because of this, difficulty in RPGs is more focused on either under tuning or over tuning enemy attributes to lower or raise the difficulty respectively. If a normal enemy does 30 points of damage to someone with 100 health points, reducing their damage to 10 would make things far easier, just as bumping it to 60 would be far harder. Due to the story-driven nature of RPGs, and that there are people who will play them just to focus on it and not the gameplay, having different difficulty settings is a good way to broaden the appeal of your game. Some titles will tie additional elements to the difficulty level – increasing loot drops for playing on harder settings, different enemy types that can show up; anything that can provide an interesting challenge to compensate for the harder attributes. Action RPGs, which are designed around replaying content and story missions, will tie the difficulty directly to the number of times the player has beaten the game. Each time the player finishes, they can restart the game on a higher difficulty – greatly raising the attributes of all the enemies and increasing the quality and strength of gear drops (Figure 9.33). The act of restarting a game and playing it with your developed character is referred to as "new game +." As with a lot of the topics in this book, how far you want to go with difficulty settings is entirely up to you and your design.

When talking about character design and party composition throughout this book, I've mentioned just how important it is to provide the player with detailed and concise information regarding character creation. Another aspect of UX for

Figure 9.33

Good difficulty design is about either offering an interesting challenge for people who want to do it or providing a meaningful incentive to keep raising the difficulty up. In *Diablo 4* on the left, raising the difficulty will increase the quality and type of equipment that can show up and is meant to push people to go forward. *Hades* (released in 2020 by Supergiant Games) allows someone to manually tweak the difficulty using the "pact of punishment" – letting them make the game harder if they want more challenge, but not forcing people to do it to finish the game.

RPGs that allow for full character creation is to provide options for everyone. There are some players who will spend hours fine-tuning and building a character literally from scratch, and if your game has an in-depth character personalization tool, they will use that as well. Just as there are people who will pick a default-looking character, choose a class at random, and start playing. One of the major churn points for a lot of CRPG-styled RPGs is overwhelming new players at the start with too many choices. As the designer, try to come up with preset class options so that someone can quickly start playing and enjoy your title. And if someone wants to go all out with character creation, that should be an option too.

When thinking about the UI, GUI, and UX of your game, there is one thing above all else you should remember and be your mantra when figuring out how to set things up that applies to every game imaginable. The purpose of the UI and improving the UX is all about keeping the player engaged with the core gameplay loop of your title. If there is any aspect of your gameplay or UI/GUI that detracts or keeps the player from engaging with it, that is a point of concern for your UI/UX. This is where studying other games in the same genre can help – if something frustrates you in another game, that should be something for you to avoid when building your own. I cannot stress this point enough – just because a super popular game made a UI/UX mistake doesn't mean that it's okay for your game to have the same issue. For indie developers

reading this, smaller games that don't have the clout or recognition of a major studio are often more scrutinized by consumers.

Because different games can focus on specific gameplay or mechanics, it's also why there is no one-size-fits-all approach to UI/UX. The more important a specific system is to the playing of your game, the more you should focus on the UI/UX related to it. Some developers and critics may argue that UI/UX doesn't matter if the gameplay is good enough, but the churn rates of games tell another story. The consumer doesn't have to put up with issues in games anymore; instead, they can just refund and go to another game on their list. The earlier in your game's development that you can start looking at how your UI/UX is going to turn out, the better. In some cases after launch, looking at popular mods that add quality of life features to your game and integrating them is another way to improve the UX. With both *XCOM 2* and *Grim Dawn*, both games received improvements with their expansions that came from looking at popular GUI mods that were made by fans. Understanding UI/UX will undoubtedly make you a better game designer and why I'm going to be talking about this in all future deep dives.

Good UI/UX design is what I consider an unsung hero of game design. If you do it right, people will often not talk about it; if you do it wrong, they will scream about it. This is one of those fields that once you start thinking about it and putting good practices to use, you can carry these skills over to other games in other genres as well. Likewise, I've seen developers who have unfortunately not learned lessons when it comes to the UI/UX of their games, and they continue to make the same mistakes from game-to-game. Eventually, consumers are going to stop giving you a chance to improve and will not look at future games from your studio.

For RPG design specifically when it comes to UX and UI/GUI design, the amount of usable information you provide the player must be considered while building your UI/GUI. Part of the challenge of creating a usable GUI for any kind of abstracted game is how much information the player needs, and does it get to the point where the game is essentially playing itself? As I said further up, the goal of good UI/UX is to keep the player engaged with the core gameplay loop, but what does that mean regarding too much or too little information? There is a difference between showing the player the estimated damage that attacks will do each turn and just telling them what the best tactic or option is to do. For someone to learn a game, they need to understand the results of their actions. The more abstracted design there is, the harder it can be to draw a relation from choosing an action and what that action will do (Figure 9.34).

The push and pull between information overload and hiding it can be most felt when it comes to many CRPGs built from tabletop rules. As I talked about with the history of Bioware and *D&D*, part of the attraction of CRPG design has been the very fact that it can handle the "fiddly" aspects of managing and playing an RPG. For someone who is well acquainted with how the systems and rules work in an RPG, they're not going to need an extensive tutorial or any quality-of-life features to figure it out. For people with no background, however, they are going to be completely lost. Incidentally, this is where a lot of Indie RPG designers tend

Figure 9.34

Abstracted games are some of the hardest ones to onboard new players to, and the king of this difficulty belongs to grand strategy games like *Europa Universalis IV* from Paradox Interactive (released in 2013). Their games are very deep to play and difficult to even begin to learn if you have no experience in the genre. Part of your challenge as a game designer is figuring out how to present information that grows the player's understanding of what is happening as opposed to just pushing buttons.

to find trouble when trying to break into the larger market and finding that the general consumer is far less willing to figure something out that is confusing to learn. One of the ways that JRPG design has been more approachable in this respect is that while they hide all the formulas and rules for combat, they make use of abstracted stats and information relayed to the player. You don't need to understand the exact formula for how damage is calculated when the game will just tell you that equipping this sword will do "X-Y" damage to an enemy. If someone cannot learn how your game works and how to make decisions in it, then that is a failure on your part and on the UI/UX design that you implemented.

A necessary aspect of UI/UX work is with the onboarding or tutorial of your game. This is another detail that will be discussed in every Deep Dive going forward to some extent. For RPGs, the goal of your tutorial is to onboard the player about the UI and GUI, how combat works, and point the player in the right direction on how to proceed. Another universal rule of game design is that the first 30 minutes of your game are extremely important to get right, as this is the window that most consumers are going to judge your game and decide whether to keep playing or not. It is not uncommon for games to have additional tutorials when new systems or mechanics are introduced later in the game. Your goal is to move through the onboarding phase as quickly as you can while making sure that the

player is understanding the lessons and mechanics of your game. This is not something that you can just read about and instantly grasp; it will take playtesting and studying how someone plays your game to figure out the best way to teach someone the mechanics. For games built on procedurally generated levels and situations, the tutorial is often set up as a fixed event as a way of properly onboarding the player to the different kinds of situations and how to play the game.

In RPG design specifically, there is a tendency among designers to frontload storytelling into the onboarding and this can backfire on you. When someone is trying to learn how the game works, the last thing on their mind is keeping track of major characters and plot points. Several of the *Final Fantasy* games will start off with a bombastic set piece that also introduces combat mechanics and systems before slowing down and introducing the world proper. And for every tutorial or informative aspect you put in your game, there should be a way to view them again without having to restart the game. If you want to have a lot of story at the start of your game, that should be separate from the tutorial/onboarding. A good approach to tutorial design is to make it as lean as possible – it should only be as long as it is needed to educate the player on how to play the game. As an example, if your game is made up of three different gameplay systems that are the focus of the experience, then you want to move the player through all three of them as quickly as possible. There have been cases where players quit a game before they even get to the actual gameplay or past the onboarding section.

For the final point in this section, I want to touch on accessibility options and additional aspects that can be added to a game. Accessibility and approachability are oftentimes conflated, but there is a subtle difference between the two when talking about game design and gameplay. Approachability features improve the overall playability of your game and fix or mitigate potential issues in the game that can stop someone from playing. Accessibility features can make a game playable for people due to outside issues or conditions, and they should always be integrated whenever possible. Examples include color blind mode, subtitles for the hard of hearing, control rebindings, and more. Accessibility features are becoming more standard in games today and should always be considered when developing your game.

A popular approachability option used in games today is having ways to affect certain aspects of the gameplay beyond just difficulty settings. This can include adjusting the encounter rate, instantly winning battles, disabling or reducing the impact of specific mechanics, and many more that are handled on a design-by-design basis. In the past 5 years for me, I have played more RPGs that have the option to "auto-win" any fights, including bosses. I have come around to having approachability features like these in games, because they are going to be used by people who the next step would have been to just quit the game. However, you should not be balancing your game under the assumption of people just skipping content. In this respect, these features should be treated as the failsafe option to retain someone, and if your game has them, be sure to mention them within the

Figure 9.35

Having the option to turn on "auto-win" for encounters has become more popular over the 2010s as an UX option, especially for longer games and for people who want to see how the story plays out, but may not want to keep repeating battles or a difficult section. And for people who don't have a lot of free time, having the option to skip battles helped me play through *Ikenfell* (released in 2020 by Happy Ray Games).

game itself. Most consumers will not dig into your options menus to find fixes to your problems or to search if it does have approachability options (Figure 9.35).

In summary, UI/UX is something that no game designer who is interested in selling their game as a product can ignore anymore. For students and first-time designers reading this, consumers don't care about any excuses for why there are issues with the UI/UX in a game. There are too many games being released week-by-week for someone to spend time being frustrated in any title. If people are finding issues with the UX of your first game, they don't want to be dealing with them by your fifth or sixth, and the earlier in your career you learn will help you as a designer.

9.9 RPG World Design

After some major sections for this chapter, I can now turn to something that is a bit easier to discuss. The world design of an RPG greatly varies based on the kind of RPG you're making and the scale that you are aiming for. For smaller RPGs, or those that are just focused on battles, there really isn't a "world" per say, but a series of battle maps with possibly a hub area that players return to after a battle. Likewise, a dungeon crawler doesn't have a world either, as every floor of the dungeon is the setting.

The world itself in any RPG acts as a form of progression. Wherever the player starts the game at, will feature the weakest enemies and the lowest tier of gear. As the player begins to move through the world, each new area will raise the difficulty of the enemies while introducing new equipment and quests to do. This has been the general progression of CRPGs and JRPGs, with both sometimes using story progression and events as a gate to stop the player from reaching certain areas until they are at a certain point progress-wise in the game. For RPGs that are completely open-ended or feature multiple areas to go to, like the *Elder Scrolls* or soulslikes, this kind of progression can still exist but done more implicitly. How enemies are set up in the world can be a gating mechanism – with an extra strong enemy in a lower-level area cluing the player that they may not be ready to go down that route yet (Figure 9.36).

At the most basic design for traditional RPGs, an RPG is made up of three distinct kinds of locations. Towns/safe areas are places where the player can restock items, learn about the local area, get quests, and is typically when the player is not going to be attacked by anyone. For many open world RPGs, the player could cause trouble in towns to get attacked by the local guards depending on the gameplay. Towns and cities are where players will get access to quests that can be found in the general area, or those that can carry them from town-to-town as a form of progression. For most RPGs that follow the traditional designs of the genre, the following services should be available:

Figure 9.36

Some of the best world designs are about creating an interesting environment, which has its own story and lore to it, and make it fit in with everywhere else. Caelid in *Elden Ring* is an area you can go to very early in your game...except it's a nasty area with enemies far stronger than the opening area – hinting to the player they may not be ready to here yet, or try to tempt fate by exploring.

- A shop or shops where players can buy new items, weapons, and equipment
- A way to fully restore health, cure all aliments, and resurrect any dead characters

For RPGs that feature a questing system – where players can get and complete quests from NPCs, they will find most of the quests inside towns. Shops will sell the player a variety of items and equipment, with the potency of items and the strength of the gear increasing the further into the game the player is. Likewise, keeping with the discussion of balance earlier in this chapter, the more powerful gear is or the potency of items should be reflected in the price to buy them. Towns, outside of specific plot points, are considered safe havens for the player. In dungeon crawlers that usually only have one town or safe area to return to, the town itself can be updated based on the player's progress to have more features and offer better items for the player to buy. A common progression aspect is to tie unlocks based on the loot players get from defeated enemies.

The second kind of area are major and minor set pieces that I will refer to as "points of interest." A point of interest can be literally anything – a decrepit cabin in the woods, a mysterious pond, a foreboding cave, a crashed spaceship, you name it. The main detail is that a point of interest is a fixed location and is hand-made by the design team. This is not where you would use procedural generation as you want this piece of content to be uniquely made. Points of interest are used as a way of fleshing out the world and providing the player with something to explore. For games that do use procedural generation, a point of interest can be placed within a procedurally generated stage as a fixed event that has to happen. A very simple example of this would be having an exit staircase or door for the player to leave the floor or area that they are currently in.

Many RPGs used points of interest as the main form of their progression in the world – having to clear out a dungeon or fight a bad guy in their castle as two examples. Not every point of interest needs to be an epic encounter, some could literally just be there as a form of environmental storytelling. When it comes to expanding a RPG with more content, a popular option is to develop a new area and/or create new points of interest on the main map. Story-driven points of interest are written as their own fixed vignette within the world itself – what happens in it doesn't drive the larger plot or is reference elsewhere (unless the story continues at another point) but exists as its own personal short story for a player to enjoy. From a narrative point of view, this gives the designer the freedom to create whatever kind of situation or kind of story they want within their world, knowing that it won't impact the main narrative of the game.

For required areas to explore, they are in essence like a stage in your game, complete with a beginning, middle, and end to the dungeon. Some dungeons may have puzzles or unique elements in them, and it again depends on the scope of the design you are trying to reach. For a dungeon crawler specifically, a set of floors may be considered as a biome; complete with a boss fight waiting at

the last floor of the section. When the player clears it, they move on to the next set of floors and the pattern repeats.

With that said, there are cases where developers will use procedural generation for points of interest. For many action rpgs that are designed around repeating areas for gear and rewards, they will procedurally generate all but specific story sections and boss fights so that the player can explore new areas each time. There have also been story-driven RPGs that made use of a procedurally generated dungeon as either a late game or bonus content for the player to go through. As an example, let's imagine how the game could procedurally generate a dungeon and what elements are required, and which ones can be added in during the procedural generation:

Required:

- Entrance
- Exit
- A Treasure Room
- A Boss Room

Now, let's break down the elements that are optional or not inherently required by the design of the dungeon:

- Monster Rooms
- *Special Events
- Traps
- Elite Encounters

The listing for "Special Event" is different from the others, as it refers to any kind of situation that can be randomly put into the dungeon, but is still created by the designer. An example could be finding a mysterious peddler who sells strange items, or a miniature puzzle for the player to solve. With the listings of treasure and boss rooms, just because the rooms themselves are fixed, doesn't mean that the outcomes are. Many roguelikes and games that feature procedurally generated stages will have certain aspects that can be shuffled on each play – like a different boss-class enemy at the end of a stage. How far you want to go with procedural generation will be dependent on the scope of your game and your ability as a designer (Figure 9.37).

The third, and largest type of content, is the actual space between everything. These are the roads, mountains, forests, deserts, and so on that make up your world. For many RPGs, they will use procedural generation to create the general topography and then set up points of interest and tweak the environment after. For turn-based RPGs, this is where you'll need to set up how random encounters work – can the player be attacked everywhere, or are there specific spots where enemy attacks can occur? On top of that, how does the game determine when the player is going to be attacked? There are different ways of triggering a random encounter while exploring. Many games base this on the number of steps the character has taken in

Figure 9.37

To use *Hades* as an example of biome design. The game's structure takes the player through four distinct biomes. Each one has enemy encounters and events exclusive to it, such as mini boss fights, but also those that are general such as stores and upgrade rooms. The overall path through the game is consistent from run to run, but the individual rooms and events the player will experience are different each time.

an area meant to have a random encounter – with the chance of a random encounter growing the longer it has been since the last attack until it gets to the point where a fight is guaranteed to happen. Another option is that after every character step, the game will run a check behind the scenes to see if it should activate a random encounter event. This can lead to situations where the player completes a battle, and then immediately gets into another one after taking one step. Another option is that after the encounter is over, some games will give the player a "grace period" before the game goes back to checking for the condition to generate a fight.

The actual size of your world is dependent on the length of the game you are trying to reach and the number of points of interest you want to include in it. Just remember, the more space there is between points of interest, the more time the player can be delayed by fighting and the overall length of your game will grow. It is common in games today to feature some way for the player to return to areas they've previously visited, otherwise known as "fast travel."

Quest design is something that doesn't quite fit as a standalone topic for this chapter, but I want to touch on it here. Quests in RPGs greatly vary based on the design and intent of the gameplay. For linear story-driven games, quests are just literally the main plot from beginning to end. For open-world and MMORPGs, the quests are there to provide the player with more backstory about the world, give them experience and gear to grow in power, and gradually move them

around the major areas in the space. Having some way to notate quest givers or quest areas on a map is a form of good UX if you want the player to easily find them again. Another point, if quests are essential to the game, having a quest log and an easy way to keep track of what you need to do is necessary. Many side quests are designed as optional content that can reward the player with items and resources to help them on the main quest but are not required to move the story forward. There are RPGs and other games where the side quests can lead to powerful upgrades, or the best equipment in the entire game. Returning to the topic of balancing your game, it is fine to include "ultimate" gear as a final reward for doing something challenging, but you shouldn't be balancing your main game under the assumption that players will be using that tier of equipment.

If your game does have quests that are tied to the player's position in the story, it's important to notate if a quest is only accessible for a given time. This is often referred to as a "point of no return" – when the player moves to a point in the plot where there is no going back to other areas. Quests should also be balanced based on the general level of the area they're in unless the point of the quest is having something harder that requires returning to a previous area. A UX point here is telling the player the recommended level for a quest before they start it to give them an idea of if they're ready to do it.

When it's time to build the world and environmental design of your game, you need to always be thinking about the general power levels of the player's characters in each major area. For story-driven or linear RPGs, what level should the player's character(s) be to fight the enemies? And can the player find or buy

Figure 9.38

Returning to From Software, a common design of their worlds is to have surprising encounters that can shock a player in the early game, and something to fight against when they feel ready for it.

equipment that is comparable to the enemies and their statistics? With that said, it is not uncommon for developers to put in hidden content that is way above the rest of the content for a general area (Figure 9.38). Hiding a secret boss who is not beatable until the end of the game or having a very powerful weapon tied to a low drop chance from an enemy.

For games that do not have random encounters, the world design becomes a bit trickier. You'll need to set up specifically how many enemies will be in each area, where they are going to be located, how many enemies per fight, and can the player reach the right level or equipment power needed to beat the boss and move on to the next area? Many players will skip fights if they can, and this is where the idea of scaling experience based on the difference in levels that I mentioned earlier in this chapter comes in. It is also common to set up enemy groups specifically near quest items, treasure, or anything important in the area that you want the player to go after. Returning to *King's Bounty*, the game would purposely set up strong enemy fights near the best resources in each area but would have smaller ones sprinkled throughout the map that the player can go after first. You will also need to decide if enemies can repopulate an area after the player is done clearing them. This is a tougher decision than you might realize at first. Many players like to clear out regions under the assumption that they can just move through an area without any encounters. If you do repopulate, then someone can just keep grinding a section before moving on. And to that point, if the player is over leveled for a section, many RPGs will either reduce random/fixed encounters or outright stop them from happening if the player gets nothing from fighting them.

In terms of quality of life with the world design of RPGs, the biggest one has to do with saving the game. At minimum, there should always be save points at the start of major dungeons/points of interest, and possibly right before the boss of the area. Many older RPGs would only allow the player to save at fixed save points, but the time in-between save points could prove to be too long for people with busy lives. A popular system that has been integrated is known as a "quick save" or "temporary save." When the player uses a quick save, the game creates a save at that very moment in time and exits out of the game. Upon loading it, the quick save is deleted, and the player resumes literally where they left off. For CRPGs and open world RPGs, the player should be able to save just about everywhere provided they are not engaged in combat or being chased by an enemy with an exception I'll talk about further down.

One of the changes that soulslikes brought to RPG design has been a slightly different form of progression that focuses on individualized areas with multiple routes between them. I will be discussing soulslikes in a future deep dive, but for a quick lesson, their level design is about being "dense" rather than long corridors. Areas will frequently double back on itself to unlock shortcuts that let the player skip through parts they've already done or just get right back to a boss fight depending on the design. Each area is always punctuated at the start by a rest point that doubles as the spot characters will revive at if they are killed in that area.

For open world RPGs, another factor to consider is the general "liveliness" of the enemies and characters moving around. A term that has been popularized to describe the AI doing their own thing separate from the player is called "AI Life." In these games, various NPCs will have their own basic goals or routine that they will do. More advanced versions could have different AI groups interacting with each other, such as: setting up trade routes, fighting, exploring on their own, and more. If you want to give NPCs their own AI behavior, it is important to balance that with the quest and structure of your game. You don't want an essential character to wander off and get killed before the player even knows that they exist.

The previous paragraph brings up a potential technical issue, that while this is a design book, it is important to understand. Many games build their world and progression around event triggers – when event A happens, event B can now be done, and so on. Many RPGs will do this for their different quests, with quests designed around a chain of events. If something breaks that chain for whatever reason, it can leave the player with a quest that is literally impossible to complete. For games that have AI Life systems, or allow the player to attack any NPC, you will need to consider if the player can break the game and if there are alternatives.

Regardless of if your world is open or linear, random or fixed encounters, the one thing you need to be most aware of is preventing the player from "softlocking." A softlock is when due to the mechanics of a game, either because of a bug or just the design, a player cannot progress anymore in the game. For the RPG genre, these games are some of the longest ones outside of live service games to be released. If someone makes it 20+ hours in and reaches a point where there is no way for them to progress other than to restart, that person is most likely never going to finish your game. A common example in an RPG is when the player is at an area where the enemies are too difficult to fight, they are not able to replenish their healing items, and there is no way to return to a previous town or strengthen their characters further. A few paragraphs up I mentioned point of no returns, and this is one of the primary reasons why many games will let the player save the game before the point but not allow them to save in the middle of it. If a player overwrites their save and then becomes stuck, there will be no way for them to continue.

With regards to traveling, besides fast travel, there is also the option to create vehicles or other ways of traveling. One of the most iconic in this regard are the chocobos featured in the *Final Fantasy* series that allowed the player to travel faster on land and not have to worry about random encounters. Much like a lot of the topics in this chapter, having different forms of travel is entirely up to you as the designer. Just remember, the more the player must travel on foot, the more time that can add to the game.

World and environmental design can mean very different things depending on the design of your game. Some games, the world is just there as a map that frames each battle; in other titles, the world is a living, breathing, place with its own history (Figure 9.39). Many video games that have gone on to become major names do so by treating their world and their world building with as much

Figure 9.39

For games with a focus on combat or all points of interest, a node-based map can work, and this can be embellished by creating an actual world, but the player is limited from node-to-node like in *Star Renegades*.

respect as their gameplay and story. When done right, good worldbuilding can elevate a game far higher than it would have gone otherwise and is an essential element for people who are going to play your game for the story. To go into more detail about designing the world and lore leans more toward storytelling and narrative which is not the focus on this book.

9.10 A Primer on Subsystems

This section is all about a very nebulous topic when it comes to RPG-based games with subsystems, and why it is going to be very short compared to everything else in this chapter, as there are no rules for what you could include in your game. A subsystem is another form of content in a game that is too big to be considered a minigame but is separate from the core gameplay loop. The role of a subsystem is to provide another way of progressing in the main game, or as a diversion that someone can do when they want to take a break from the main gameplay. The most popular example of this would be "crafting." The act of crafting greatly differs throughout every game that features it. Some games allow the player to craft better gear provided they have the right resources; other games let the player directly add or modify existing gear to boost its capabilities (Figure 9.40).

9. Advanced RPG Design

Figure 9.40

Subsystems can also be the content that defines and differentiates one RPG from the other. The *Atelier* games by Koei Tecmo focus on crafting items and gear that can be used to solve quests or for exploring the world.

Subsystems can also be considered a secondary progression system for characters, such as having a unique passive tree with its own resources and abilities separate from the main one. In this respect, there is a symbiotic relationship between the main gameplay loop and the subsystems – by using the subsystems allows the player to get stronger and progress through the core gameplay loop which in turn will unlock more ways of using the subsystems to get stronger. A great example of this in effect is the *Disgaea* series that I talked about in section 6.3. Just in the first game alone, a player could upgrade weapons, switch characters to different classes to train in other skills, collect special characters that could be affixed to gear, level up the use of different weapon categories, and use edicts to make the game easier or harder.

The *Final Fantasy* games have been another great example of subsystems and tying them to the greater progress throughout the entire game. Starting from *Final Fantasy 7*, each game would experiment with some kind of additional progression or subsystem that would be interactable throughout the game; 7 had a variety of games to play and chocobo racing. I mentioned earlier in the book Triple Triad and Blitzball from 8 and 10, respectively. On the lower end, these modes were fun diversions from the rest of the game, for people wanting to see it all, some of the best gear in the game for specific characters was tied to doing everything in these modes.

One aspect of subsystem design that you need to consider when balancing your game is just how vital they are to winning. The secondary content's role in

a game is to either provide something for the player to do as downtime or act as supplemental progression to help them in the game. There's a difference between someone playing a game and using every system available to dominate it, and someone being forced to use these systems as the only means of progressing. Returning to *Disgaea*, if someone just wants to play the game without using those systems, they can and treat the combat as the main gameplay loop. For other people, they view the act of powering their characters up as the main content, and the combat as more of a secondary act.

The problem with subsystems in this respect is that they can either become a necessity or ruin the core gameplay loop. Many AAA titles have used perk trees and secondary quests as a form of progression when trying to add in RPG systems. What ends up happening is that the main storyline often becomes invalidated once the player has a fully upgraded character with all the best gear – it is akin to being all dressed up with nowhere to go. This is where actual RPGs will design optional or post-game content specifically to challenge players and test their use of subsystems.

Another potential use of subsystems is to possibly test the waters with unusual or completely different game systems to see what people think of them. Sometimes, it can be surprising what people will latch on to in a game. Many mobile games will often throw in limited-time events with different game mechanics compared to the rest of the game as a way of shaking up expectations. And if people respond positively to these systems, then they could be explored further down the line.

There are no rules for subsystems in any game, and you'll never really know until after your game is out if people enjoyed doing them. I wish I could be more helpful here, but I have seen games where these systems went completely unnoticed, and some that were so popular that they helped inspired full games to be made from them (Figure 9.41). Just remember from a development standpoint, the more additional modes and systems in your game, the more work it's going to be to put them all in.

9.11 No Rules to the Rules

I did not expect this chapter to be this long when I started writing it, and this may be the longest chapter in any Deep Dive. The RPG genre has tremendously changed, and with it, so has what is considered an RPG. Everything that I've talked about in this chapter, from how to balance gear, skill designs, party compositions, enemy compositions, has undergone changes. In an odd way, RPGs exist now in two forms – games that use the RPG systems and mechanics as the dedicated core gameplay loop, and those that use it simply for the progression and/or depth that it can provide to other gameplay loops.

And what that means for you reading this, is that unless you are setting out to create a dedicated example of a JRPG, CRPG, or any subgenre design, there are no fixed rules for what you must include if you want to have RPG mechanics in your game. While I was writing the chapters looking at the growth of sub-genres, it dawned on me how so many of these genres came to be simply because

Figure 9.41

Experimenting with short-form games with different gameplay have grown in popularity among indie designers over the 2010s. The *Dread X* collections (published by DreadXP) have been a way to promote smaller developers and give them a chance to make something different. Some of these projects became popular enough to turn into actual series like *Sucker for Love* (developed by Akabaka and released in 2022).

someone wanted to do an RPG a bit differently than the other games. The individual systems themselves – gear design, skills, etc., have fundamental aspects that you need to consider if you want to include and balance them, but the decision to include them in the first place is not set in stone (Figure 9.42).

While unique, complicated systems can draw in hardcore fans, not getting the fundamentals and UI/UX right are more damning to the success of an RPG, and this is where I see a lot of first-time developers mess up on. As I've said, even the best RPGs of the 80s and 90s would be heavily criticized for their designs if someone tried to replicate them in a new IP. The best tip I can give you for how to approach this genre came from interviews I did with developers trying to make RPGs based off the Apple 2 hardware. Their goal wasn't to just create a game that could fit on it, but to create one that would also show the evolution and iteration that could have come if the platform was still around. Don't just think about the hardcore fanbase with your RPG design, think about what it would be like to play your game with no experience in any of the great examples. Never assume that the consumer has played and mastered every single game in the genre – every game is someone's first. Like every other genre that exists today, there are more games available than anyone has time to play them all from start to finish. Good game design is an iterative process, and that means doing what you can to make your game more approachable, and more enjoyable to your audience (Figure 9.43).

Figure 9.42

RPG design is not as cut and dry compared to other genres, and it can include games that are more traditional like *8-Bit Adventures 2* (developed by Critical Games and released in 2023) and *Deltarune* on the right. Both are considered RPGs but have vastly different design philosophies behind them.

Figure 9.43

And to that point, this is the game *SKALD: Against the Black Priory* (developed by High North Studios AS). The pitch for this game was to be a classic CRPG built off the Apple 2 hardware. Over development, a lot of work has been done on the UI/UX to make it more approachable to the modern audience, without diluting the systems and designs that the developer wanted to include.

There is always room to improve the basic functionality and UI/UX of a game, especially for games that make use of abstracted design. As I will discuss in the next chapter, the market for videogames has shifted over the 2000s, and that means understanding just copying the great RPGs of the 80s and 90s is not how you will succeed today. Do not be afraid to mess with any of the systems or mechanics that may be deemed as "required" from RPGs in the past.

This is one advantage that abstracted design has over reflex-driven. In games built on real-time decision-making and control, everything is always going to be paced and controlled by the player. If you try to break how a game feels to play or the pacing here, the player is going to notice that something is wrong. This is when a game can feel clunky or unresponsive to play and that alone has been reason enough to stop playing a game. With abstracted design, you are free to create or use whatever systems and mechanics you want in your game, or don't use if you don't want to include them. Many RPGs and RPG-based games in the 2010s came to be by picking and choosing what elements they wanted to focus on with their systems, and then creating the mechanics to focus on them. All the different elements and systems in this chapter are only relevant to your game if you decide to include one or many of them. It's at that point after you have decided to have them in your game that you need to understand the balancing that goes into them.

For those of you disappointed that this book didn't include a complete breakdown of all the best RPGs of the past 40 years to use in your design, that would not be relevant to making a successful RPG today. Even the games designed as traditional forms of CRPG and JRPG design still have to understand what the market and audience are looking for in their games presently, and make changes and accommodations to their design. Just because you are designing your game to look and feel like a game from 30 years ago doesn't mean it should play exactly like them. Being inspired by an older style or kind of design is fine; meticulously trying to recreate it from scratch with no further changes or improvements is not going to help your game commercially.

Making a successful RPG in the market today is not about copying *Final Fantasy* 6 or trying to make the next *Mass Effect* – it is about elevating the genre and not just repeating what has been done already.

Conclusion

10.1 What Does "RPG" Mean Today?

If you have been paying attention throughout this book, you may have caught on to how much RPG design has changed and what that means for the traditional examples and systems. Over the past decade, what used to be the biggest money-makers for the genre – the traditional JRPGs and CRPGs – are no longer in vogue at major studios. While there is still a sizable fanbase for them, RPG design has evolved and so has the genre qualifiers.

And that brings up a question that fans and developers have been asking and debating for over a decade: Is it time to retire the terms JRPG and CRPG? When I looked at the steam store page for "Role Playing" while writing this, every game listed on it could not be further apart from those two terms, and even the trending "JRPGs" feature many that would confuse any fan who grew up in the 80s and 90s with the genre. This is not the same discussion I had in *Game Design Deep Dive: Roguelikes* arguing that the roguelike genre has evolved, and that there must be a distinction between "traditional roguelikes" and the newer examples and "roguelites."

With that said, there's another question we need to answer, what is an RPG (Figure 10.1)? If you were hoping to find a definitive example in this book, I've

DOI: 10.1201/9781003331599-10

Figure 10.1

I went through my steam library to see what games I've played over the last year that were tagged as "RPGs" and here are four very different games that look nothing like the RPGs that anyone played in the 80s/90s.

discussed in detail many kinds of RPGs, but not one that would be considered "the true RPG." We can't say it's a game with abstracted design anymore, as almost every game under the sun now features abstracted progression in some fashion. It can't be about storytelling, as there are plenty of games with amazing stories that don't belong to the RPG genre. And we can't even say it's about inhabiting a role or character, as there are plenty of games where the player is allowed to create a character or in-game avatar and manage a party of characters. Further still, we could arguably say that every video game ever made is about inhabiting some kind of role or character in it.

But we still need to try and create a working definition that separates games that use RPG systems and mechanics from actual RPGs. A friend of mine, Craig Stern, from Sinister Design, has been working on strategy RPGs for over a decade now. He has also thought about this and made a post on the very subject[1] and came up with this definition:

"A game is a computer RPG if it features player-driven development of a persistent character or characters via the making of consequential choices."

When we examine how the RPG genre's design has spread to other gameplay loops, it's always about the progression and rarely about the choices (Figure 10.2). In a game like *Call of Duty*, I can fully customize my weapons, killstreak bonuses, and perks, but those choices can by instantly changed and adjusted whenever I want. In an RPG, if the player wants to switch from using bows to maces, that is going to require either creating a brand-new character or completely changing how they built a character going forward. The same goes for the many mobile games

Figure 10.2

The difference between a game that is about building a character in an RPG, and a game that just uses RPG progression, comes down to the goal of the systems. In series like *Fire Emblem*, upgrading or promoting characters is a huge decision that there is no easy answer in terms of your overall strategy. In a game like *Payday 2* (released in 2013 by Overkill Software), the modifying of weapons always has an end goal – get the most performance out of your weapon which is definitive. The systems essentially dilute the fact that there are "best ways" of modifying a gun, that again, comes back to the chase for more numbers.

that have RPG progression systems – there is no greater choice at the end of the day, the player is just focused on getting more numbers. And this is also why games that feature linear RPG talent or perk progression, no matter how detailed it may be, would not be considered an RPG, but a game of genre X that has RPG systems.

With that said, even though you want the choices for character development to matter, I do not think you should make it difficult for someone to redo a character via a respec option that I mentioned in Section 9.5. The goal of an RPG, and specifically, RPG game design, is that there must be choices that the player makes about their characters that should have gameplay-affecting ramifications going forward – does the player choose fire magic and invest in gear related to it, or do they go with water magic? Until the player decides to change their character, every aspect of gameplay will be different based on a choice like that.

With that said, let's go back to the first question, do we still need JRPG and CRPG qualifiers? I would argue that, yes, they are still necessary just as it is important to define differences in strategy games, roguelikes, and other genres. However, what I feel does need to eventually happen, is to create better qualifiers that aren't restricted to either where the game comes from or what platform. As I've said, there are CRPGs today that focus just as much on the mechanics and unique systems as they do with the storytelling; just as JRPGs have become more

story-driven alongside their unique systems. Unfortunately, I don't have an easy answer to this, as so many descriptors are already being used to define subgenres for RPGs. The first step would be creating a working qualifier that defines RPGs where the mechanics/combat system is the focal point for playing it, and those where the overall narrative and world inhabiting are the focus. Perhaps one day, we will have an agreed upon new terms to describe these games. For any game developer working in the genre, understanding the kind of RPG you are making is important when you are trying to market it to consumers.

10.2 Market Trends for RPGs

The RPG market is one of the harder ones to examine for several reasons. As I mentioned in the last section, what even is an RPG has changed far more compared to other genres, and what is the intended consumer market? As an interesting point, one question I haven't really answered in this book is, "what makes a bad RPG?" In the other Deep Dives, I can talk about the foundational aspects of their gameplay and try to provide you with a spectrum of elements that are in the best and worst examples of it: a platformer that feels poor to control, or a horror game that isn't scary, would obviously be bad examples of those genres. With RPGs however, due to how diverse the genre has become, it's a lot harder to just say that if X is in your RPG, then it's either good or bad.

Returning to the argument over JRPG/CRPG qualifiers from the last section, we could make some definitions based on the type of RPG you are designing. If you're making a JRPG and the general systems are confusing or not well implemented, that could be an example of a bad JRPG. Just as having a poor story or a lack of meaningful interactivity could describe a bad CRPG. But again, in today's market with both qualifiers meaning different things, these considerations aren't as fixed as they were 30 years ago. I can define one aspect of quality that is universal for any RPG regardless of its subgenre – does the game remain enjoyable to play from beginning to end? (Figure 10.3) The RPG genre, even the shortest examples of it, is still the longest games being made today. The days in which an 80+ hour RPG was a positive selling point are long over. What consumers have realized is that the longer a game is, the less chance it can keep a positive momentum across the entire game. This is often where RPGs suffer larger churn rates compared to other genres thanks to the level of investment needed to play growing along with the difficulty. Part of your job as an RPG game designer is to create an experience that keeps the player invested from the first story text to the end, or a combat system that is as enjoyable to play from the first fight to someone's 5,000th battle.

This is where UI/UX is vital, perhaps more so than other genres, to RPG design. Even something that sounds minute like the speed of animation in combat can become a factor that stops someone from playing your game. For any professional RPG designers reading this would like to scoff at this idea, I have seen RPGs that lose more than half the player base who bought them within 2 hours; even those that lost a decent percentage within 20 minutes of starting the game.

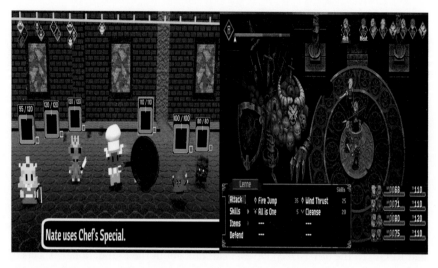

Figure 10.3

The greatest change in how games are being designed and marketed today than they were during the golden age of RPGs is about length. In the 90s, it was considered poor form to release an RPG that didn't provide at least 80–100 hours of gameplay. Today, that bullet point can repel consumers who have way too many games and not enough time. For RPGs today, it's more about the quality of the experience than the quantity, and why many indie RPGs are being designed around shorter game lengths like *Video Game Fables* (released in 2022 by Momiji Studios) and *Chained Echoes.*

A major trend that has affected the entire game market, not just RPGs, has been a focus on qualitative, not quantitative experiences in games. There will always be hardcore fans who will keep playing a game no matter how long it is or the overall quality of the gameplay, however, designing a game purposely for a very specific audience and no one else is not how you want to try and grow a game studio. Always look at ways to improve the playability and UI/UX of your title; even small details like how responsive the UI/GUI is can mean a world of difference.

Indie developers today have the tools to create wildly expressive RPGs of any subgenre, and the variety of design is only going to grow this decade. As for fully traditional takes on the RPG genre, while there are still fans of it, we are living in a market of consumers who grew up with mobile takes and the many subgenres. For developers who are designing RPGs specifically like the ones from the 80s/90s, they are going to find that the market for that kind of RPG has shrunk, but still has plenty of fans.

In Section 9.11, I spoke about why you should not treat older examples of RPGs as the direction to take your game, and while that is good advice for some- one wanting to evolve the genre, it's important to mention what that means for your game in the market. For any genre, RPG or otherwise, the more you move

10. Conclusion

away from what is considered standard for it, it arguably becomes harder to market that game. In the beginning of this book, I mentioned that I wasn't going to catalog every RPG released in the past 40 years nor would it be even possible, and part of the reason was the sheer number of experimental RPGs made by indie developers in the 2010s. On itch.io, there are thousands, at this point, of unique and experimental RPGs that are never going to make it to mainstream audiences. One of the hardest aspects of marketing an RPG, or any game that uses abstracted design, is that you cannot show "the flash" of your game in screenshots or trailers the same way as watching a character move or fight works in a reflex-driven game. Anywhere that you go differently from the qualifiers of the subgenre, you need to be able to show that in your marketing. One, to make sure that people don't accuse you of false advertising in your game, and two, because that's a unique selling point that you want people to know about (Figure 10.4).

And it's for the previous paragraph why just focusing on what was considered "the best" RPG 10, 20, 40, years ago, is not how you want to approach this genre. One of the challenges of writing these Deep Dives is that game design changes with the market and what people expect from their games, and what kinds of games they are playing. If I was writing this book 30 years ago, I would have highly suggested studying any game from Squaresoft or Bioware, because that's what dominated the market. Today, with how much the RPG genre has now spread to other genres,

Figure 10.4

The #1 marketing point for games today is having a strong and unique aesthetic. For RPGs, being able to stand out from everyone else with just one screenshot can mean the difference in coverage. Here we have *World of Horror* (first released in 2020 by Panstasz) and *Get in the Car, Loser!* (released in 2021 by Love Conquers All Games) two very different RPGs that both stand out thanks to their gameplay and aesthetics.

a traditional take on any RPG design with no modern-day additions will not be viewed favorably by mainstream consumers. The successful RPGs today, regardless of what subgenre they are aiming for, know which systems and aspects of RPG design they want to include in their game, and then focus on making them the very best that fit with their gameplay. Making a dungeon crawler RPG where players craft all their gear is going to be fundamentally different, and have a different audience, compared to an RPG dealing with turn-based battles with spaceships.

As for future trends, this is a tough one to predict. The genre has already grown so much over the past decade that it's hard to see where else it could expand to. One area where I would like to see change to is finally putting an end to the stigma of using the *RPG Maker* series as the engine for your game. In the 2010s, there were many people who viewed Unity as nothing more than an engine for **shovelware** games, and a lot of people incorrectly associating the engine as the reason why certain games turned out bad. An engine is nothing but the foundation and the tools that you are going to build your game with. And like I said, even though other game engines are far more powerful and offer more utility, *RPG Maker* and its iterations have led to the creation of games that wouldn't have been made otherwise. And just like there is a greater appreciation for using modding tools for creating new shooters, which will be discussed in a future deep dive, I hope we see the same level of appreciation for *RPG Maker* games that push the envelope on what can be made with it.

One last point and a place to keep an eye on is the mobile market. Mobile games are the most played platform in the industry today, as per the ESA annual statistics[2]. This is where more consumers are seeing RPG systems and design. In *Game Design Deep Dive: F2P*, I talked about how the mobile scene has rapidly evolved over the 2010s to where it is today. It is quite possible the next big RPG trend will not come from a console or a PC, but from being inspired by mobile game design. And when it comes to UI/UX, many mobile RPGs feature impressive GUIs and a polished UX worth studying, because the designers know that they are competing with all the other mobile games for the consumer's attention.

10.3 Wrapping Up

I can't believe how long this book grew as I was writing it (Figure 10.5). If we focus on the reach of game mechanics and designs, RPGs clearly have the widest out of any other genre with the most experimentation from the original designs. In the future, I will most likely be returning to the subgenres for, hopefully, smaller books focusing on each one's specific design and mechanics.

Understanding the balance and design of RPG systems will also help your understanding of abstracted-based design that can fit just about any kind of game today. Despite all the examples and the ease of tools discussed in this book, it can be a surprisingly difficult genre to do right today. There is a reason why I didn't spend a lot of time studying the major names that defined it in the past,

Figure 10.5

I may still be recuperating from writing this book by the time you are reading this; please send well wishes and/or pizza.

because those designs are now arguably considered outdated by the market today. We now have a generation of consumers that grew up with the likes of mobile RPGs and Indie games who have never touched the likes of *Dragon Quest*, *Final Fantasy*, or *Ultima*. To make every one of you reading this feel old right now, by 2033, there will be people who view *Dark Souls* and *Elden Ring* as just another relic of the genre.

One topic I did not touch on in this book specifically was the difference between fans of a genre and fans of a brand. The market has seen time and time again that someone just trying to build a game in the exact same style as a famous one does not do as well, because it lacks the brand power associated with it. This is why just having the goal to make another *Pokémon* or *Final Fantasy* is not enough. I hope by the end of this book you have realized just how much work can go into making a popular RPG, and that "popular" in this respect, has turned into a nebulous term thanks to each subgenre having vastly different appeal and structures. The foundation of RPG systems and mechanics are universal, but where you go with them can take you anywhere. And when you do create something different, that will require you to take those foundational elements and change them to fit your game, instead of the other way around.

The RPG genre best exemplifies something I discuss when analyzing game design – there is always room to improve and refine. Any mechanic, system, UI element, can be iterated on. As I said in Section 9.11, don't be afraid to break or

change the core systems that others have used to suit your own. This is a genre where the tools available make it one of the most approachable genres to jump into, and one of the hardest to not only do right but stand out from the crowd.

Notes

1 https://sinisterdesign.net/what-makes-an-rpg-an-rpg-a-universal-definition/
2 https://www.theesa.com/resource/2022-essential-facts-about-the-video-game-industry/

Glossary

Aesthetics – The tone or emotion that something is trying to convey. For video games, used to describe the kind of theme the art and gameplay are trying to evoke.

Algorithm – A series of commands or instructions for a program to use. In games, algorithms can be set up for the game to procedurally or randomly generate content.

APM – Stands for actions per minute and is used here to measure how fast someone is interacting with a keyboard or gamepad when playing a game.

Avatar – A character in a game that is created by the player to represent them in the world.

Biome – For videogames, it is an area defined by its environment, obstacles, enemies, and rewards that the player can find.

Buff – A passive modifier that can be attached to a character or piece of gear making them better in some capacity.

CCG – Short for "collectible card game" and are card games played digitally where players can collect cards but are not able to buy and sell them the same way as TCGs.

Core Gameplay Loop – The primary game system/form of gameplay that is in a video game.

CRPG – Short for "computer role playing game" and typically refers to RPGs where the focus is on interacting with the world and playing as a character created by the player.

Customization – Customization refers to any in-game choices that the player can make that change the abilities or utility of a character.

Debuff – A modifier that can be attached to a piece of gear or character that weakens them in some capacity.

Gacha – A videogame that takes after the gachapon capsule games in Japan. Where the player will collect characters or other rewards by spending money to get a randomly chosen prize.

GUI – Short for "graphical user interface," and essential part of examining the user interface of a product. The GUI represents all the on-screen interactions and information that someone will be using to interact with a program, or in this case, a video game.

IP – Short for "Intellectual Property" and is the original creation from a human. For video games, it is the brand or copyright of popular characters or franchises that can be used in a title.

Kaizo – Roughly translated from Japanese to mean "modification" and other synonyms. For video games, it refers to incredibly difficult platformer games which are often full of traps that can't be spotted until falls for it.

Mechanic – The "verbs" or actions a player can do in a game, with similar mechanics tied together as a game system.

MMORPG – Stands for massively multiplayer online role-playing game. A type of RPG that focuses on playing a single character in a large world with the ability to meet up and play with and against other players.

MOBA – Stands for "multiplayer online battle arena" a popular multiplayer-styled game where players each control a single character and teams fight over control of a map.

MUD – Stands for "multi user dungeon" and were text-based games that could be played by a lot of players at one time and were the precursor to MMORPGs.

NPC – Stands for "non-playable character" and represents every character in a video game that exists in the world, but is not controlled by any players.

Personalization – The ability for the player to change how a character looks without directly impacting the gameplay.

Procedural Generation – Also known as procgen. A kind of content generation when the game is programmed with a series of instructions, or an algorithm to generate content during the running of a game.

PvP – Stands for player vs. player and is a term to describe any kind of gameplay where two or more players are fighting against each other.

Shovelware – A derogatory term to describe games purposely designed as cheap as possible to make a quick buck.

Skill Floor – A way to describe the lowest skill level that is required by someone to start playing a game. Usually paired with a skill ceiling which is the highest skill needed to finish the game.

System – A collection of individual game mechanics that are all there facilitate a specific kind of gameplay.

TCG – Short for "trading card game" and are card games played using physical cards that players can buy and sell to create their own decks.

TTRPG – Short for "tabletop role playing game" and refers to any RPG that is played using pen and paper and not on a computer or game console. Another term to describe them would be "pen and paper RPGs."

UI/UX – Stands for user interface and user experience, respectively. Two terms meant to describe the ways to improve how someone interacts with a program or device. The user interface is the actual piece of hardware that the person is using, and the user experience represents how it feels to interact with a product or software.

Index

Note: *Italic* page numbers refer to figures.